Dedicated to the photographers
who have lost their lives
trying to capture precious moments of history

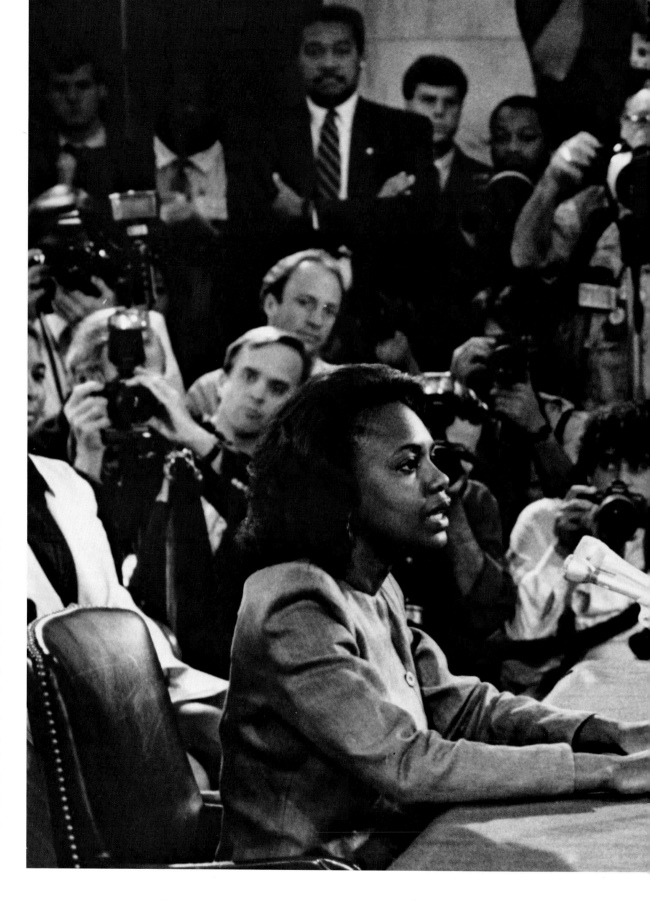

AN ANNUAL BASED
ON THE 49TH
PICTURES OF THE
YEAR COMPETITION
SPONSORED BY THE
NATIONAL PRESS
PHOTOGRAPHERS
ASSOCIATION AND
THE UNIVERSITY OF
MISSOURI SCHOOL
OF JOURNALISM,
SUPPORTED BY
GRANTS TO THE
UNIVERSITY FROM
CANON U.S.A., INC.,
AND EASTMAN
KODAK CO.

PICTURES OF THE YEAR
PHOTOJOURNALISM 17

Bill Snead, The Washington Post
Surrounded by photographers, Professor Anita Hill testifies before the Senate Judiciary Committee during hearings to confirm Judge Clarence Thomas to the U.S. Supreme Court.

FROM NPPA'S PRESIDENT

I t has been a year of incredible worldwide change. It's been quick. It's been decisive. It was unexpected. The Soviet Union broke into its individual states. The Persian Gulf war ushered in a new technological era in warfare and raised many questions about how photojournalists will cover wars in the future.

Drugs have become one of the most pressing national issues, as reflected in Eugene Richards' essays on the inner city.

The 17th NPPA/University of Missouri Pictures of the Year book is the 49th edition of a contest that mirrors the life and times of our planet. It includes pictures from world-changing events as well as some of the simplest human acts. It reflects human thought and interaction across the globe. Contained in the pages you hold in your hands is the best reportage of the best visual reporters. They are professional witnesses, the recorders of the images of history.

Many of these photographs will linger — becoming icons that reflect the events and transitions of their times. They represent the truth, the substance, if not a portrait, of 1991. With this book you can study and reflect on these events. Read it and laugh. Read it and weep. Read it and understand.

— Mike Morse
President, NPPA

© 1992 National Press Photographers Association
3200 Croasdaile Drive
Suite 306
Durham, NC 27705

ISBN (paperback): 0-56138-067-9

Front cover photo by David Turnley/Detroit Free Press.
Back cover photo by Melanie Rook D'Anna/Mesa (Ariz.) Tribune.

Printed and bound in the United States of America by Jostens Printing and Publishing Division, Topeka, KS 66609.

Canadian representatives: General Publishing Co., Ltd., Don Mills, Ontario M3B 2T6.

International representatives: Worldwide Media Services, Inc., 115 East 23rd Street, New York, NY 10010.

9 8 7 6 5 4 3 2 1
Digit on the right indicates the number of this printing

This book may be ordered by mail. Please include $2.50 for postage and handling. But try your bookstore first!

Running Press Book Publishers, 125 South 22nd Street, Philadelphia, PA 19103.

TABLE OF CONTENTS

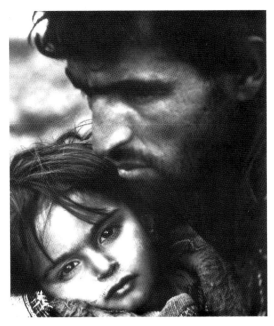

AWARD OF EXCELLENCE, MAGAZINE NEWS
Judah Passow, Network/Matrix for Life
A Kurdish child is comforted by her father.

THE STAFF

Editor, designer
Howard I. Finberg
Associate editor, photo editor
Joe Coleman
Associate editor, photo coordinator
Michael Spector
Associate editor, designer
Susan Love
Associate editor, designer
Diana Shantic
Associate editor, designer
Phil Hennessy
Associate editor, designer
Carolyn Rickerd
Associate editor, designer
Pete Watters
Text editor
Patricia Biggs Henley
Computer assistance
Julie Sigwart

IN ACKNOWLEDGEMENT

Larry Baca, *Aldus Corporation*

Dave Klene, *Josten's Inc.*

**Grant Hall, Fran Williams, Jearl Crowder,
Paddy Cairns, Lori Cutrell,** *American Color*

Anne Wilson, *Apple Computer (Phoenix)*

Marilyn Upton, *University of Missouri*

INTRODUCTION

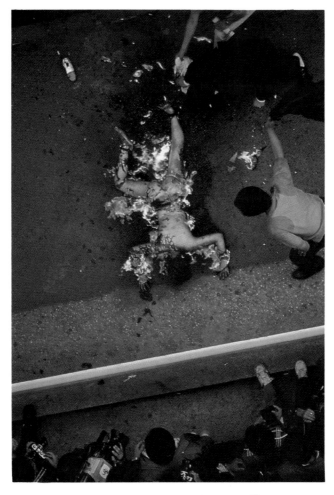

AWARD OF EXCELLENCE, MAGAZINE NEWS
James Nachtwey, Time
A South Korean woman sets herself afire to protest her
nation's government.

It is a strange alliance photographers have with technology. At times it is symbiotic, advantageous to both the journalists and the companies that make the equipment.

At other times, technology seems to get in the way of a photographer's goal to communicate. It is a strange paradox — the very equipment that should aid in communication seems to get in the way of that necessary connection with the reader.

The book you hold reflects that paradox. In some sense it is a technological miracle, but there are two ways to view this miracle.

First, is the "techno-miracle" in the way photographs are taken and then sent to hundreds of newspapers around the world. Using the latest in camera equipment, a photographer can record a moment in history, process the high-speed film and have a picture digitally transmitted across

Continued on next page

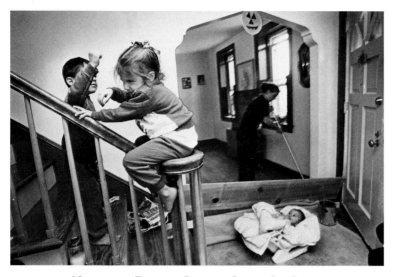

NEWSPAPER FEATURE PICTURE STORY, 1ST PLACE
April Saul, The Philadelphia Inquirer
While their mother is busy cleaning, Joseph Gesualdi beans his
sister, Marqessa.

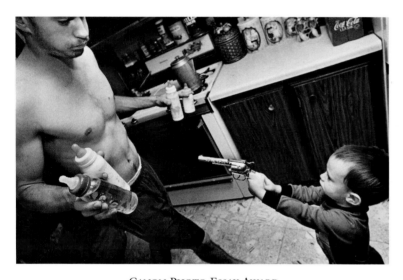

CANON PHOTO ESSAY AWARD
Eugene Richards, Magnum
Sam braves kitchen robbery to prepare baby bottles. The bandit is
his son, Sam Jr.

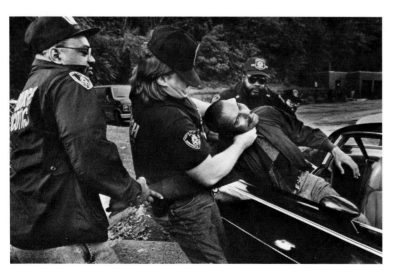

AWARD OF EXCELLENCE, NEWSPAPER SPOT NEWS
Candace Barbot, The Miami Herald
Pittsburgh narcotics agents make an arrest for possession during a
sweep of the city's drug-ridden "Hill Street" area.

Images taken in remote places once took days to reach communication channels for distribution; now they take only minutes. Stored electronically, hundreds of pictures can be viewed daily by editors, each image of the same quality as if it were taken down the street rather than across a continent.

The second "techno-miracle" involves how this book was created. In a matter of a few years, the Photojournalism Book series editors have gone from mechanically "pasting up" photographs on paper layout sheets to creating the design and final output electronically on desktop computers. Despite numerous hurdles and challenges — some too technical to interest most readers — the final proof of this successful transformation is in your hands.

But before we praise our electronic "flash and daring," it is important to remember that technology does nothing by itself. It is a tool that can be used (and misused). By itself, technology doesn't communicate with readers; it doesn't allow photographers to take better pictures; it doesn't make wiser editing choices.

Neil Postman in his latest book, *Technopoly*, writes eloquently about the impact of technology on society and culture and how technology, by itself, adds nothing to our lives. But, he argues, once introduced, technology changes everything.

It is much like the introduction of a new species of animal into an ecosystem. Life for every other animal — hunter to prey — is affected.

Graphic and design technologies are much like a new animal — changing the journalistic ecosystem not just for the photographers and artists, but also for reporters and editors and eventually for the readers. Each group is touched in ways not thought of when the technology was first created and then introduced.

This is not to suggest that technology is bad and that we should embrace a neo-Luddite movement. Rather, I wonder whether technology is helping us communicate any better and if it is getting in the way of seeing the image and understanding its impact upon the reader.

Lately journalists have spent a great deal of time and energy on converting processes from mechanical to electronic. But have we spent any time lately on the images themselves?

Caught up in daily and weekly deadlines, will editors have time or the desire to reflect upon what technology has done to their "ecosystem," how it has changed the way they do their job or how it has altered their relationship with their readers?

If they do, they'll be taking a first step to ensure that technology is used as a tool for communication and not communication in itself.

— Howard I. Finberg, editor

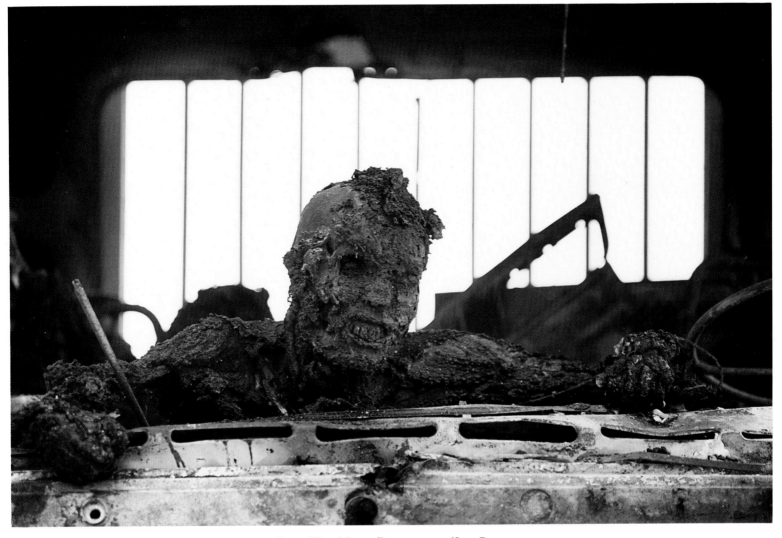

GULF WAR NEWS/INDIVIDUAL/3RD PLACE
Kenneth Jarecke, Contact Press Images for Time
The charred body of an Iraqi soldier still clings to the side of an armored personnel carrier. The soldier was among those who fled, too late, from Kuwait City after the end of the Persian Gulf war.

Following page:
GULF WAR NEWS/INDIVIDUAL/1ST PLACE
David Turnley, Detroit Free Press
An American soldier reacts to the news that the victim in a body bag is a man he knew.

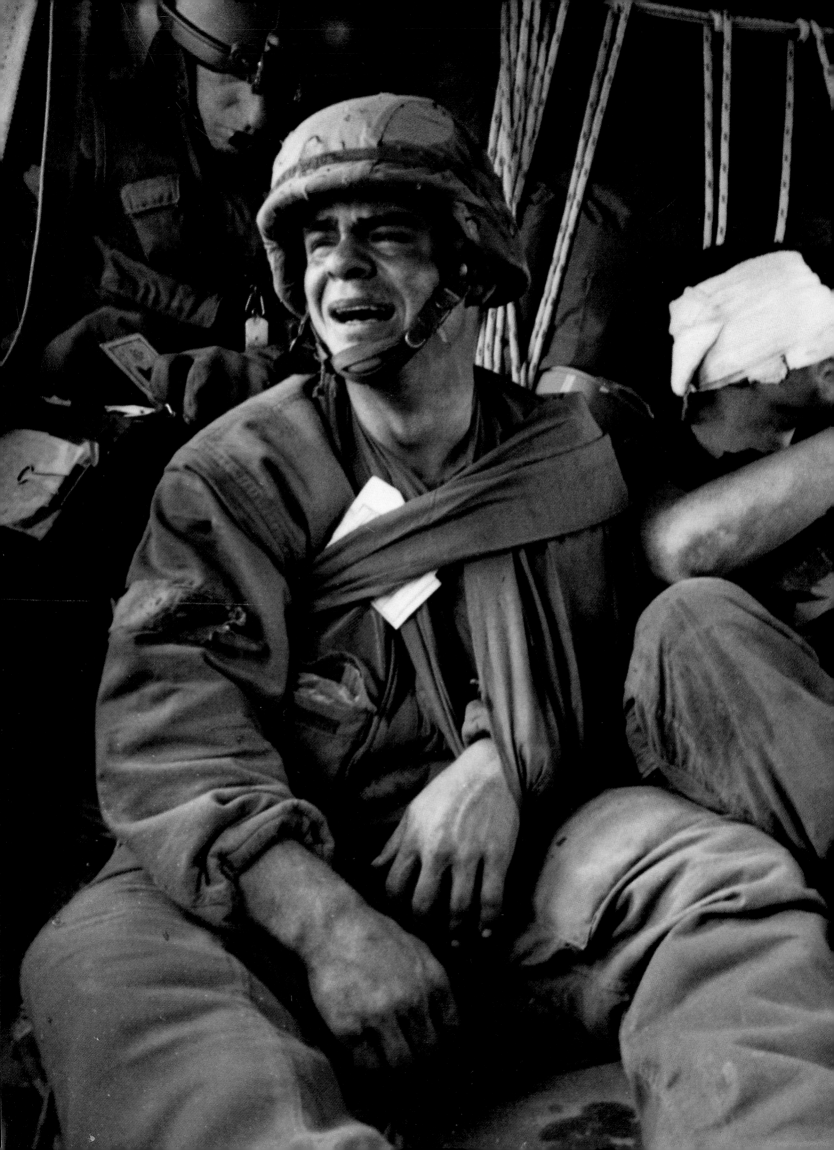

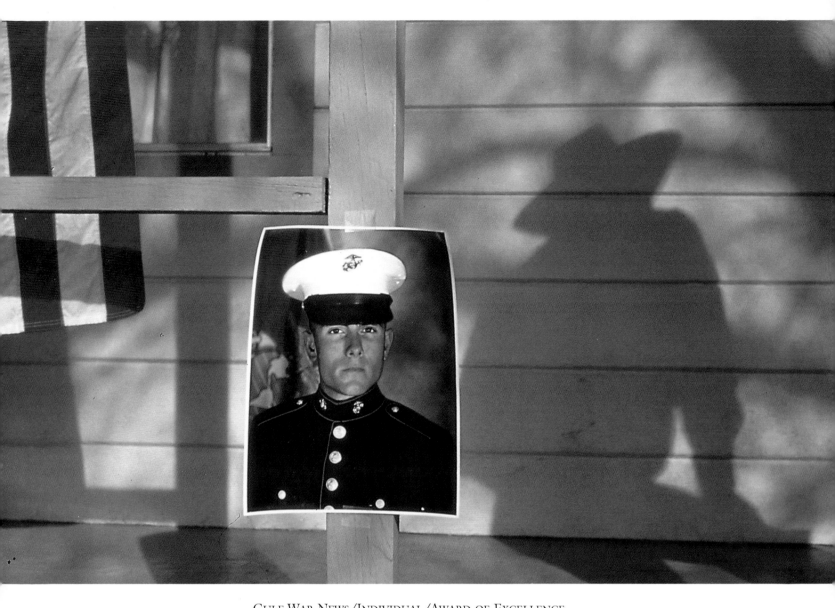

GULF WAR NEWS/INDIVIDUAL/AWARD OF EXCELLENCE
Lois Bernstein, The Sacramento (Calif.) Bee
A photo of Marine Lance Cpl. Thomas A. Jenkins, a victim of friendly fire, hangs outside his family's home in Coulterville, Calif.

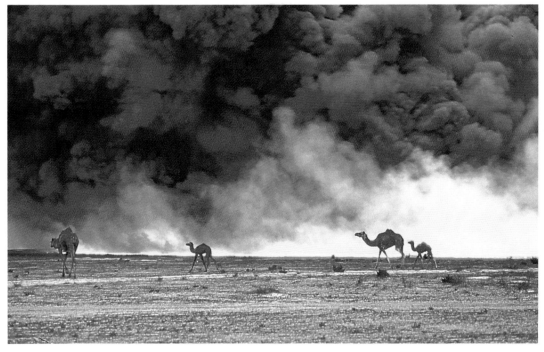

GULF WAR NEWS/INDIVIDUAL/AWARD OF EXCELLENCE
Bruno Barbey, Magnum for Time
Camels search for food as Kuwait's oil wells burn.

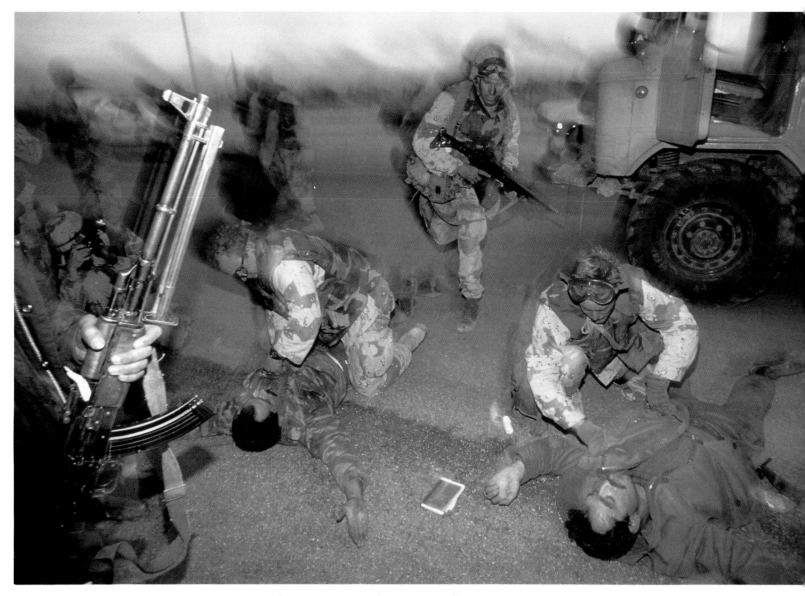

GULF WAR NEWS/INDIVIDUAL/2ND PLACE
Wesley Bocxe, Sipa Press for Time
U.S. Army Special Forces troops detain Iraqi soldiers during the liberation of Kuwait City.

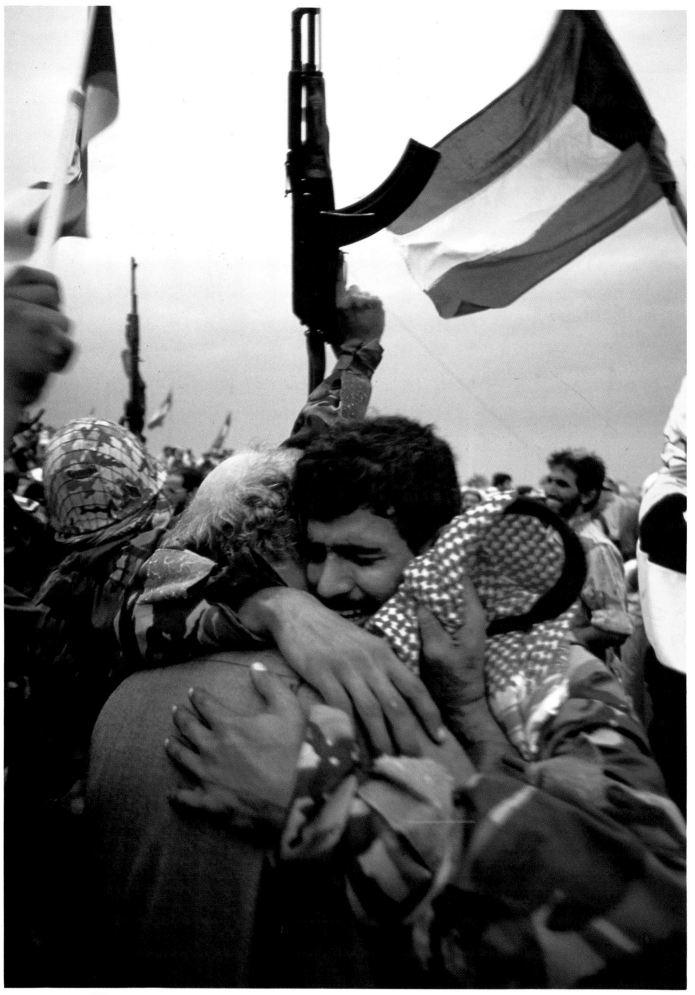

GULF WAR NEWS/INDIVIDUAL/AWARD OF EXCELLENCE
Wesley Bocxe, Sipa Press for Time
A Kuwaiti soldier embraces his father on the morning of the liberation of their country.

Steve McCurry, National Geographic Magazine

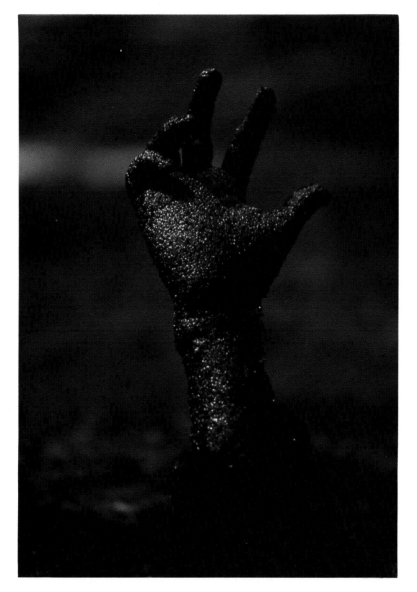

The oil-covered hand of a dead Iraqi soldier is grim testimony to the Persian Gulf war.

After the Storm

On Aug. 2, 1990, Iraqi forces invaded neighboring Kuwait, claiming it as Iraq's "19th province." For nearly six months, diplomats from many countries tried in vain to persuade Iraqi President Saddam Hussein to leave the nation peacefully. On Jan. 17, 1991, after a U.N. deadline for Iraq to vacate Kuwait had passed, Operation Desert Storm began with air attacks on Iraqi nuclear and military facilities, followed by an allied ground offensive and, finally, the liberation of Kuwait City on Feb. 27. But for the residents of Kuwait, the end of the storm marked only the beginning of a long, arduous effort toward rebuilding their ravaged nation.

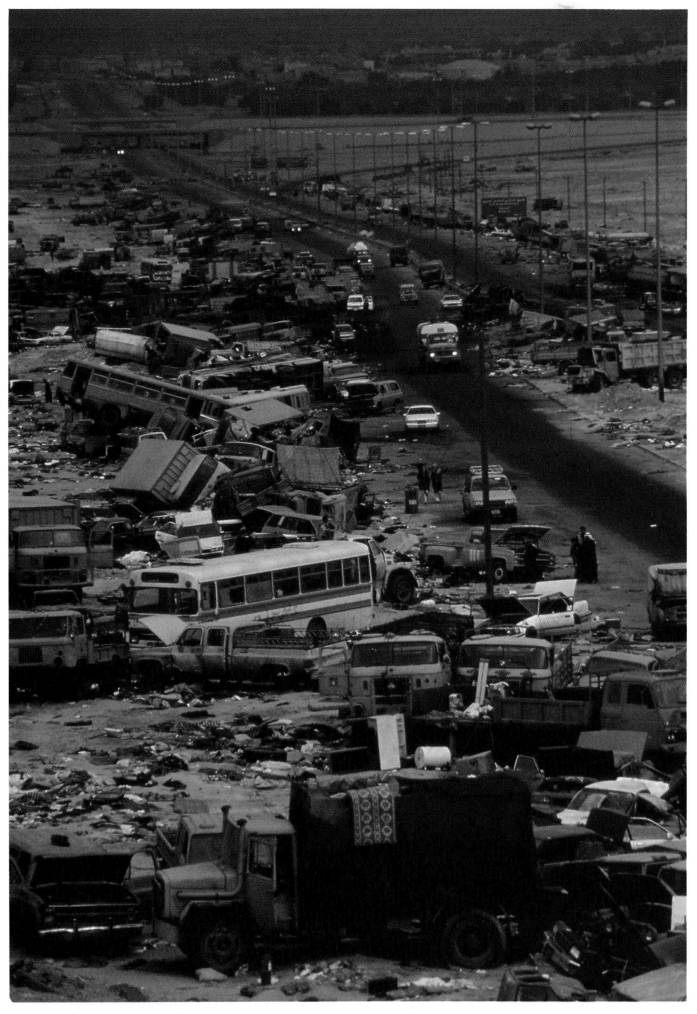

The highway out of Kuwait City became the last battleground for many retreating Iraqi troops, who had been told to leave weapons and armory behind or face allied attack.

Steve McCurry, National Geographic, 1st Place/Story

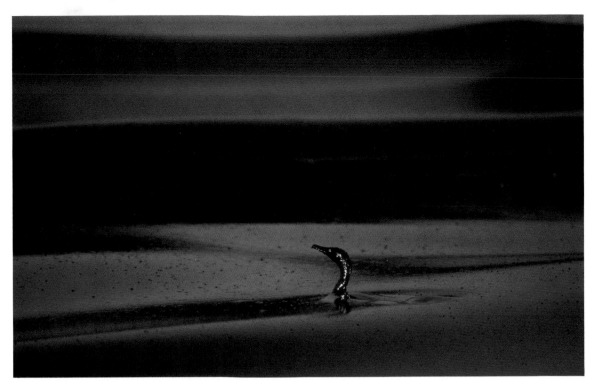

Thousands of birds, caught in oil slicks, became casualties of the war.

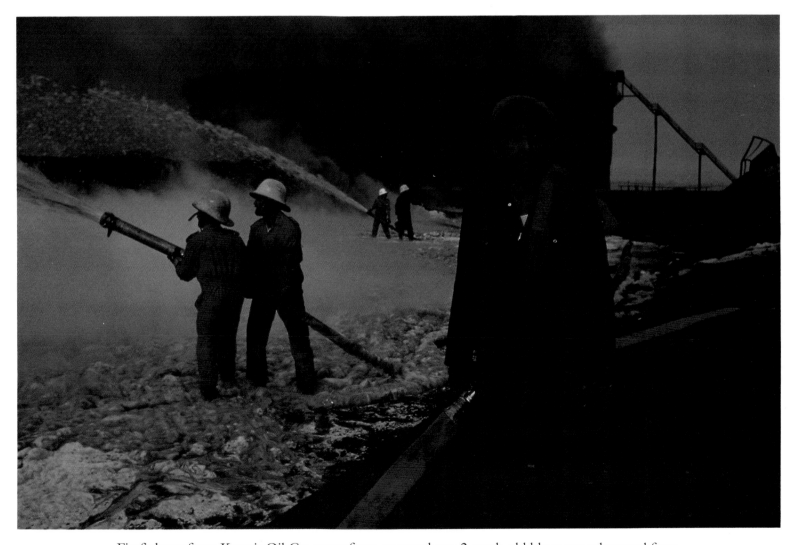

Firefighters from Kuwait Oil Co. spray foam to smother a 2-week-old blaze at a sabotaged farm.

Steve McCurry, National Geographic, 1st Place/Story

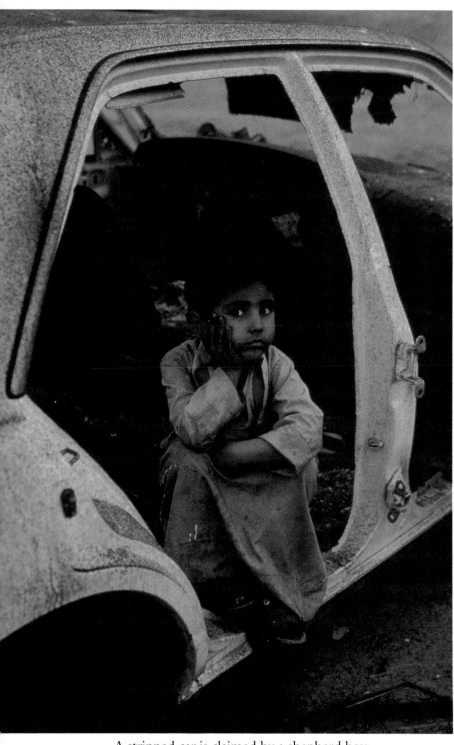

A stripped car is claimed by a shepherd boy.

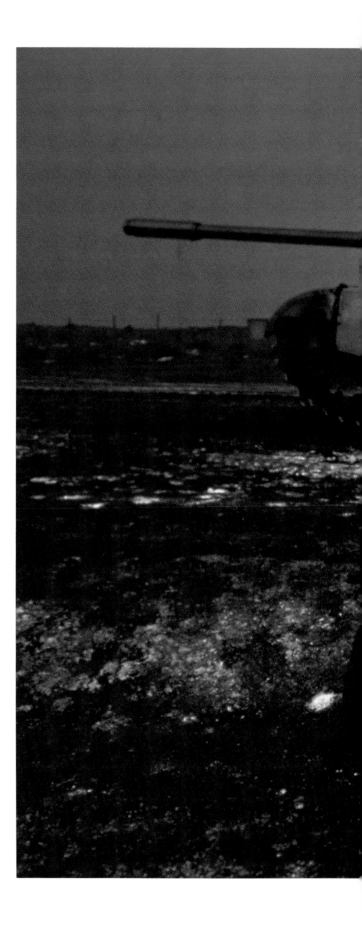

Steve McCurry, National Geographic, 1st Place/Story

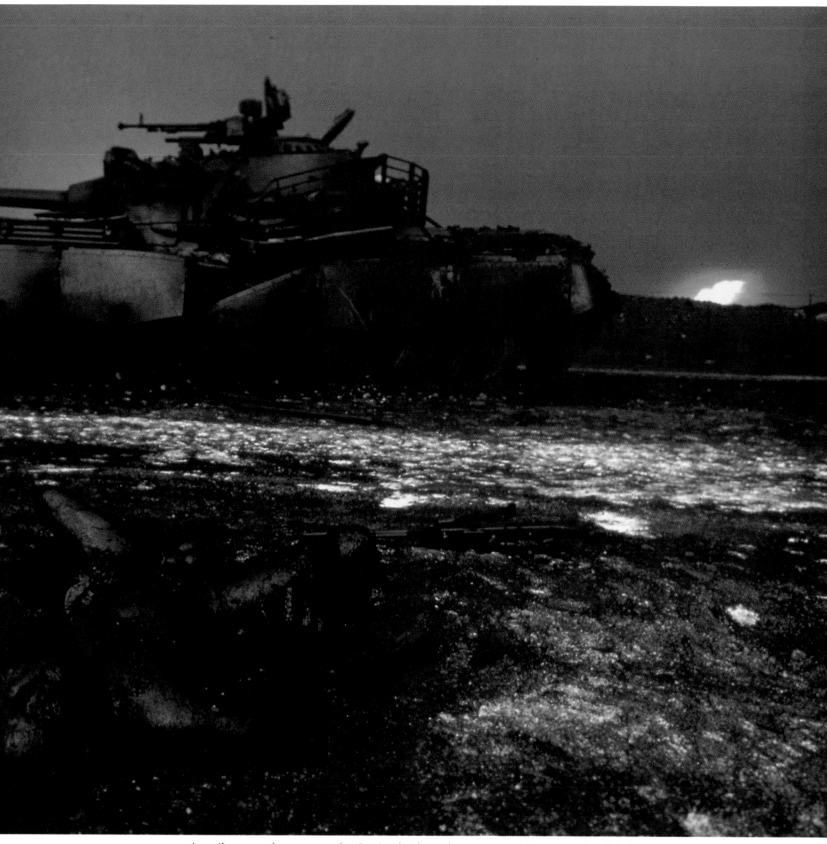

An oil-covered corpse and a Soviet-built tank waste away in a Kuwait oil field.

Steve McCurry, National Geographic, 1st Place/Story

Environmentalists examine a field where the ground has become encrusted with oil.

Steve McCurry, National Geographic, 1st Place/Story

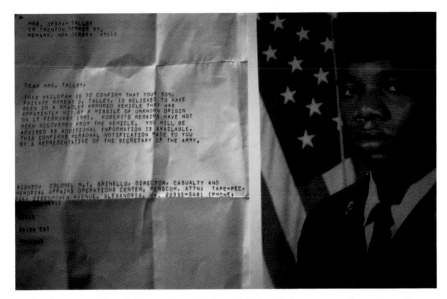

A photograph of Army Pvt. Robert Talley is juxtaposed against the
letter confirming his death during the war.

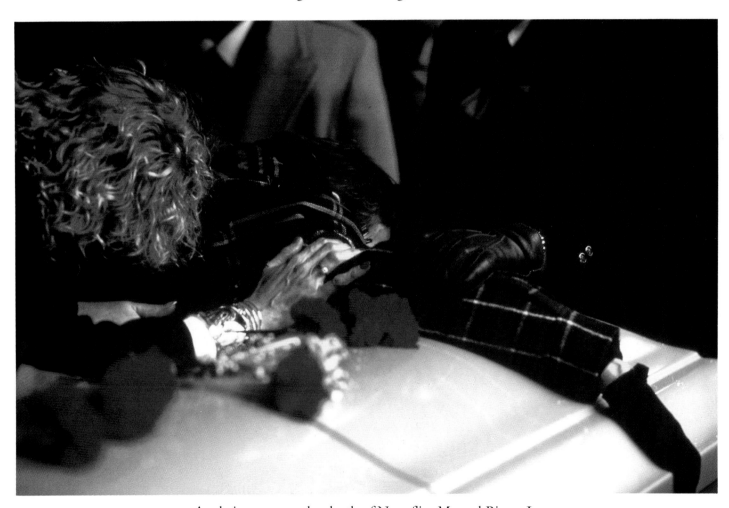

A relative mourns the death of Navy flier Manuel Rivera Jr.

Last Farewell

The Persian Gulf war began with a line in the sand and culminated in a U.S.
force of 541,000. Of those, 148 soldiers were killed in action, including
35 victims of "friendly fire," and an additional 244 "non-combat" deaths were
reported by the Defense Department. The end of the 100-hour land battle
brought parades and parties for many across America, but the ceremonies
attended by families and friends of the soldiers who died were more somber.

Mark Peterson, JB Pictures, Award of Excellence/Story

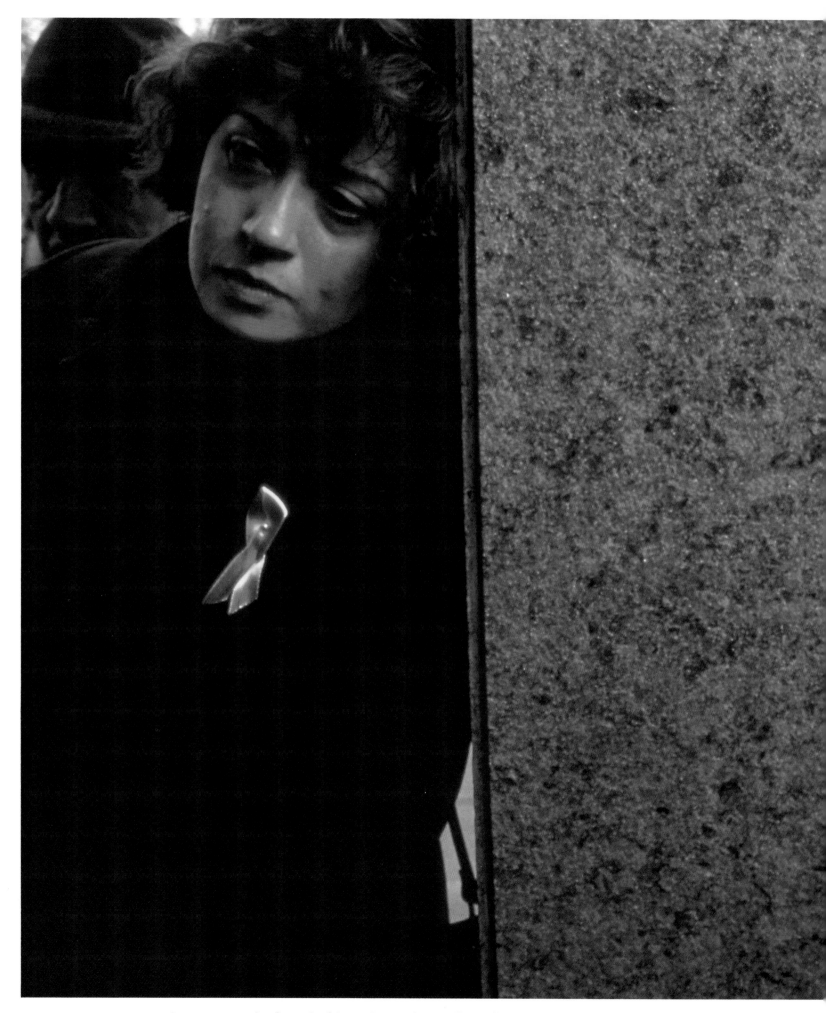

A mourner at the funeral of Army Pvt. Robert Talley still wears a yellow ribbon.
Talley, of Newark, N.J., was killed in action Feb. 19, 1991.

Mark Peterson, JB Pictures, Award of Excellence/Story

Mark Peterson, JB Pictures, Award of Excellence/Story

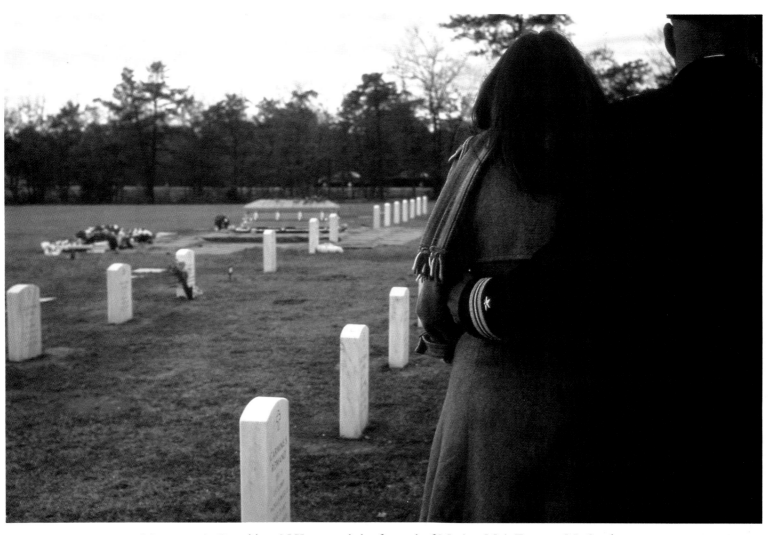

Mourners in Brooklyn, N.Y., attend the funeral of Marine Maj. Eugene McCarthy,
who was killed in a helicopter crash.

Mark Peterson, JB Pictures, Award of Excellence/Story

NEWSPAPER PHOTOGRAPHER
OF THE YEAR
FIRST PLACE

Randy Olson, The Pittsburgh Press

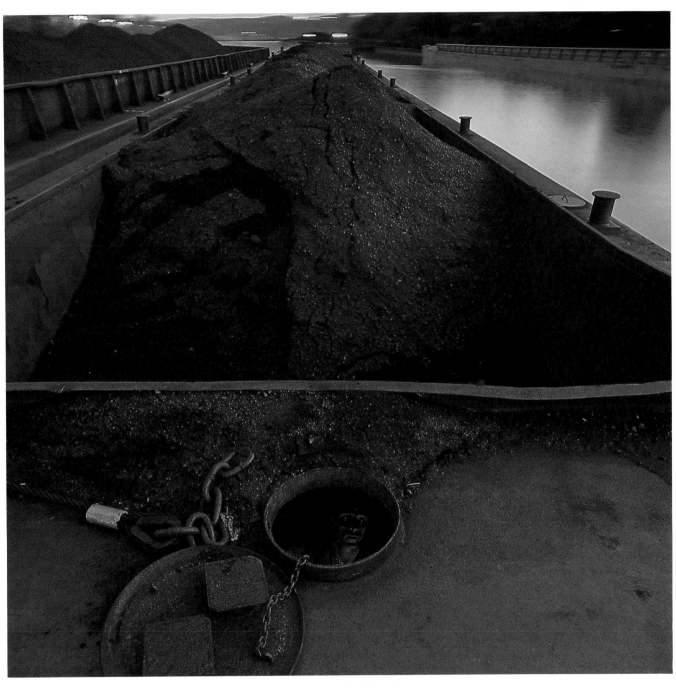

"Man on the Mon"
A barge hand at dusk on the Monongahela River.

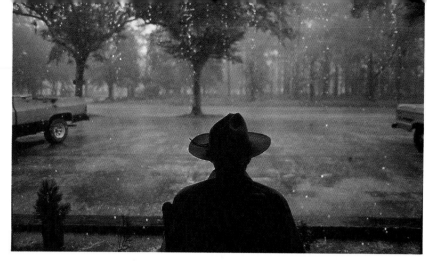

A retired turpentine-camp owner watches the afternoon rain in
St. George, Ga.

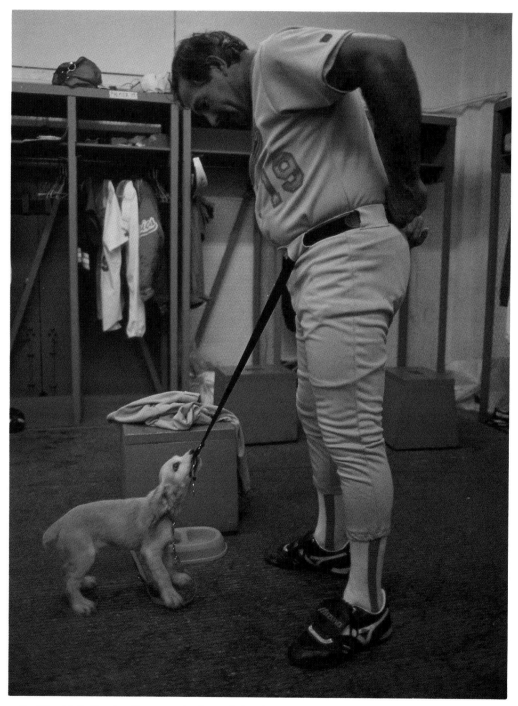

In Florida's Senior League, it doesn't bother anyone if you keep your dog in the
locker room.

Randy Olson, The Pittsburgh Press

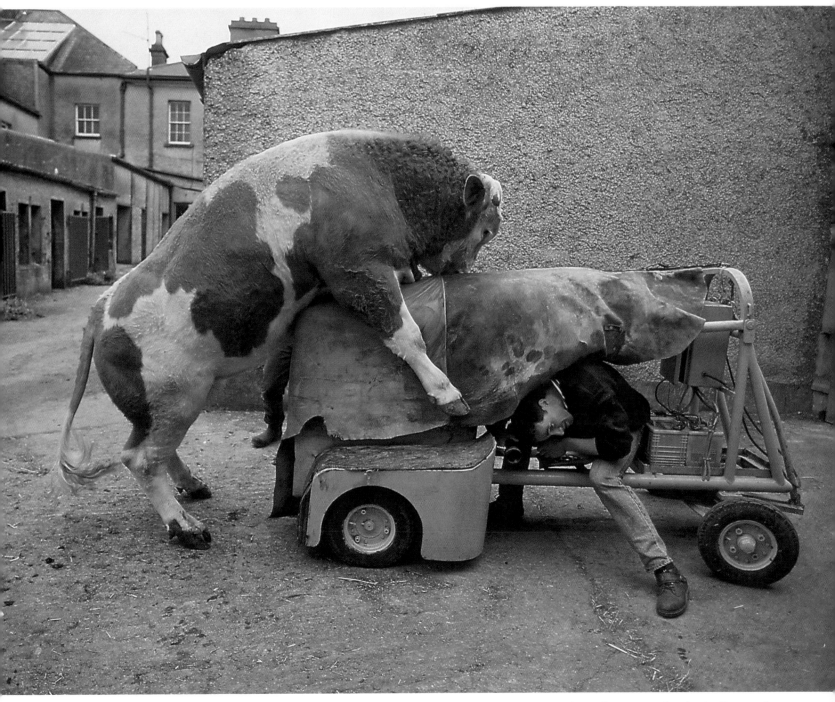

John McGrath works at an artificial-insemination station in the Republic of Ireland. It is his job to provoke the bull to such a state of excitation that, as plant manager Dermot Cahill puts it, "any port in a storm will do."

Randy Olson, The Pittsburgh Press

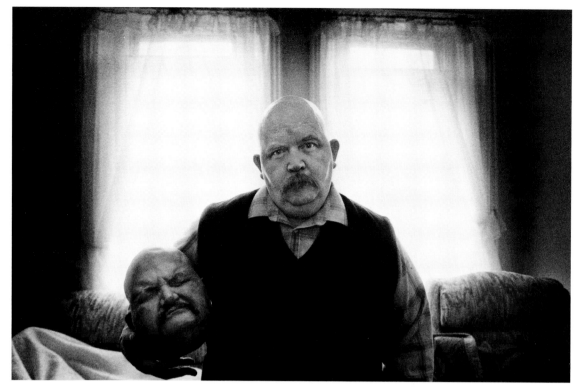

An actor holds a prop from the movie *Night of the Living Dead*.

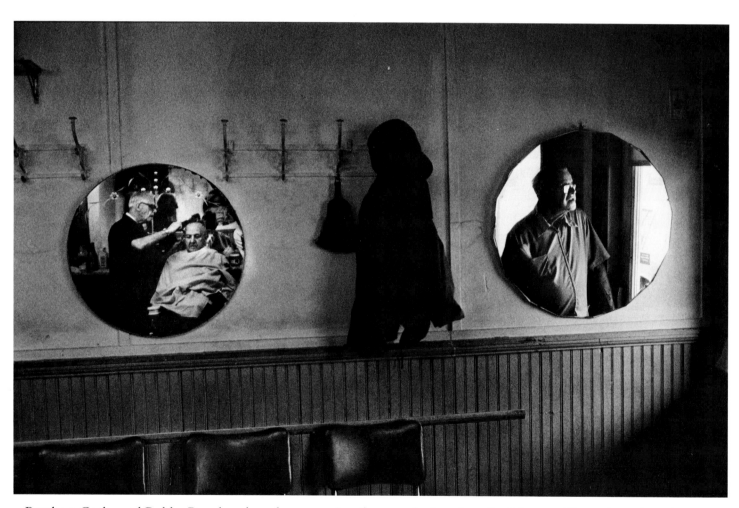

Brothers Corky and Bobby Bouchon have been running the same barber shop for 50 years. These days, they alternate hourlong shifts throughout the day.

Randy Olson, The Pittsburgh Press

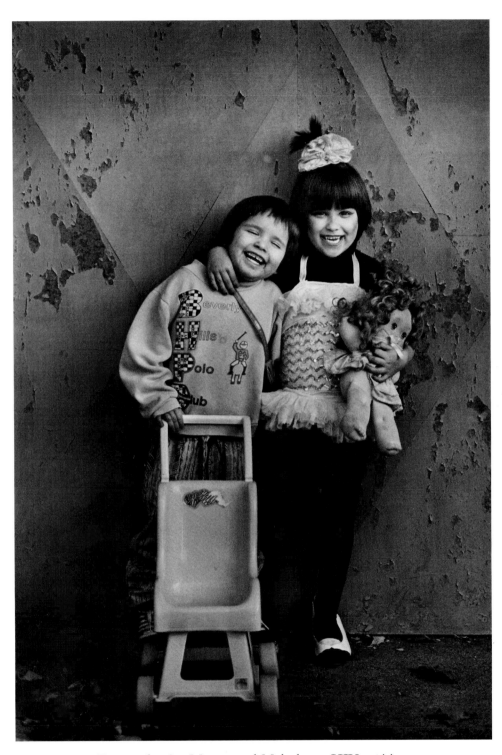

Fraternal twins Megan and Melody are HIV positive.

AIDS in the Family

Fraternal twins Megan and Melody share more than a birthdate: They share a fatal disease. The family did not know that four of seven members were HIV positive until the twins began developing complications associated with AIDS. Their brother, Corey, remains unaware that his sisters are AIDS patients. He knows only that since he gave one of them chicken pox, she has been very sick.

Randy Olson, The Pittsburgh Press

Megan plays in the fireplace at the Public Health Department. Her mother was trying to convince the director that her children are not a threat and that only the principal and nurse at their school should know that they are HIV positive.

Randy Olson, The Pittsburgh Press

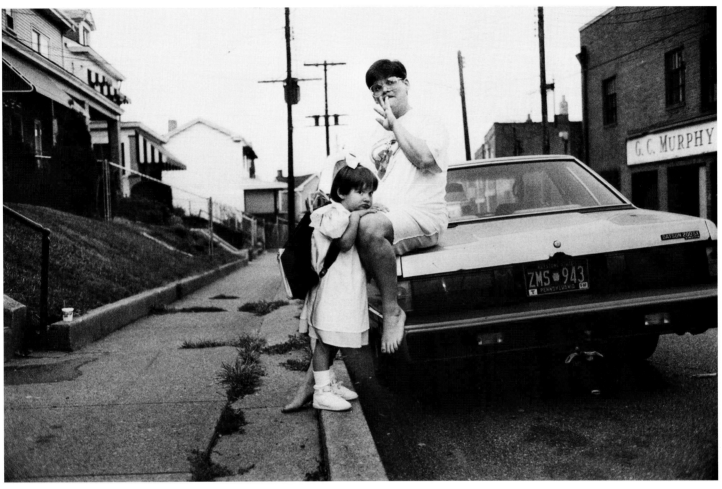

After all the meetings and stress involved in getting the children into school, the day finally came for Megan to start. But the bus never showed, and Megan and her mother had to wait one more day.

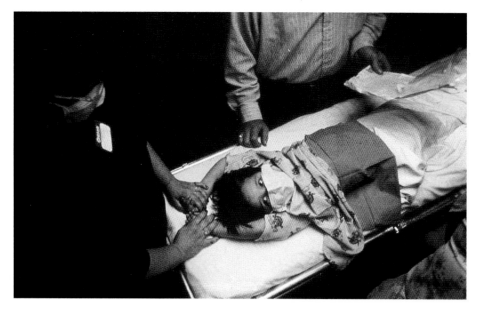

Megan has to be restrained as she is sedated for a CAT scan.

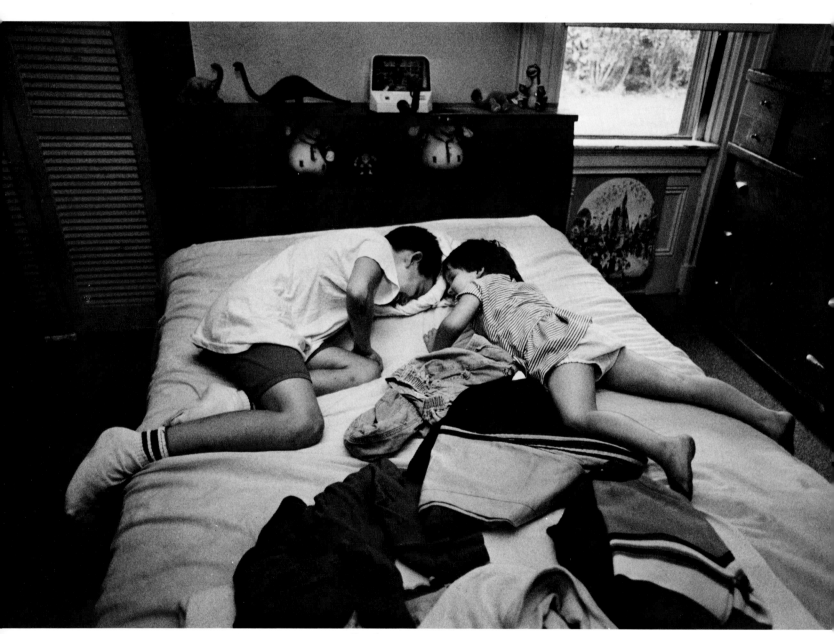

Corey, 10, is especially close to Megan, and helps care for her.

Randy Olson, The Pittsburgh Press

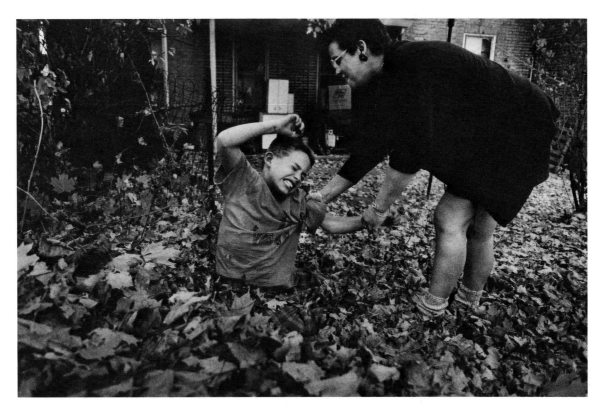

Corey's behavior becomes erratic and he often is suspended from school. His mother feels she is unable to keep him under control.

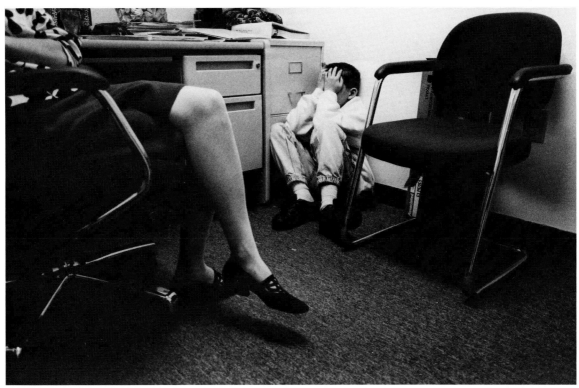

During counseling, Corey voices the fear that his sister will die. His mother, at first afraid to explain Megan's illness to Corey, eventually told him, and his emotional condition improved.

Randy Olson, The Pittsburgh Press

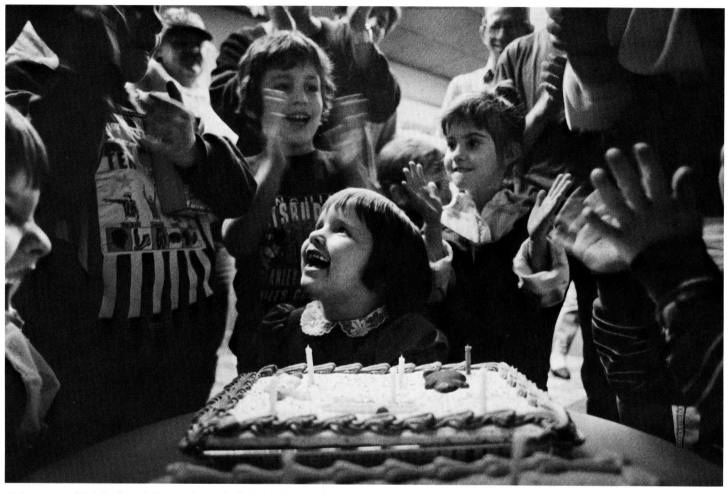

Megan and Melody celebrate their sixth birthday. "They probably won't get to go to the prom," their mother predicts. "So I take any chance I get to dress them up."

MAGAZINE PHOTOGRAPHER
OF THE YEAR
FIRST PLACE

Christopher Morris, Black Star for TIME Magazine

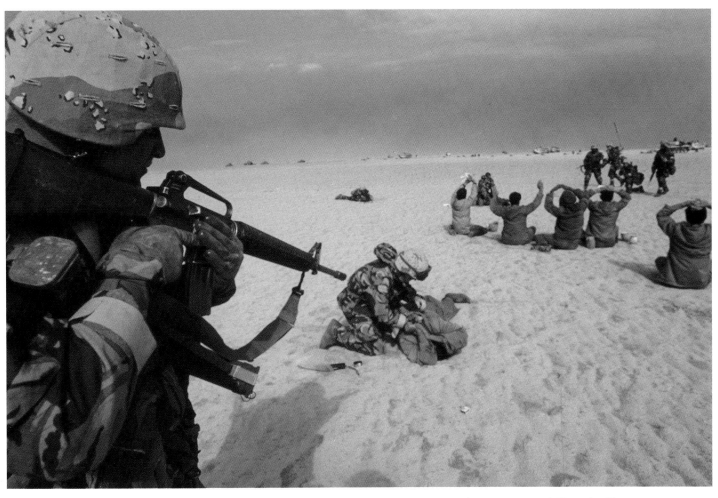

Iraqi soldiers surrender to the U.S. Marines 1st Division as it advances toward Kuwait City.

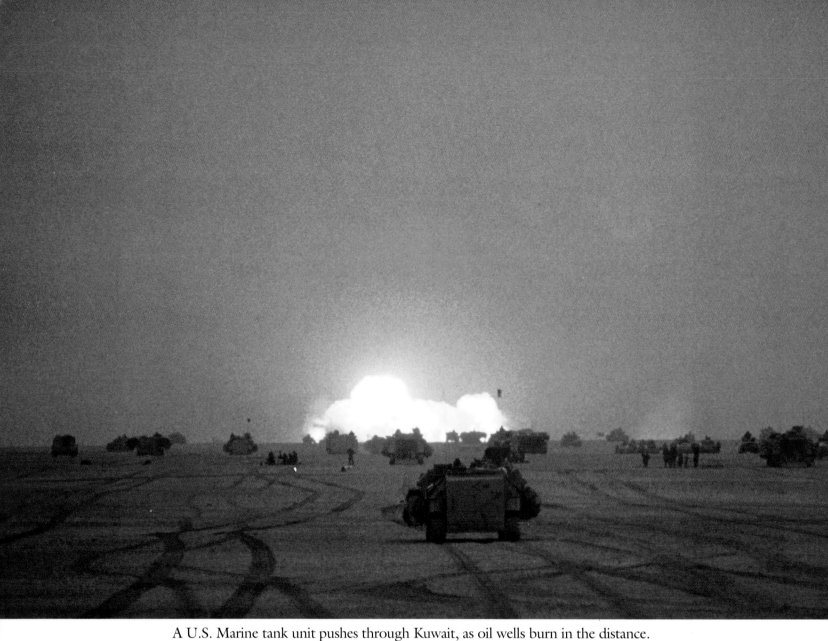

A U.S. Marine tank unit pushes through Kuwait, as oil wells burn in the distance.

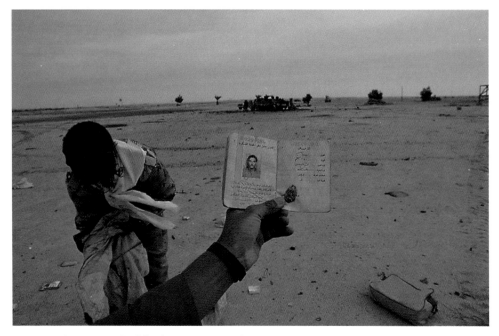

A Marine holds the passport of an Iraqi soldier who surrendered.

Christopher Morris, Black Star for Time

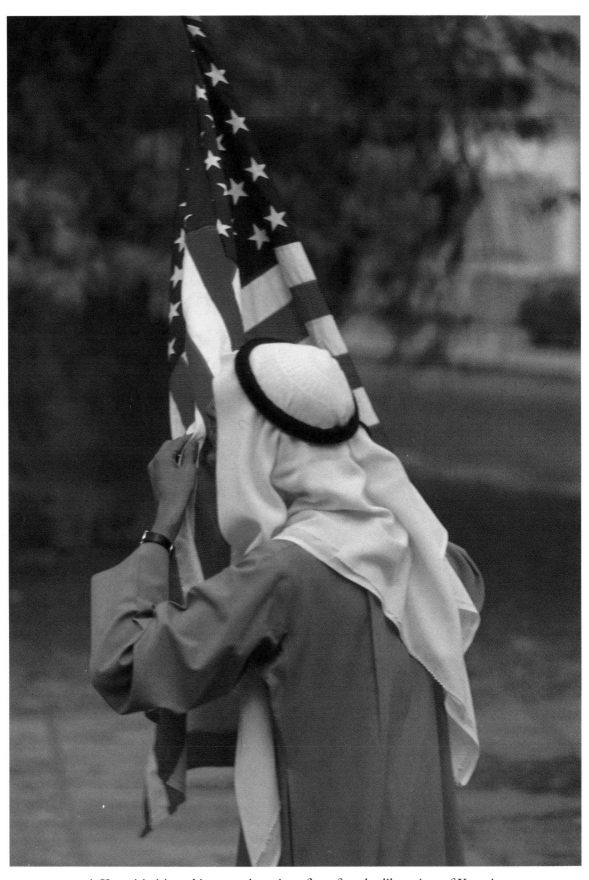

A Kuwaiti citizen kisses an American flag after the liberation of Kuwait.

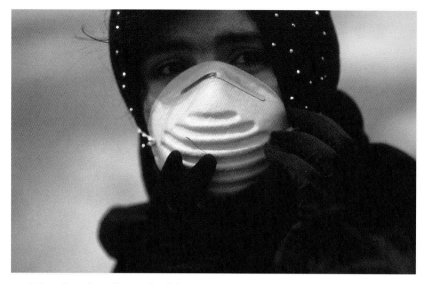

Months after the end of the Persian Gulf war, a teacher visiting
Burgen oil field in Kuwait wears a mask against the smoke pollution.

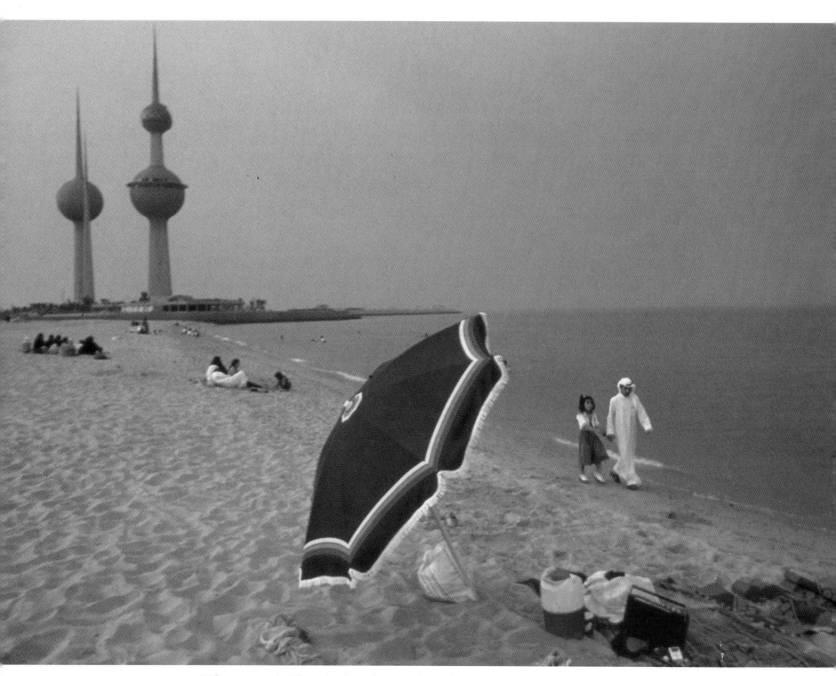

Life goes on in Kuwait City, despite the pollution from oil spills and fires.

Christopher Morris, Black Star for Time

MAGAZINE PHOTOGRAPHER OF THE YEAR

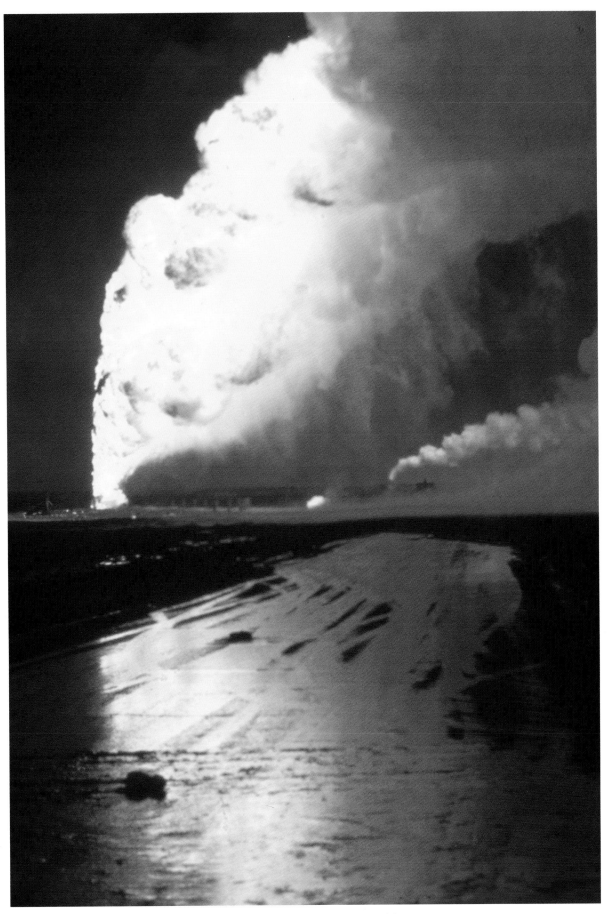

In July 1991, oil wells in Burgen field still burn.

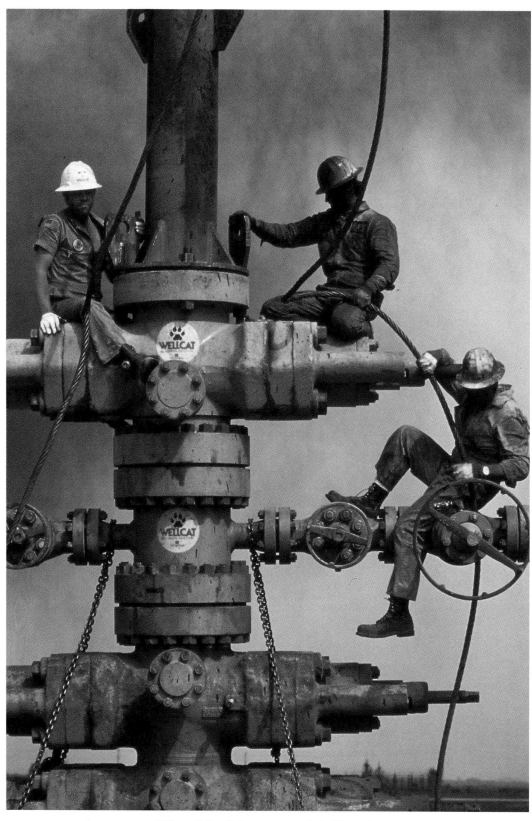

Oil-well firefighters at work in Kuwait.

Christopher Morris, Black Star for Time

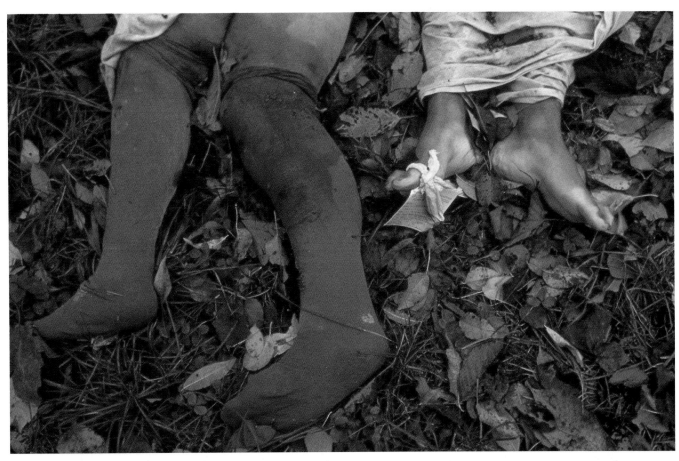

Bodies of Croatians in Vukovar, Yugoslavia, await burial after federal troops overtook the town.

Christopher Morris, Black Star for Time

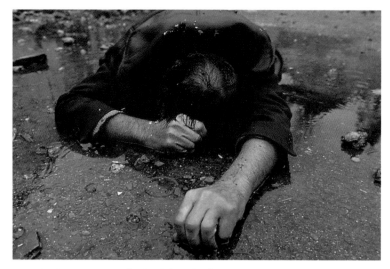

Rain mixes with the blood of an executed Croatian in Vukovar.

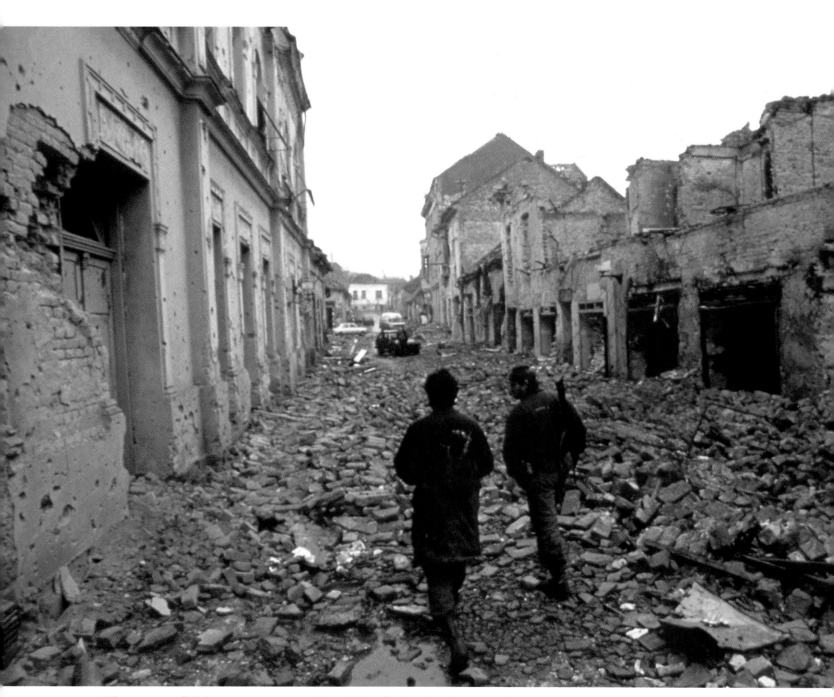

The streets of Vukovar are strewn with rubble after battles between Croatian citizens and Yugoslav troops.

Christopher Morris, Black Star for Time

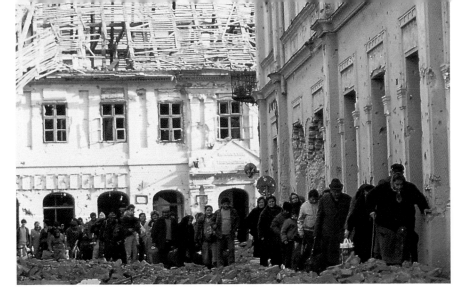

Croatian citizens come out of shelters after the fighting.

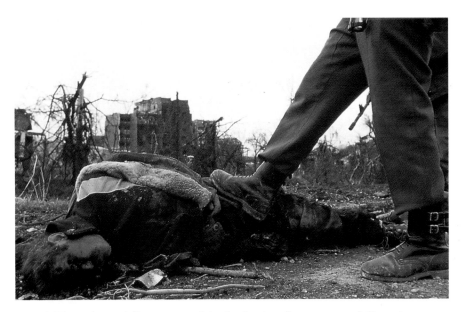

A Yugoslav soldier poses with the body of an executed Croatian.

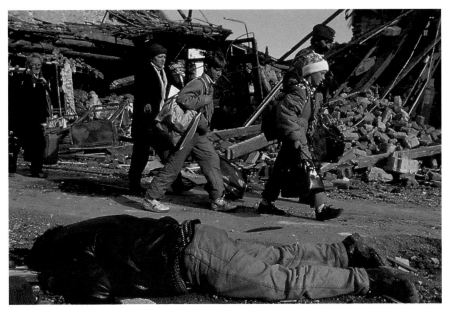

Even children seem to become oblivious to the bodies scattered throughout the town.

Christopher Morris, Black Star for Time

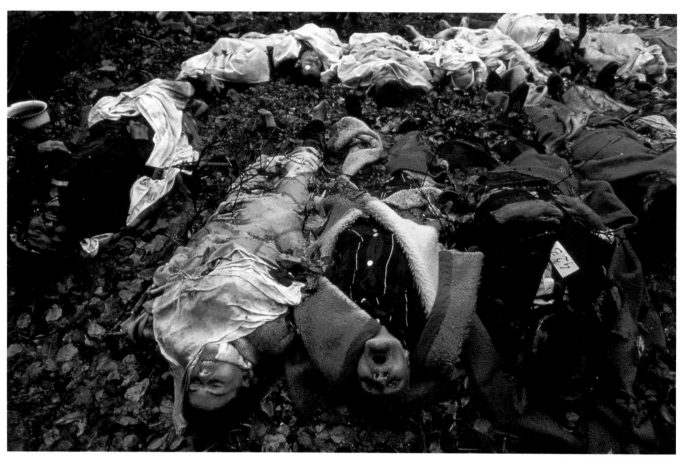

Bodies of Croatians await burial.

MAGAZINE PHOTOGRAPHER OF THE YEAR

Peter Essick, freelance

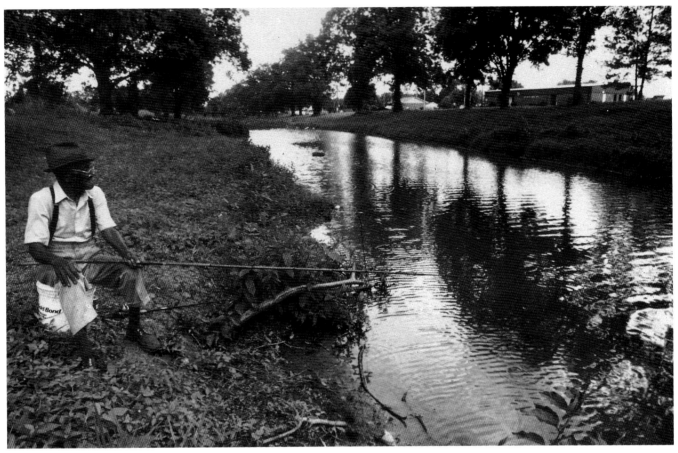

An elderly resident fishes at a bayou near Metcalfe, Miss.

A Town Is Born

Metcalfe, Miss., is a town born of determination and ingenuity. In the late 1970s, when the residents of a farming community near the Mississippi River decided to incorporate, they enlisted the help of such organizations as the Mississippi Action for Community Education. With the aid of grants, they built housing, paved roads, installed a sewer system and built a park. In November 1977, Metcalfe was incorporated as a town, and by 1990, there were 1,090 residents.

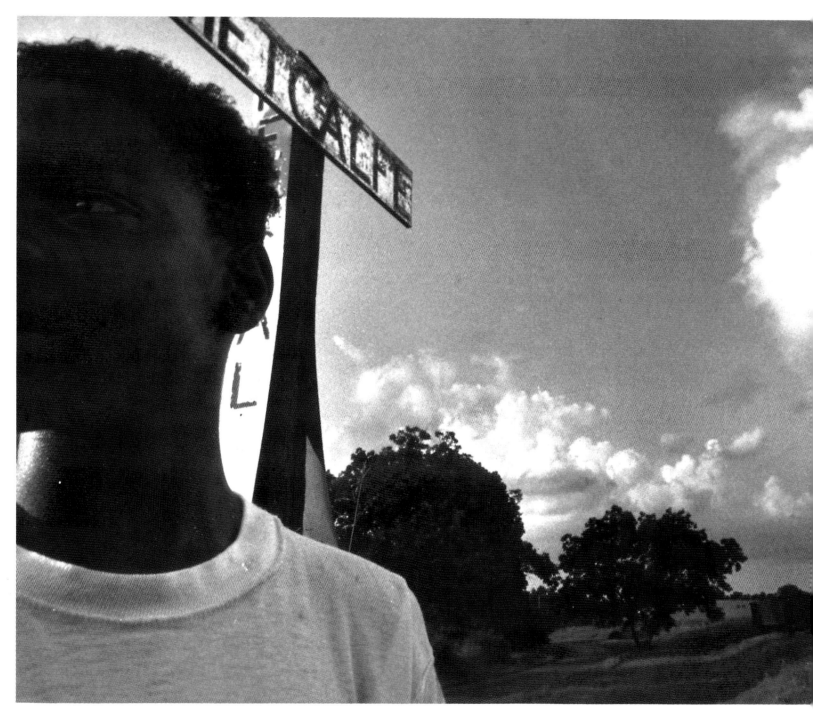

Two boys play on the railroad tracks that pass through Metcalfe.

Peter Essick, freelance

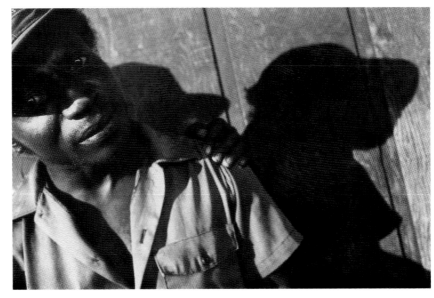

An unemployed man gets some comfort from a friend. Although Metcalfe's only manufacturing plant closed in 1991, the town has made plans with another firm to open a plant.

A young girl holds her doll while waiting in line at a summer lunch program.

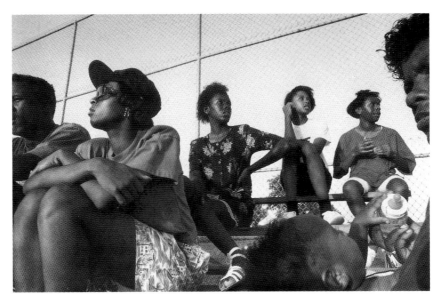

Residents of Metcalfe watch a Little League game at the town's park.

Peter Essick, freelance

The Rev. S.L. Lindsey, the first mayor of Metcalfe, relaxes in his home. Lindsey, who was one of the forces behind the town's incorporation, served until 1989.

During a Labor Day carnival in Brooklyn, two police officers are encouraged to participate in the festivities.

Peter Essick, freelance

City noises in West Harlem, accentuated by the rumble of a train, make the task of placing a phone call nearly impossible.

Jordana Guzman and Luis Camacho wait at the 125th Street station in
Harlem for the subway to take them to school.

Peter Essick, freelance

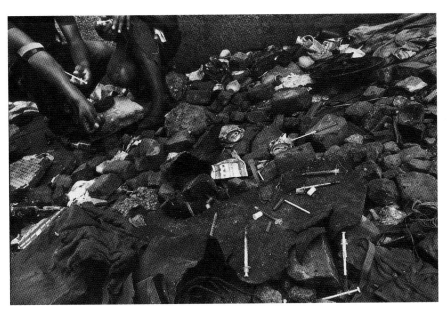

Used hypodermic needles litter an abandoned lot in East Harlem frequented by heroin addicts.

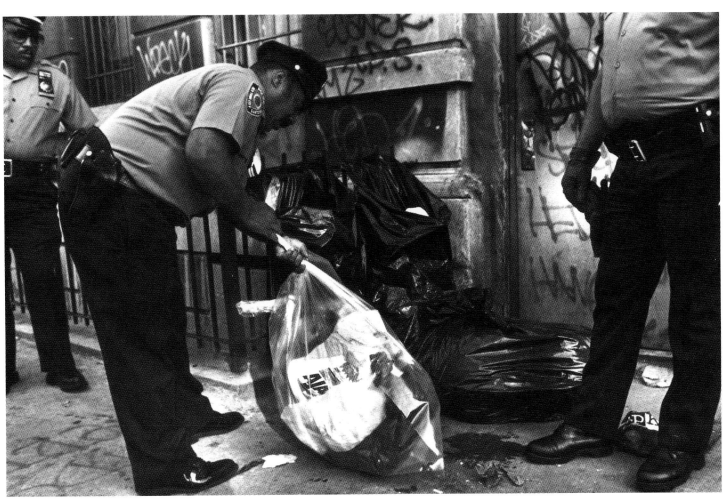

Officers of the New York Recycling Police check for compliance with the recycling program in Harlem.

Peter Essick, freelance

The Fulton Mall in Brooklyn serves a largely black clientele, but there are no black-owned businesses on the mall.

Steve Mellon, The Pittsburgh Press

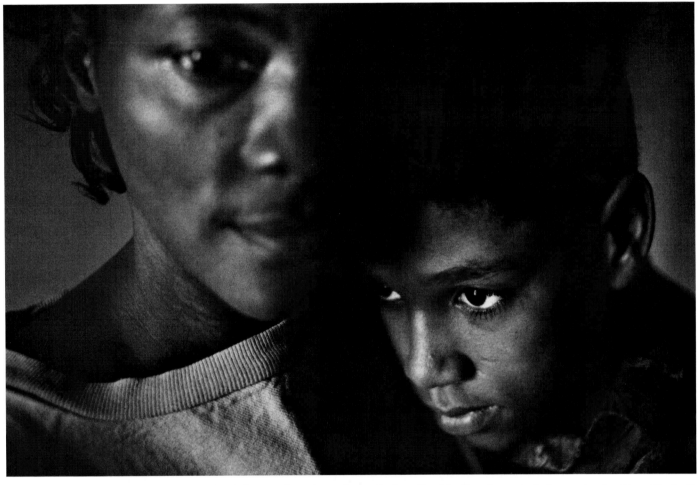

Dorothy Ramey and her son, Michael, live in fear since drug dealers fired bullets into their home in the East End of Pittsburgh. Dealers had attempted to recruit Michael, 12, as a "runner."

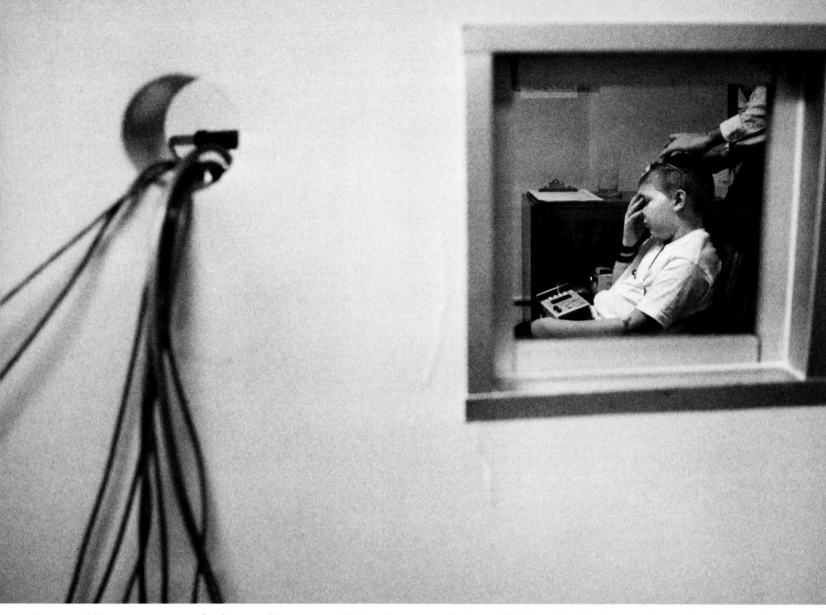

Raymond Bowser was one of a thousand boys ages 10-12 who were poked, prodded and hooked up to electrodes during a drug-abuse study at St. Francis Hospital in Pittsburgh. The boys' lifestyles will be studied throughout their teen years.

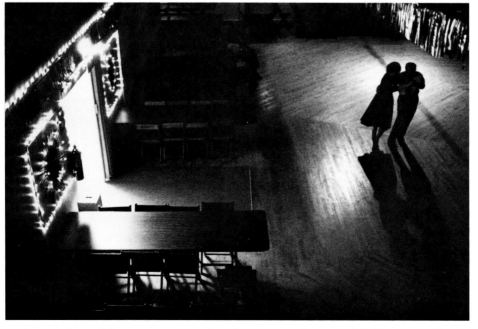

An evening of fox trots and rumbas draws to a close at a McKeesport, Pa., dance hall.

Steve Mellon, The Pittsburgh Press

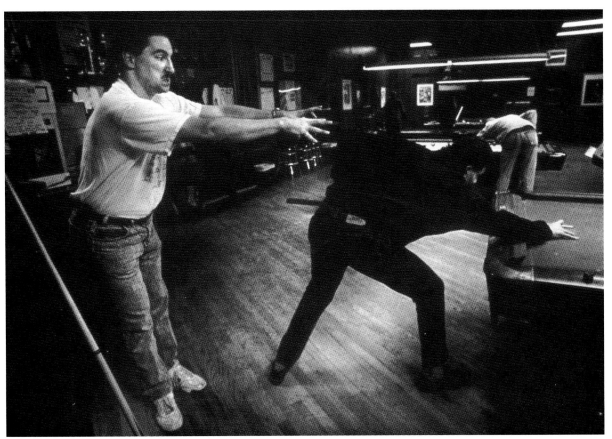

Despite putting a hex on his opponent during a billiards tournament at a pool hall in Turtle Creek, Pa., Bill Mistick still lost to Tim Mastroianna.

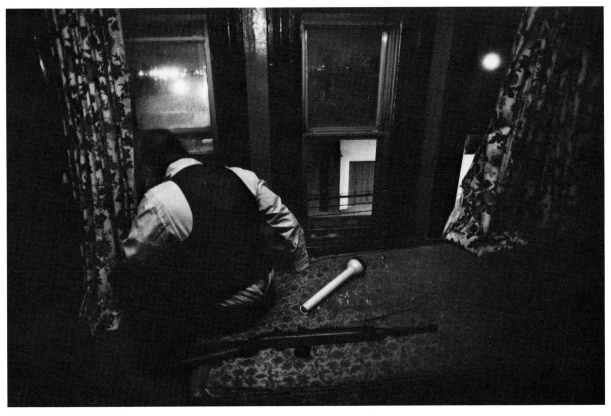

A resident of the Homewood area of Pittsburgh, where violence has increased, keeps watch at night with a rifle and flashlight.

Charlie Burgh, the proprietor of a scrapyard in Butler County, Pa., takes a break
in one of the dozens of junk cars in his yard. Burgh has owned
the business since 1936.

Steve Mellon, The Pittsburgh Press

NEWSPAPER PHOTOGRAPHER OF THE YEAR, 2ND PLACE

For years, Diane Hartman was afraid to venture outside her home in Elizabeth, Pa.

Prisoner to Fear

F or years, Diane Hartman was a prisoner in her home, held captive by an anxiety disorder that prevented her from venturing outside. To drive to nearby Pittsburgh from her home in Elizabeth, Pa., seemed an impossible task. Through counseling, Hartman was able to break the grip of her fear. She learned to drive and eventually was able to visit friends and lead a more normal life.

Steve Mellon, The Pittsburgh Press

With therapy, Hartman's condition improved and she was able to drive.

Hartman's 12-year-old son, Dennis, often wondered why his mother could not take him to ball games or other events.

Steve Mellon, The Pittsburgh Press

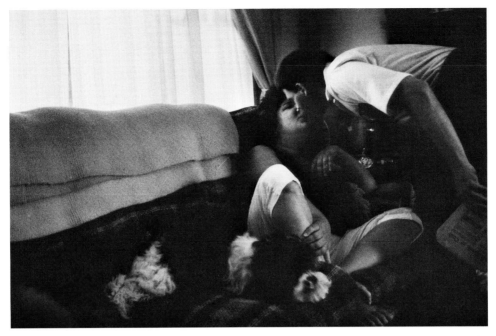

Hartman received emotional support from her husband, Denny, who often left
work early to drive her to therapy sessions.

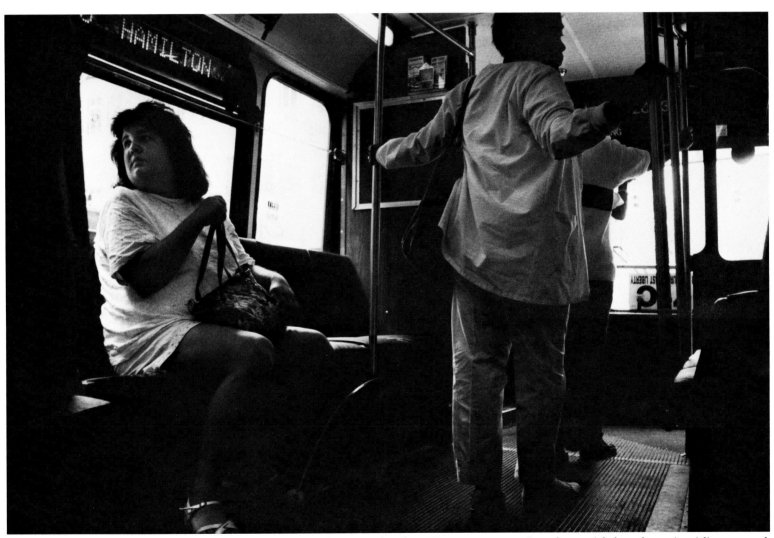

One of the first steps in therapy was to ride a city bus for several miles. Hartman was anxious but, with her therapist riding several
seats away, finished the trip.

Steve Mellon, The Pittsburgh Press

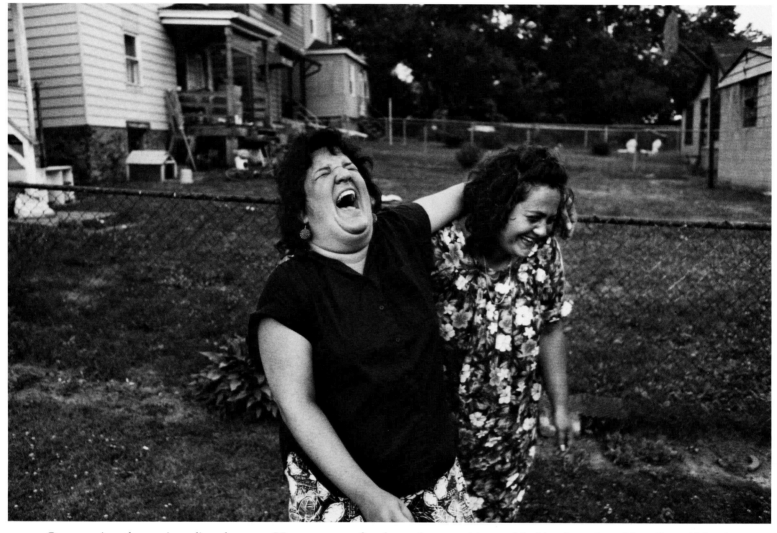

Overcoming the anxiety disorder gave Hartman new freedom; she was able to visit friends such as Mary Lou Alfonsi.

Bradley Clift, The Hartford Courant

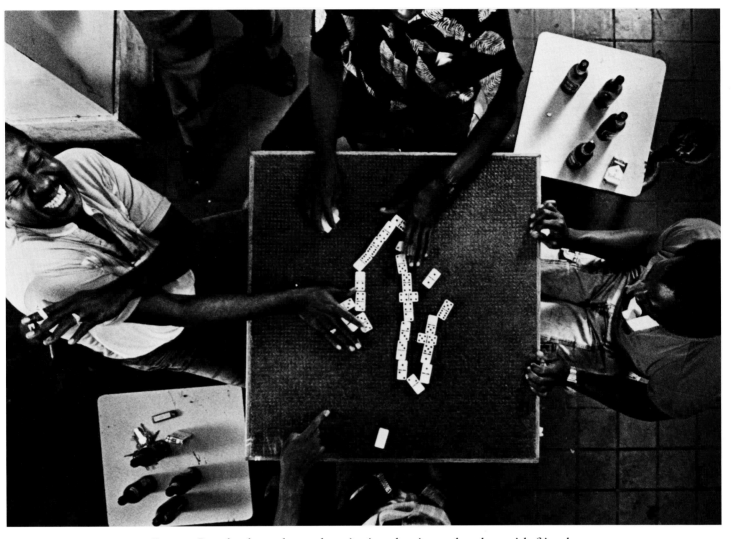

Rupert Brooks slams down the winning domino as he plays with friends.

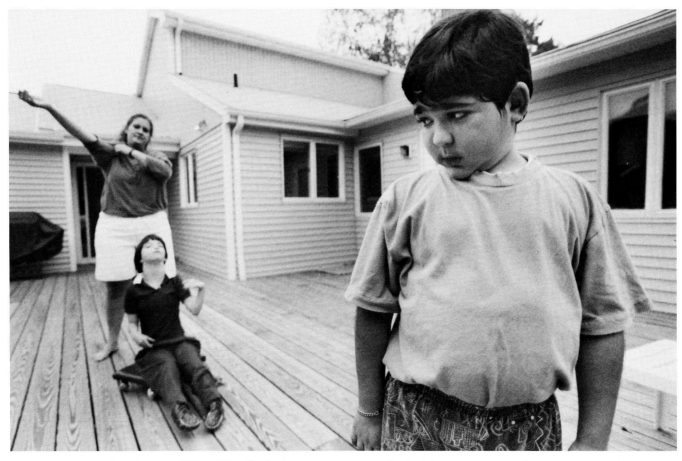

Spencer Rothstein, 8, of West Hartford, Conn., pauses to take in his new surroundings at a group home for retarded children in Bloomfield.

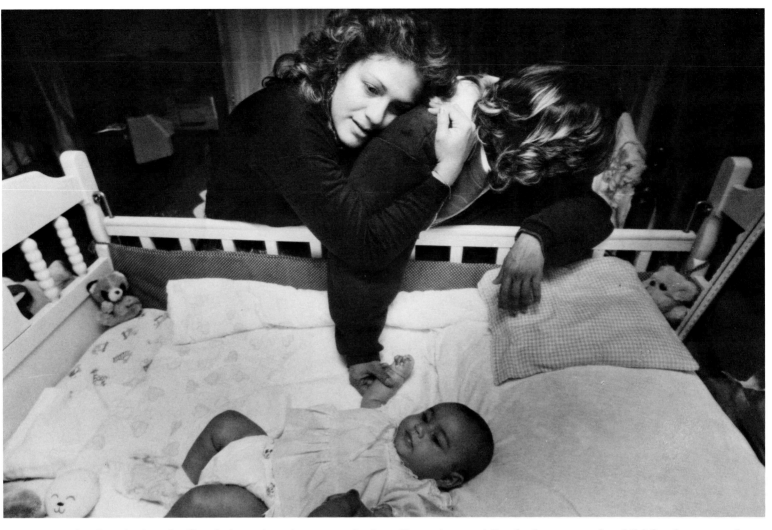

Damaris clutches the hand of her baby as her sister consoles her. Damaris, an addict, had not seen the child for three months. Her mother cares for the child.

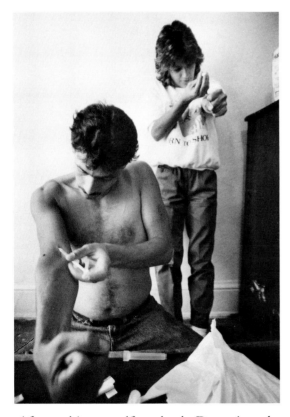

After cashing a welfare check, Damaris and Eddie shoot up at a friend's house.

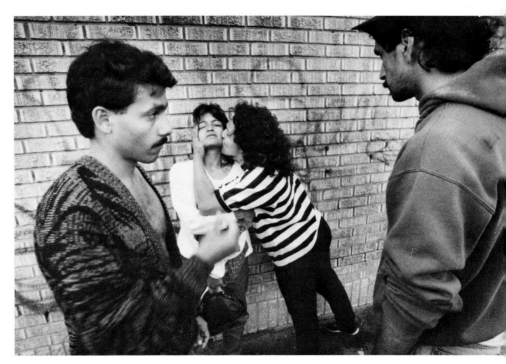

Because she is unable to kick her addiction, Damaris must live without her child. Her sister, Elizabeth, kisses her goodbye as Eddie and another man stand by. "I don't judge my sister," Elizabeth says. "I just love her."

Bradley Clift, The Hartford Courant

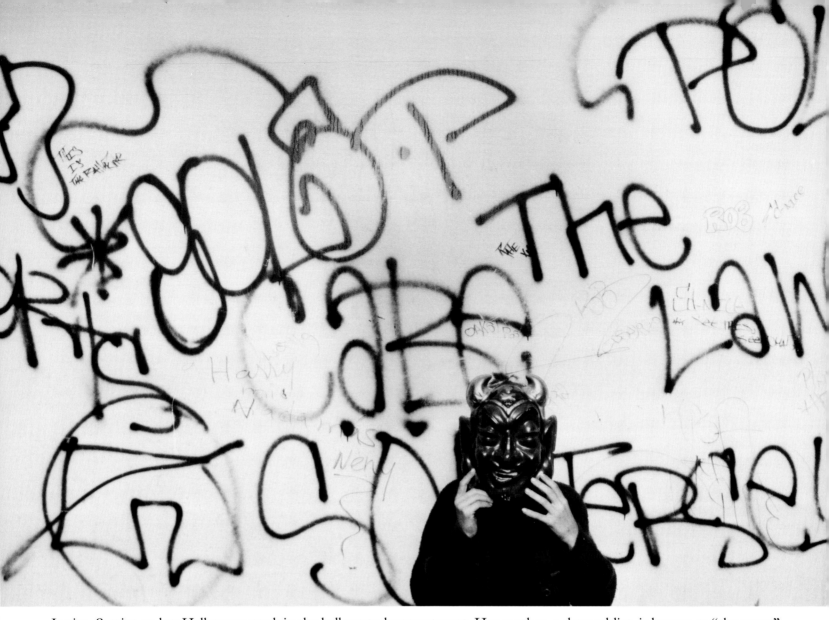

Jessica, 9, tries on her Halloween mask in the hallway to her apartment. Her mother, a drug addict, is known as "the nurse" because other addicts come to her for a fix.

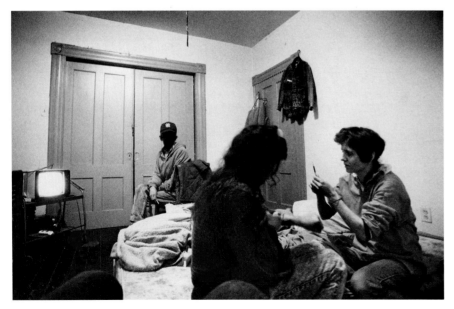

Jessica's mother, Linda, administers drugs to an addict. Also in the room is the addict's grandfather.

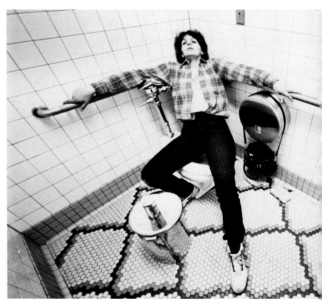

Chris uses the bathroom at a local fast-food restaurant to shoot up. "It's warm, there's light, and you don't get hassled," she says.

Bradley Clift, The Hartford Courant

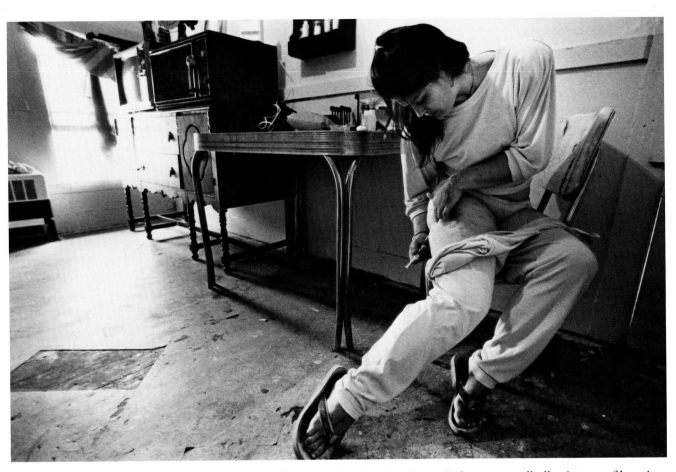

In the kitchen of her Oak Street apartment, Darlene takes her "wake-up" shot: a speedball mixture of heroin and cocaine.

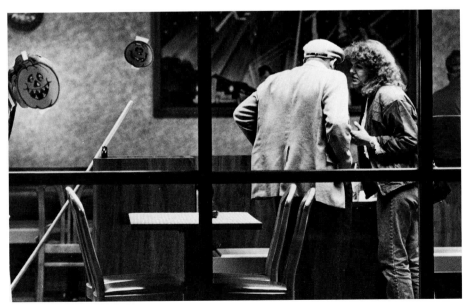

Chris, a heroin addict, propositions an elderly man for drug money. The man turned her down, but gave her some prescription drugs he had.

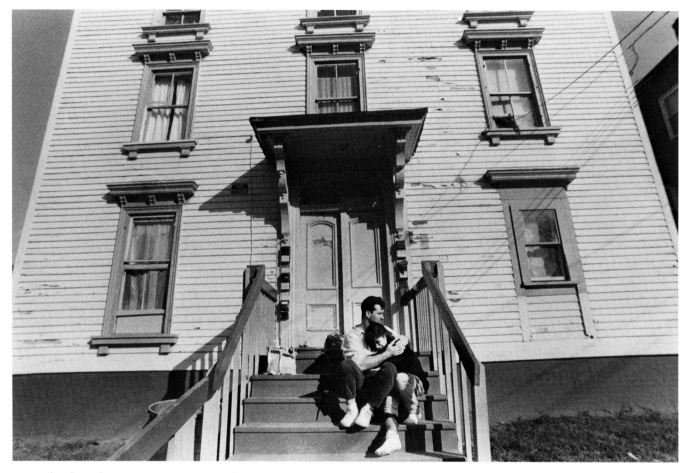

Michael Carbone, an HIV caseworker, consoles Kathy, a heroin addict who became HIV positive by sharing intravenous needles.

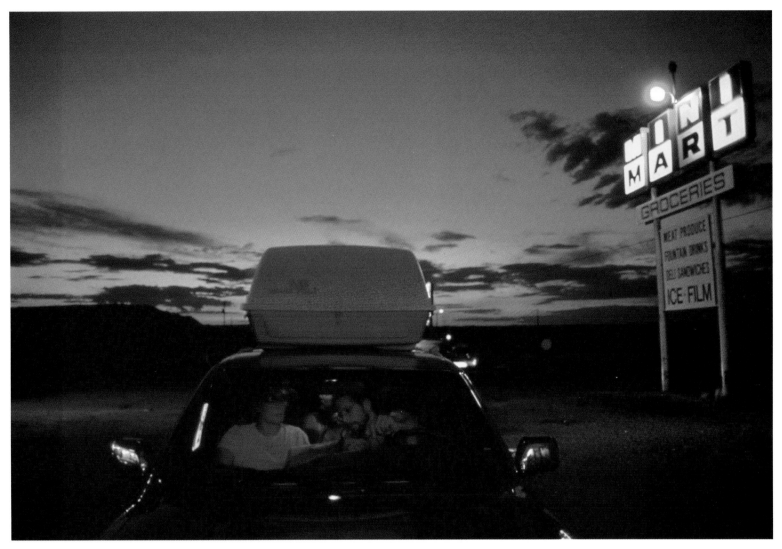

1ST PLACE
Greg Foster, freelance
Travelers in Cameron, Ariz., consult a map.

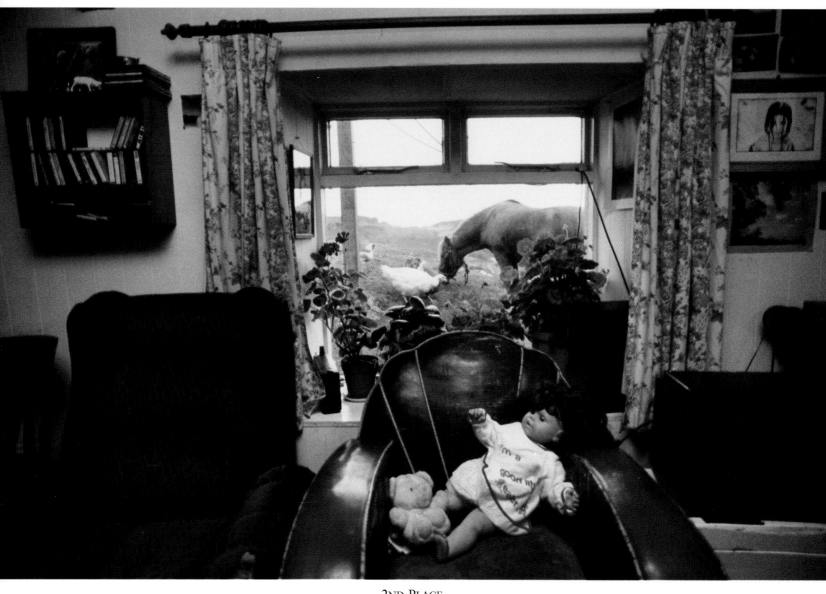

2ND PLACE
Peter Korniss, A Day in the Life of Ireland, Collins Publishers
The Vials' home in County Donegal, Ireland.

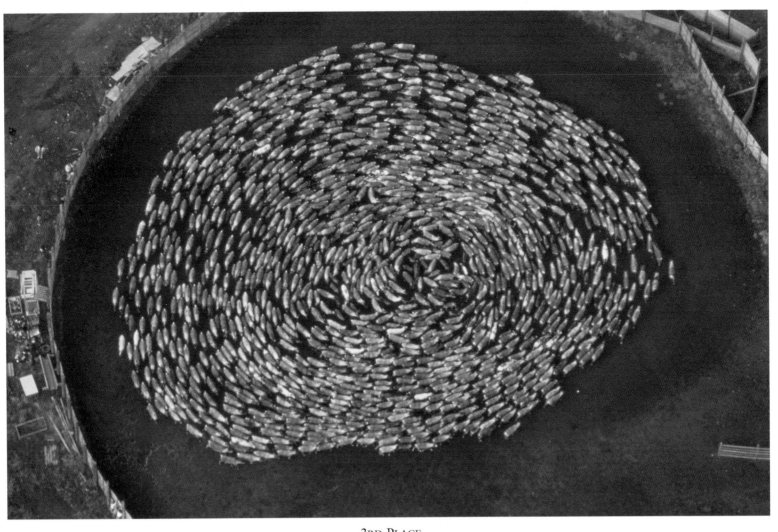

Charles Mason, Black Star
Twelve hundred reindeer circle each other in a corral north of Nome, Alaska. The circling behavior occurs
when the animals are uncertain or frightened.

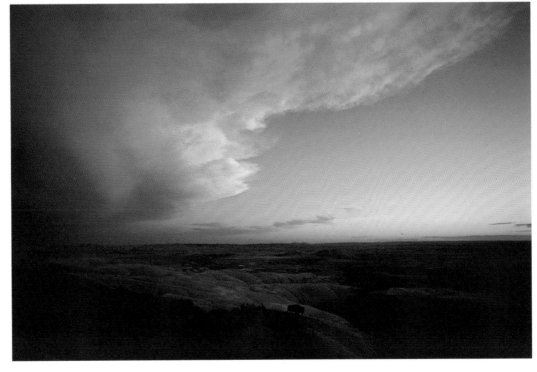

Jim Brandenburg, National Geographic
A lone bison pauses at sundown near the Oglala Sioux Pine Ridge Reservation
in South Dakota.

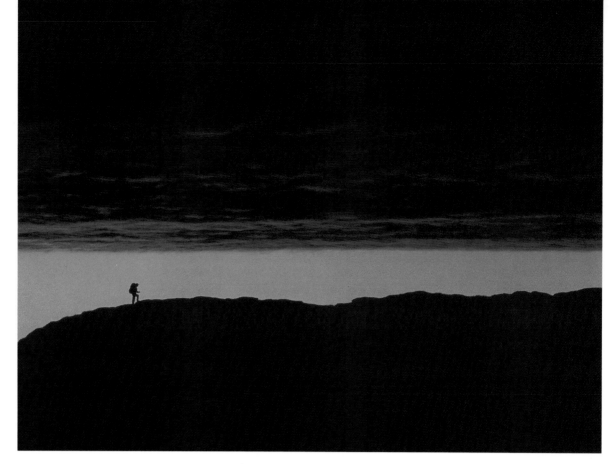

AWARD OF EXCELLENCE
Alden Pellett, freelance
Hiker on Mount Mansfield, Vt.

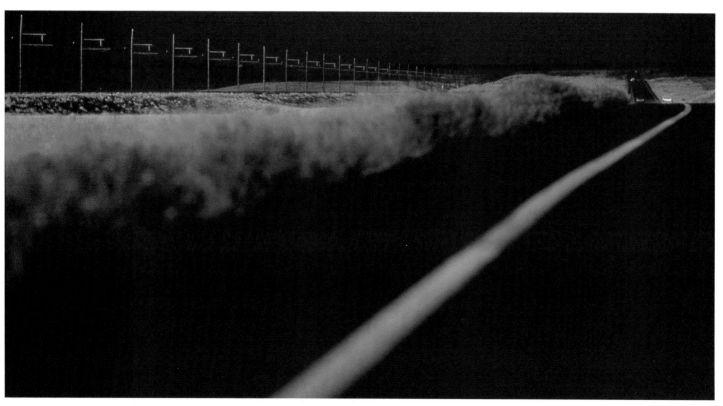

AWARD OF EXCELLENCE
Greg Foster, freelance
An afternoon storm clears in northern New Mexico.

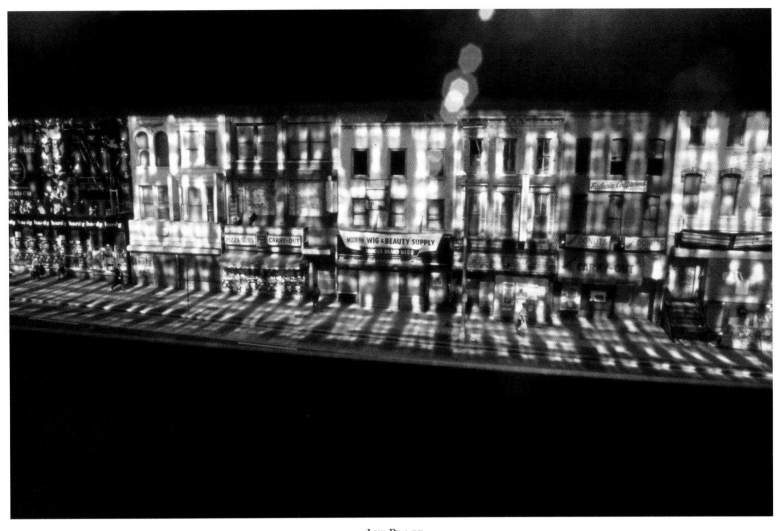

1ST PLACE
Craig Fritz, freelance
Washington, D.C., "cityscape."

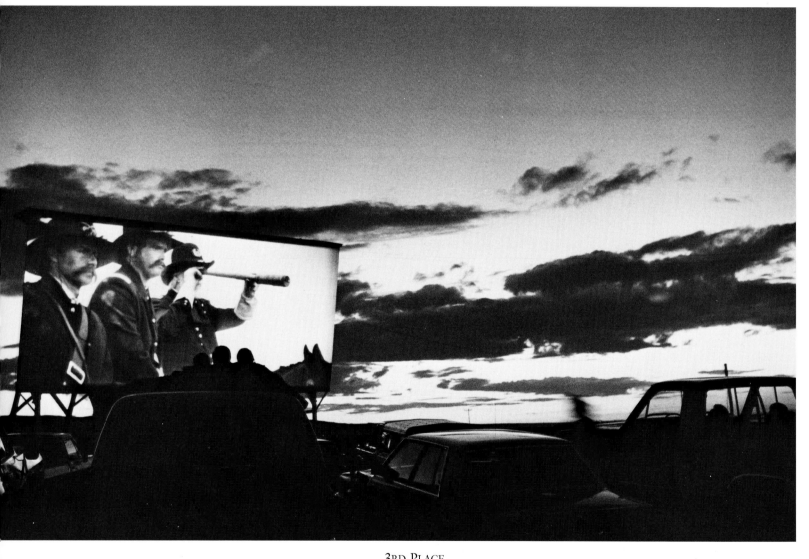

3RD PLACE
Todd Anderson, Jackson Hole (Wyo.) Guide
Youngsters watch the movie *Dances With Wolves* at a drive-in theater near Jackson Hole, Wyo.

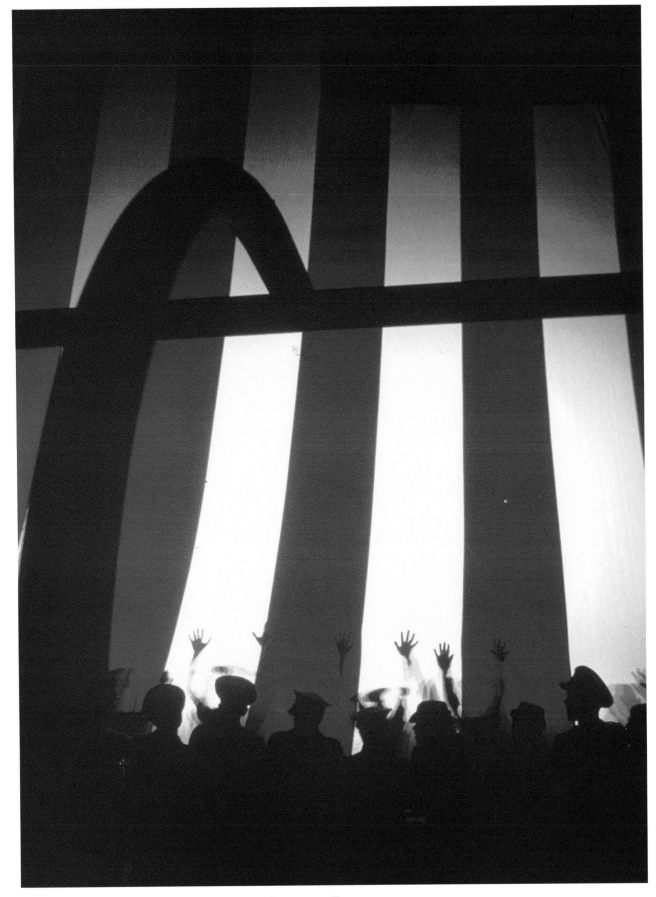

AWARD OF EXCELLENCE
John Moore, The Albuquerque Tribune
High-school ROTC members hold an American flag at the University of New Mexico football stadium
during a celebration for veterans of the Persian Gulf war.

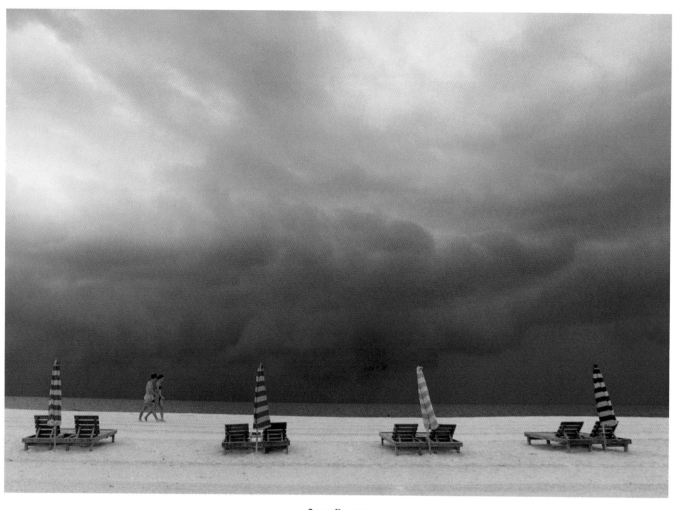

2ND PLACE
Steve Apps, Sarasota (Fla.) Herald-Tribune
An early-morning summer storm builds over the Gulf of Mexico near Sarasota, Fla.

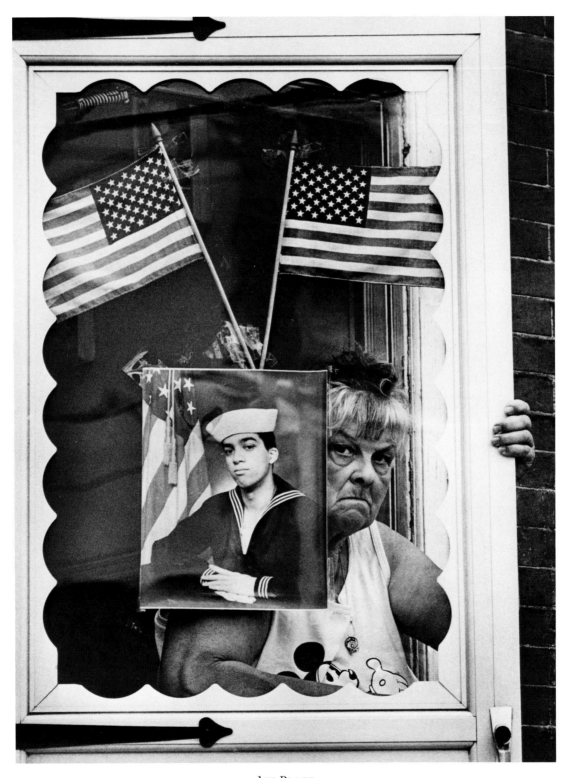

1ST PLACE
Michael Wirtz, The Philadelphia Inquirer
When her grandson, Robert Tames, left to fight in the Persian Gulf war, Eleanor Endres
of south Philadelphia put his picture on the front door.

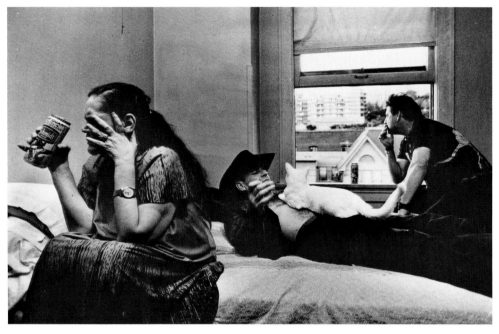

2ND PLACE
Chien-Chi Chang, The Seattle Times
Gloria Wyadd, who is blind and on welfare, is frequently visited by neighbors Ron
Cordell (with his cat) and Phil Streeter.

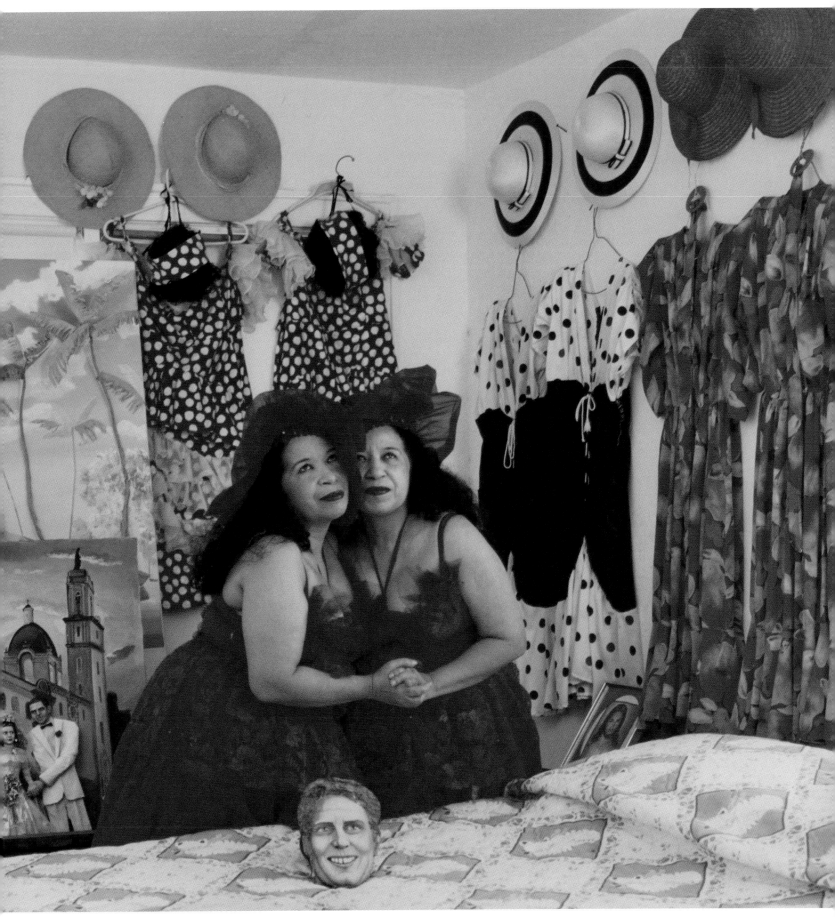

3RD PLACE
Al Diaz, The Miami Herald
Artists and twins Haydee and Sahara Scull ham it up in their Miami Beach home.

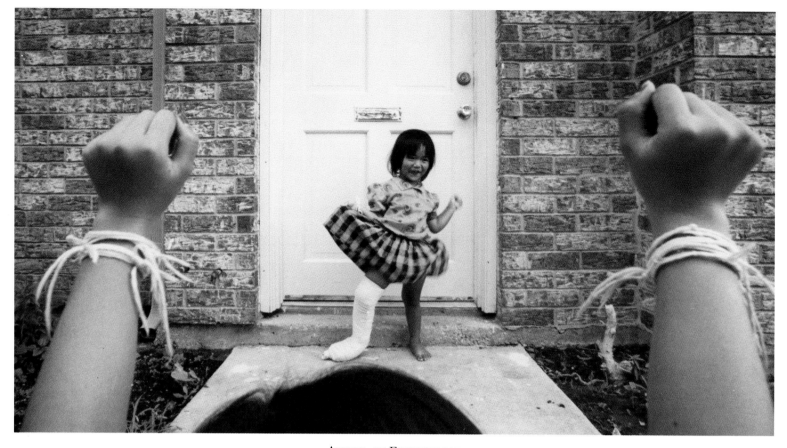

AWARD OF EXCELLENCE
Cindy Yamanaka, The Dallas Morning News
Phone Nammychai, 2, was hit in the foot by a bullet that came through the wall of her home. Her 6-year-old sister, Tho, wears
string bracelets, a Laotian custom to invite the return of the good spirits.

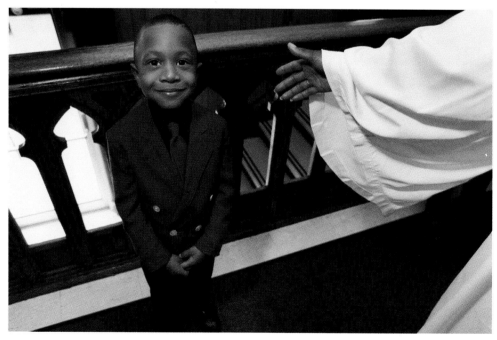

AWARD OF EXCELLENCE
Donna Terek, The Detroit News
Five-year-old Tony Estes already feels himself called to be a minister of God.

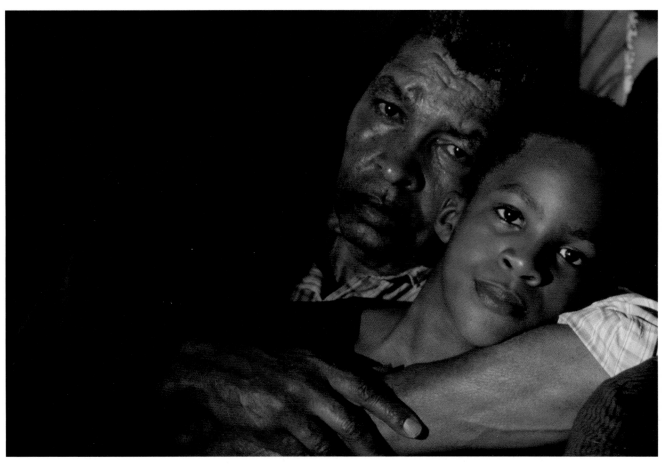

1ST PLACE
Linda L. Creighton, U.S. News & World Report
When 10-year-old Russell Anderson's mother left to fight in the Persian Gulf war, his grandfather, Harvey, quit his job in Ohio and moved to Fort Stewart, Ga., to care for the boy.

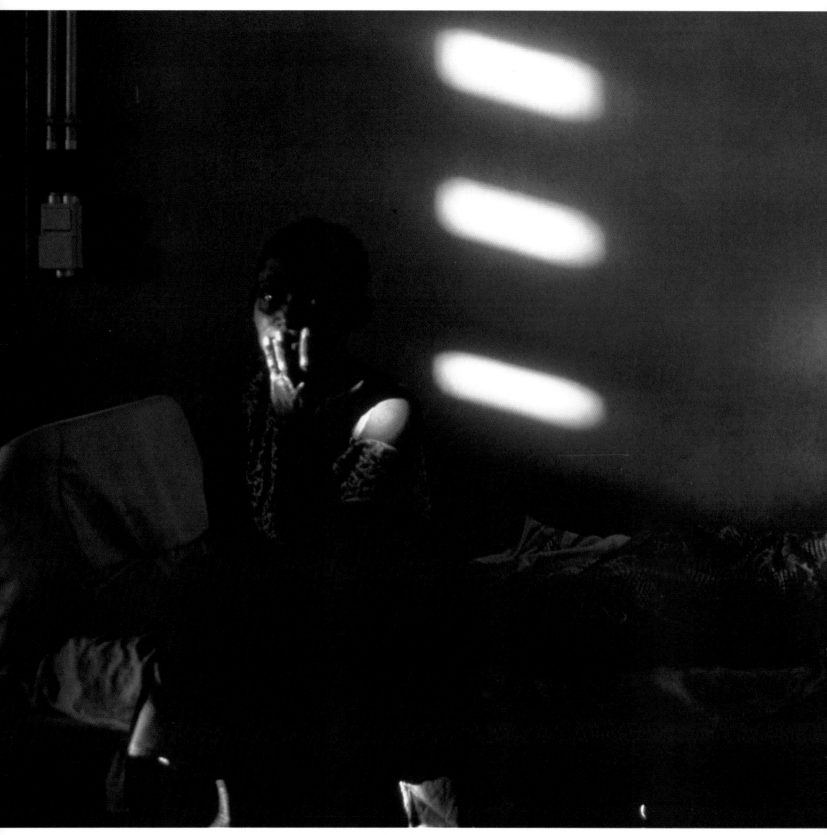

3RD PLACE
Charles Ledford, Commission Magazine
A mother keeps a vigil over her sick son in a Kikwit, Zaire, hospital.

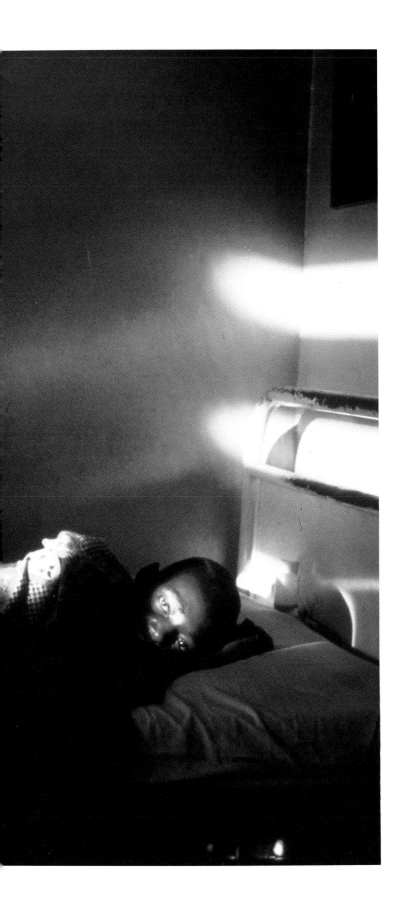

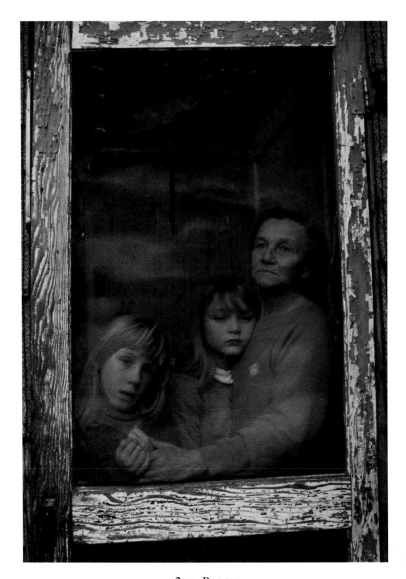

Linda L. Creighton, U.S. News & World Report
Shelley and Tabatha, in the doorway of their Richmond, Va.,
home with grandmother May Toman, are among the
3 million American children being reared by grandparents
because of neglect, abuse or abandonment by their parents.

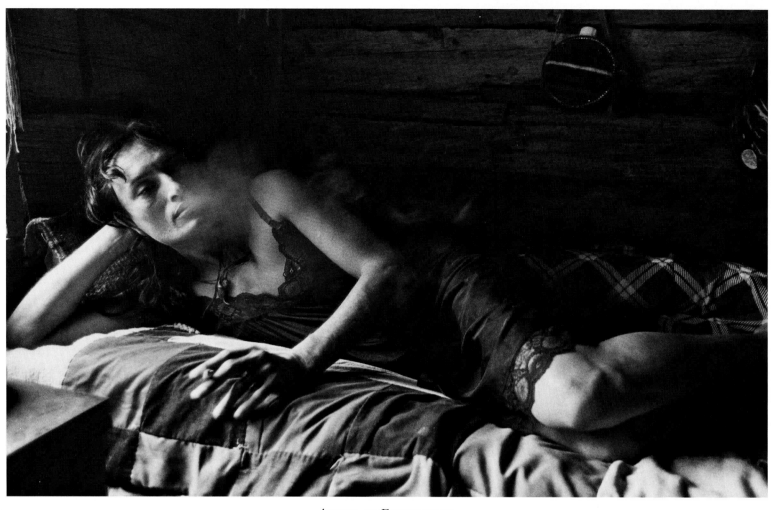

AWARD OF EXCELLENCE
Therese Frare, freelance
Peta Church, who feels both the spirit of man and woman inside, relaxes in a cabin while visiting Rosebud
Indian Reservation in South Dakota. Church is half Sioux.

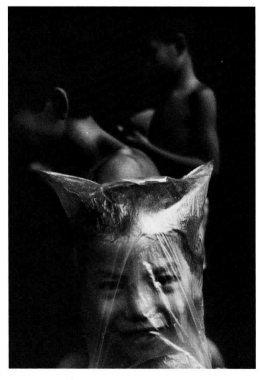

AWARD OF EXCELLENCE
**Charles Ledford, Commission
Magazine**
A Cambodian boy and his brothers play.

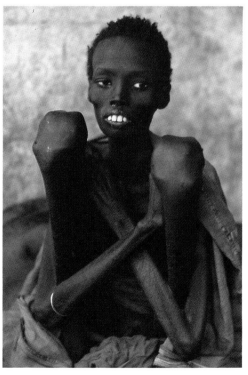

AWARD OF EXCELLENCE
Hoda Bakhshandagi, Black Star
Chan Gai, 13, is hospitalized for
malnutrition in Sudan.

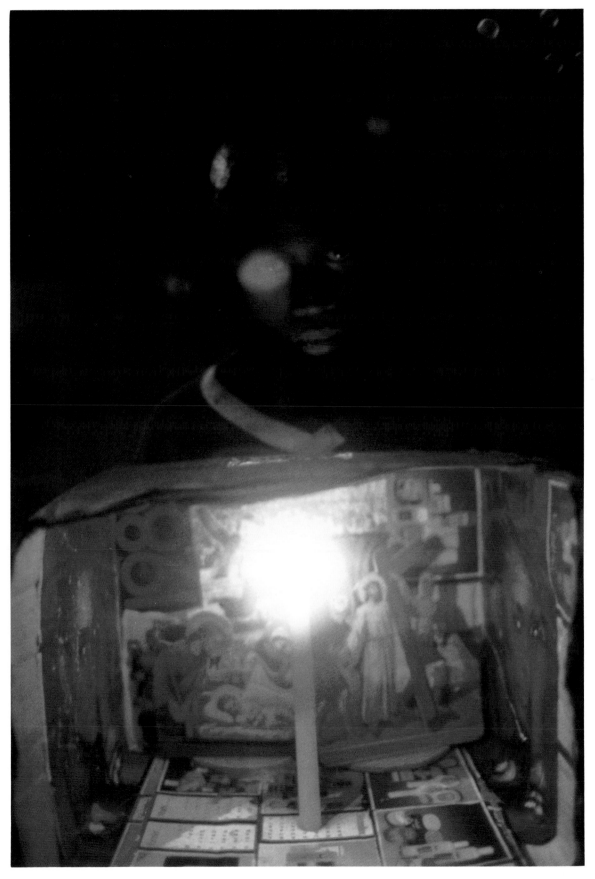

AWARD OF EXCELLENCE
Charles Ledford, Commission Magazine
A Beninese boy displays a Christmas ornament he made in school.

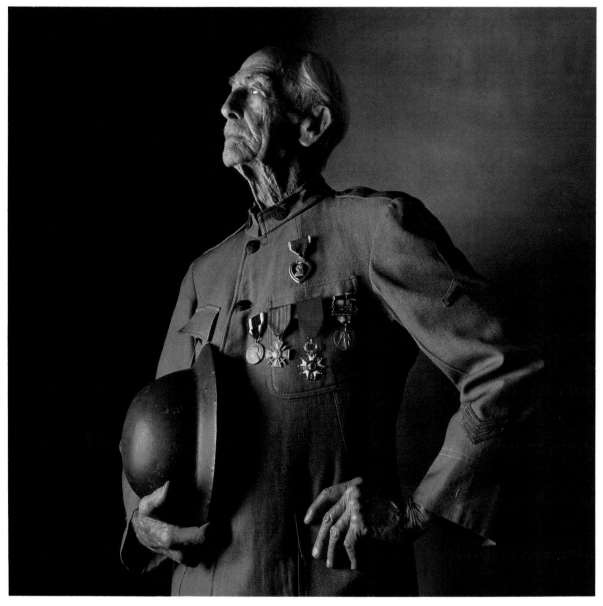

AWARD OF EXCELLENCE
Michael O'Brien, Life
Winston M. Roche served in France as a second lieutenant during World War I.
"Please excuse my cough," he says. "Mustard gas burned the heck out of my lungs."

April Saul, The Philadelphia Inquirer

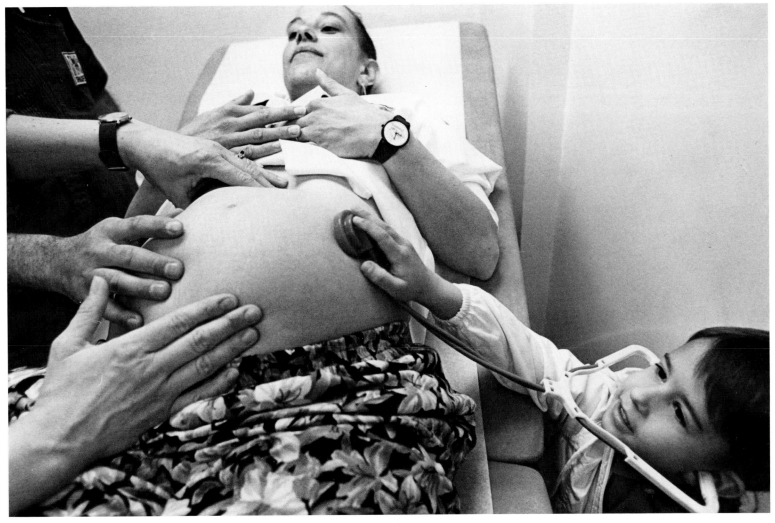

Joseph Gesualdi, 3, uses a toy stethoscope to check on his future sibling.

... And Baby Makes 5

Penny and Joe Gesualdi wanted their children to share in the excitement of a new baby, so they often brought Joseph, 3, and Marqie, 2, along on prenatal visits. The children also were nearby when Domenica was born in a birthing suite at Pennsylvania Hospital in Philadelphia. Soon, life in the Gesualdi household returned to its normal, hectic state.

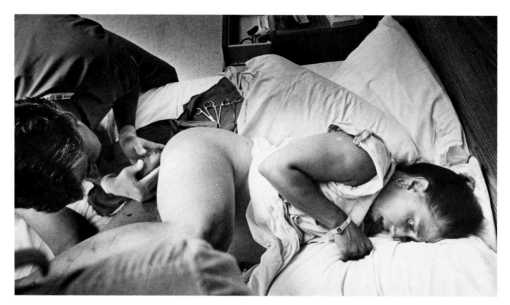

Penny Gesualdi gives birth to her third child, Domenica.

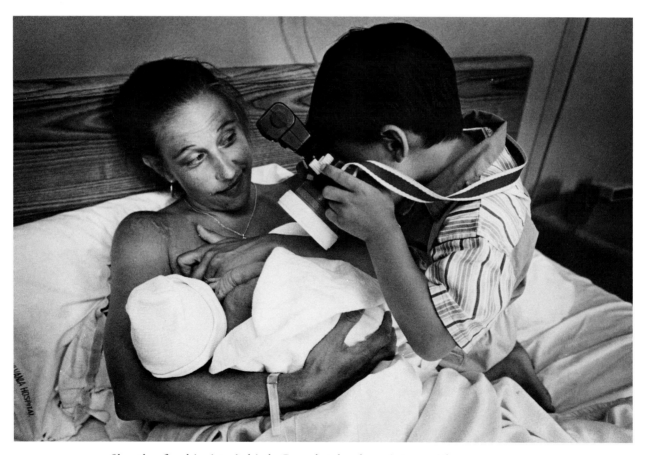

Shortly after his sister's birth, Joseph takes her picture with a toy camera.

April Saul, The Philadelphia Inquirer

NEWSPAPER FEATURE PICTURE STORY, 1ST PLACE

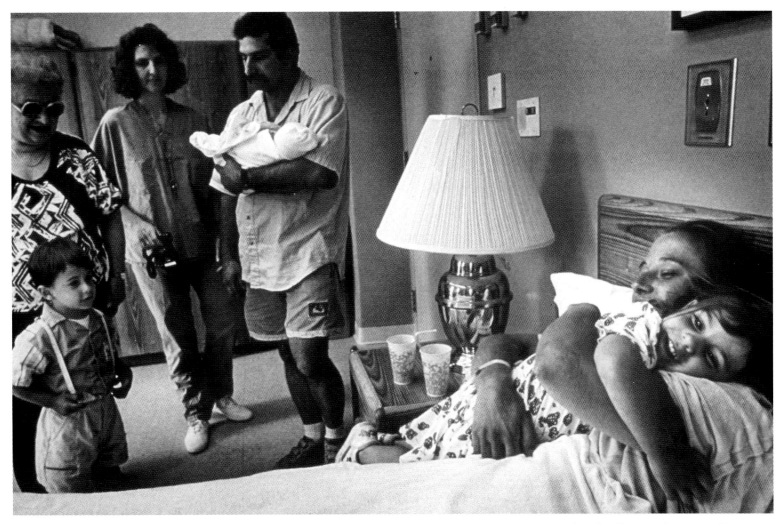

Moments after giving birth, Penny gets a hug from her 2-year-old daughter, Marqie, as other family members stand by.

April Saul, The Philadelphia Inquirer

NEWSPAPER FEATURE PICTURE STORY, 1ST PLACE

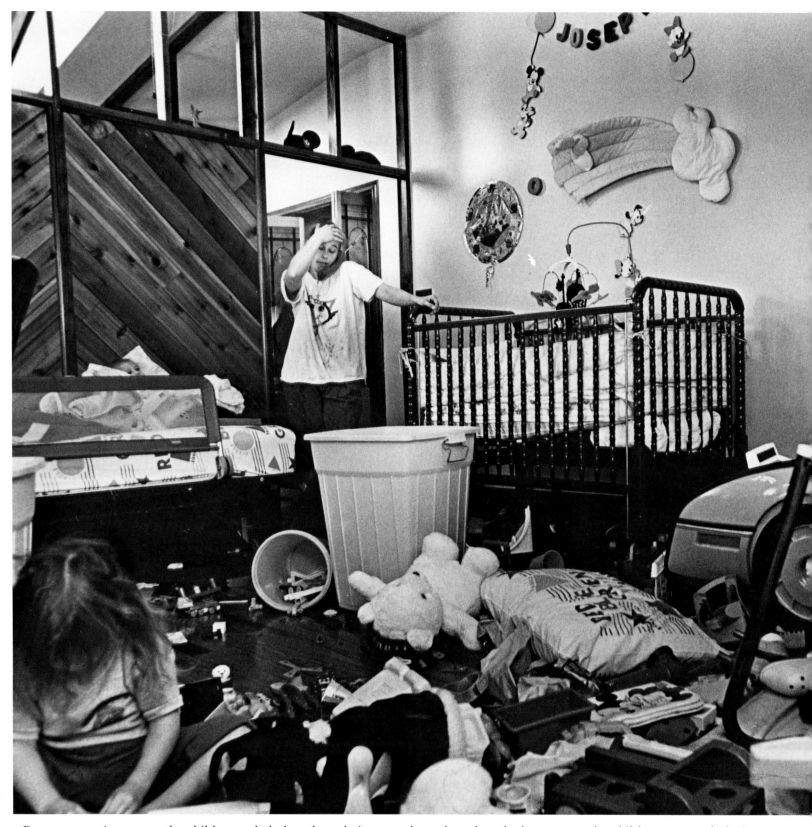

Penny was trying to get the children to help her clean their room, but when the telephone rang, the children resumed playing.

April Saul, The Philadelphia Inquirer

NEWSPAPER FEATURE PICTURE STORY, 1ST PLACE

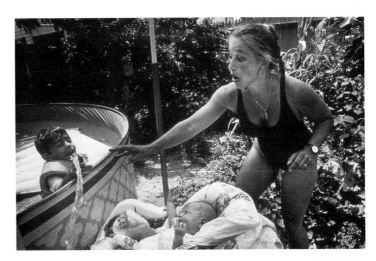

Joseph ignores his mother's warnings not to wake the baby while the family is playing at the pool.

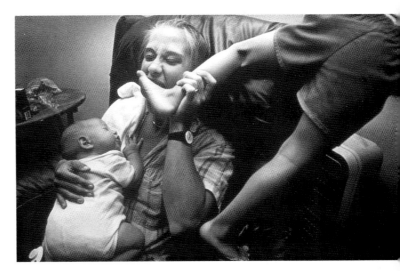

While holding a napping Domenica, Penny tries to persuade Joseph not to climb on the windowsill.

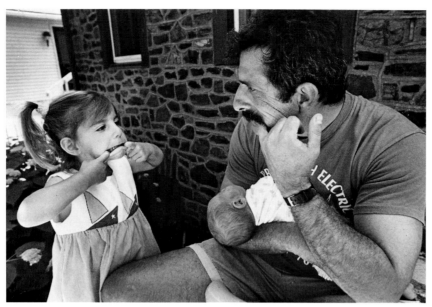

Joe Gesualdi tries to give his daughter Marqie some attention while also tending his newborn.

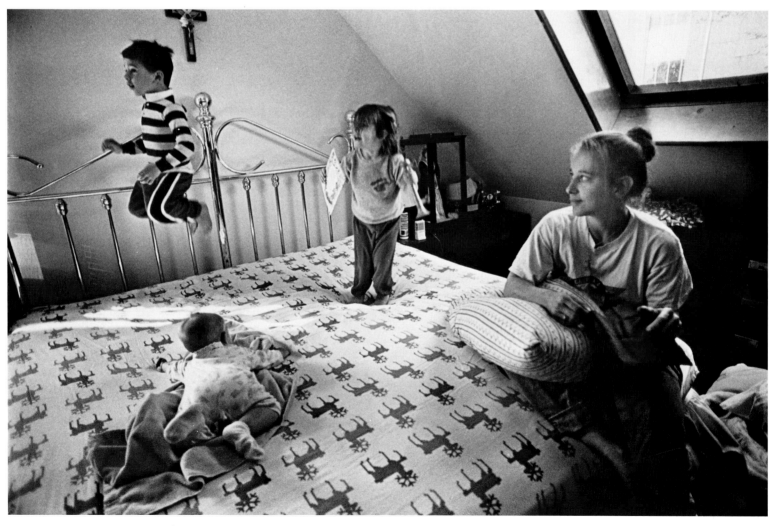

Penny keeps an eye on Domenica while Joseph and Marqie jump on their parents' bed.

April Saul, The Philadelphia Inquirer

NEWSPAPER FEATURE PICTURE STORY, 1ST PLACE

Suzanne Kreiter, Boston Globe

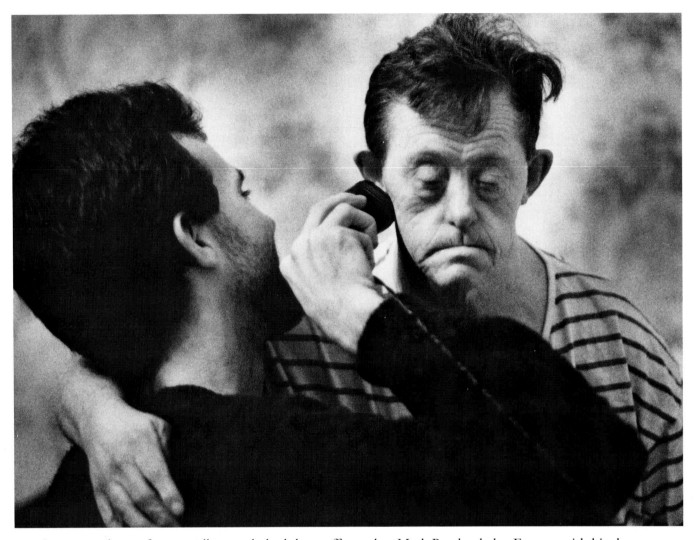

At a group home for mentally retarded adults, staff member Mark Burden helps Eugene with his shave.

Caring for Special Adults

Eight mentally retarded adults are cared for in a group home in Arlington, Mass., founded five years ago as an alternative to institutions. At the home, the ratio of staff to clients is much higher than at Fernald State School for the Mentally Retarded in Waltham, Mass. The clients in the home interact with residents of the neighborhood, playing ball at nearby parks, shopping at the stores. The clients at Fernald, for the most part, stay on the institution grounds.

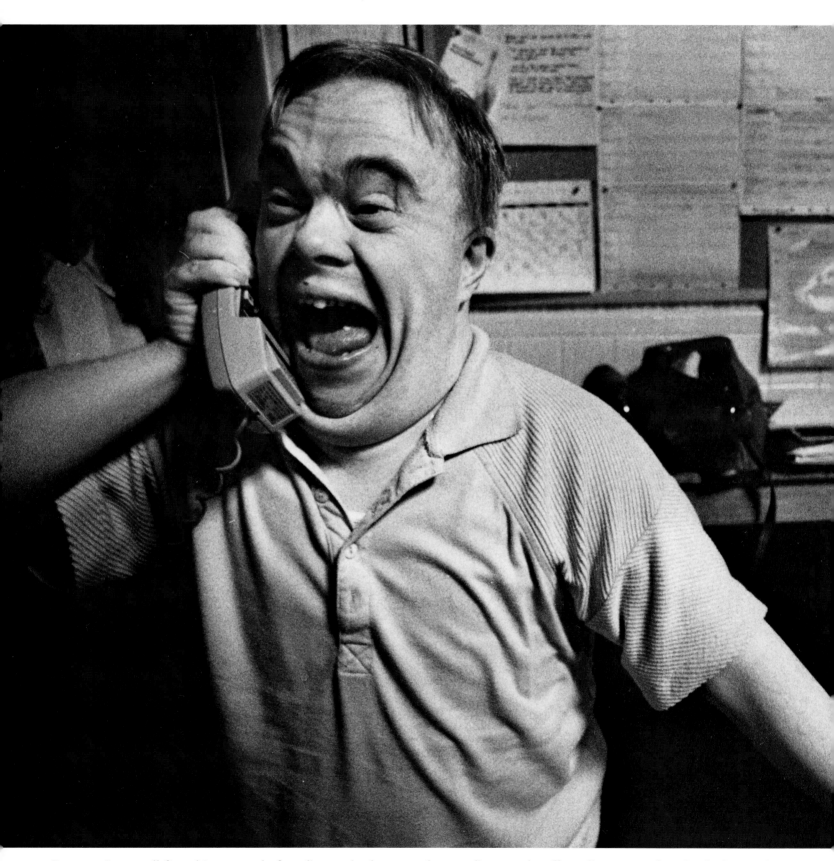

Sean receives a call from his parents before dinner. At the group home, clients and staff eat dinner together. In the institution, meals are brought in on trays and staff members watch clients eat.

Suzanne Kreiter, Boston Globe

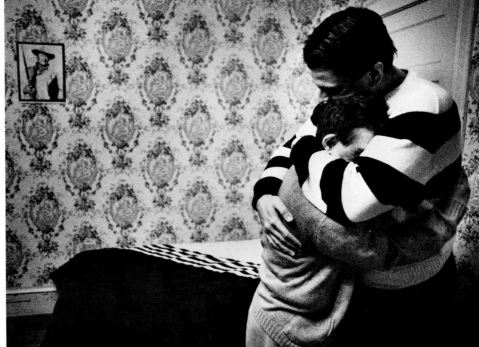

The most striking difference between the Fernald State School and the group home is the amount of physical contact between staff and clients. Eugene's day in the group home begins with a wake-up hug from staffer Bob Carroll.

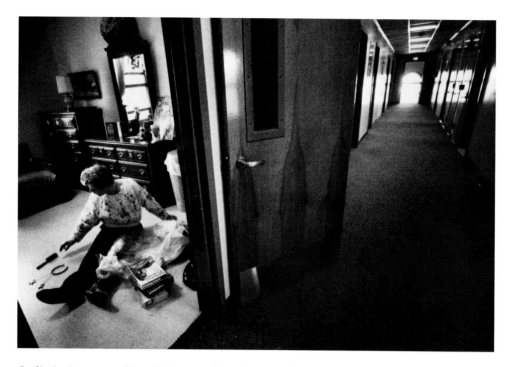

Sadie is 44 years old, mild to moderately retarded, and has been institutionalized since she was 4. She is much higher functioning than most of the residents in her ward at Fernald State School and prefers the solitude of her room.

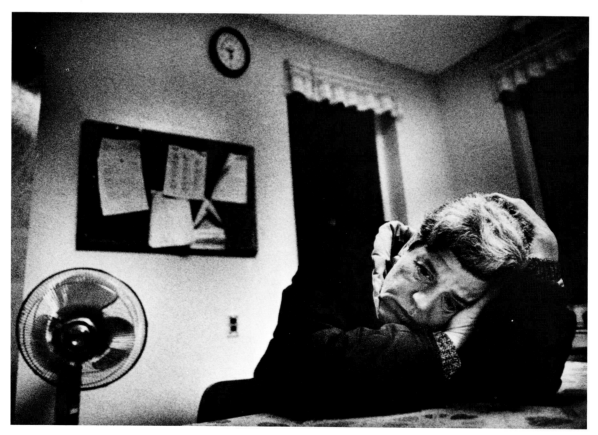

The hardest time for Sadie is the three hours between returning from her workshop and the time the activity center opens.

Suzanne Kreiter, Boston Globe

NEWSPAPER FEATURE PICTURE STORY, 2ND PLACE

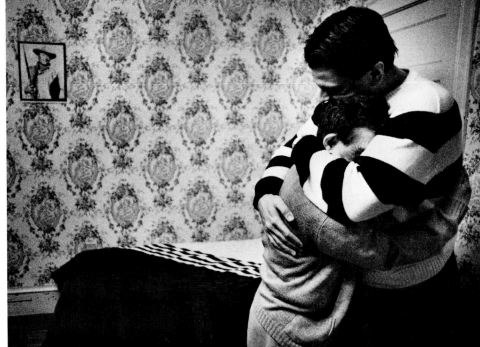

The most striking difference between the Fernald State School and the group home is the amount of physical contact between staff and clients. Eugene's day in the group home begins with a wake-up hug from staffer Bob Carroll.

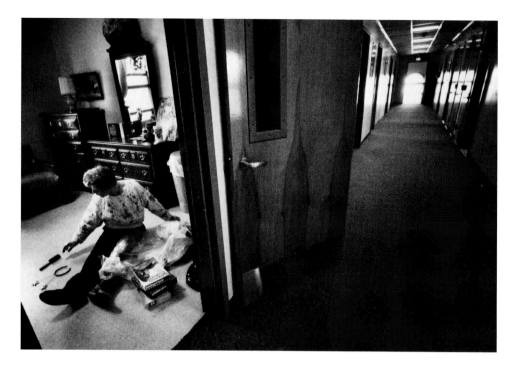

Sadie is 44 years old, mild to moderately retarded, and has been institutionalized since she was 4. She is much higher functioning than most of the residents in her ward at Fernald State School and prefers the solitude of her room.

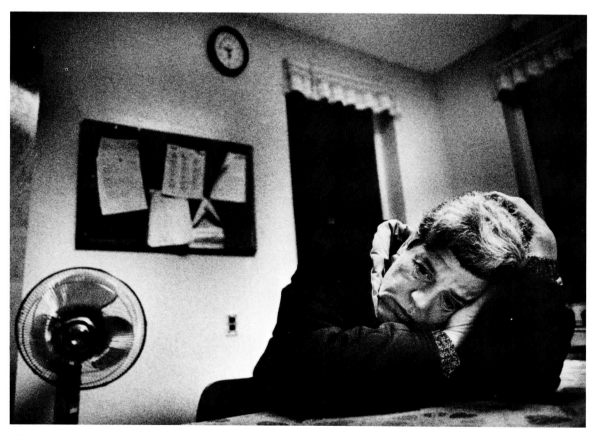

The hardest time for Sadie is the three hours between returning from her workshop and the time the activity center opens.

Suzanne Kreiter, Boston Globe

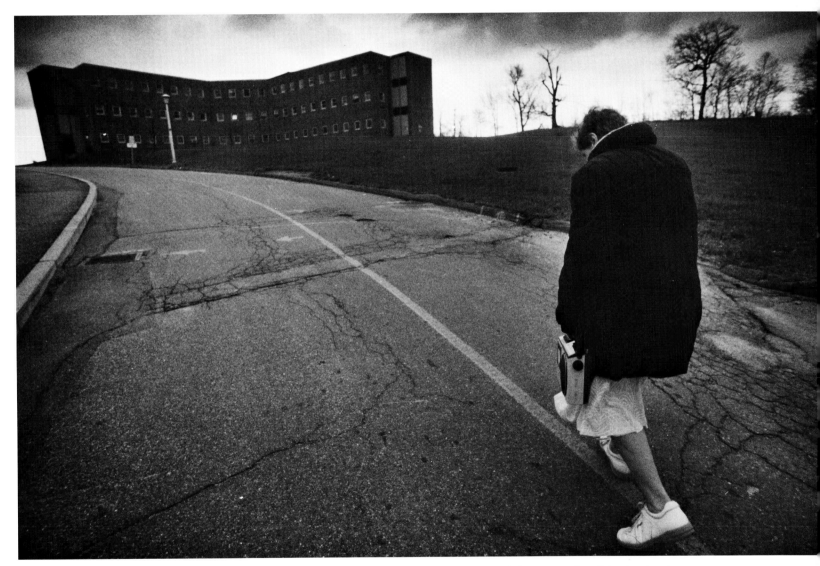

Even on bitterly cold days, Sadie escapes the ward for a walk around the grounds of the institution.

Suzanne Kreiter, Boston Globe

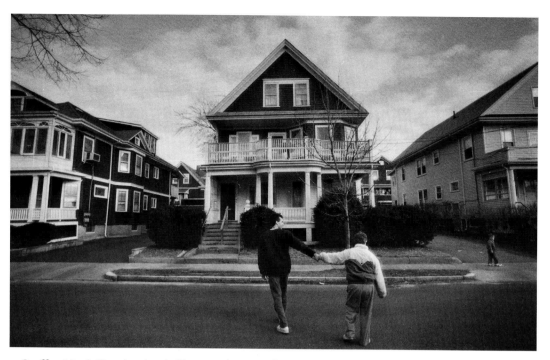

Staffer Mark Burden leads Eugene home after a walk. Clients at the group home have daily interaction with the community.

Sadie seeks out quiet spots at the institution, such as the empty activity center.

Pauline Lubens, Detroit Free Press

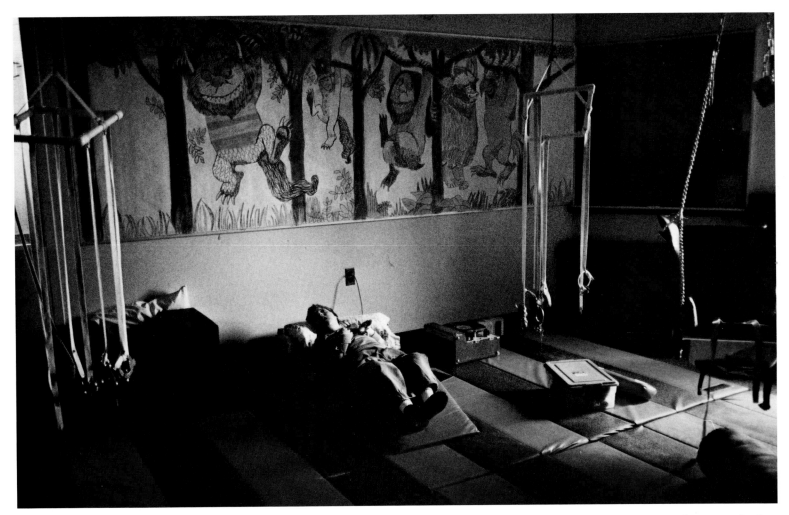

Ryan lies in a classroom at Lincoln School in Grand Rapids, Mich. He was required to attend school even though a neurologist confirmed that Ryan was unresponsive to sight or sound.

A Family Lets Go

In 1979, a hospital error left Linda Belanger's 2-year-old son, Ryan, in a "persistent vegetative state." For 12 years, doctors kept him alive, until finally Linda persuaded them to allow her to bring him home to die. Removing the feeding tube that had kept Ryan's body alive, Linda and her husband, Lou, maintained a bedside vigil. Five days later, Ryan's ordeal was over.

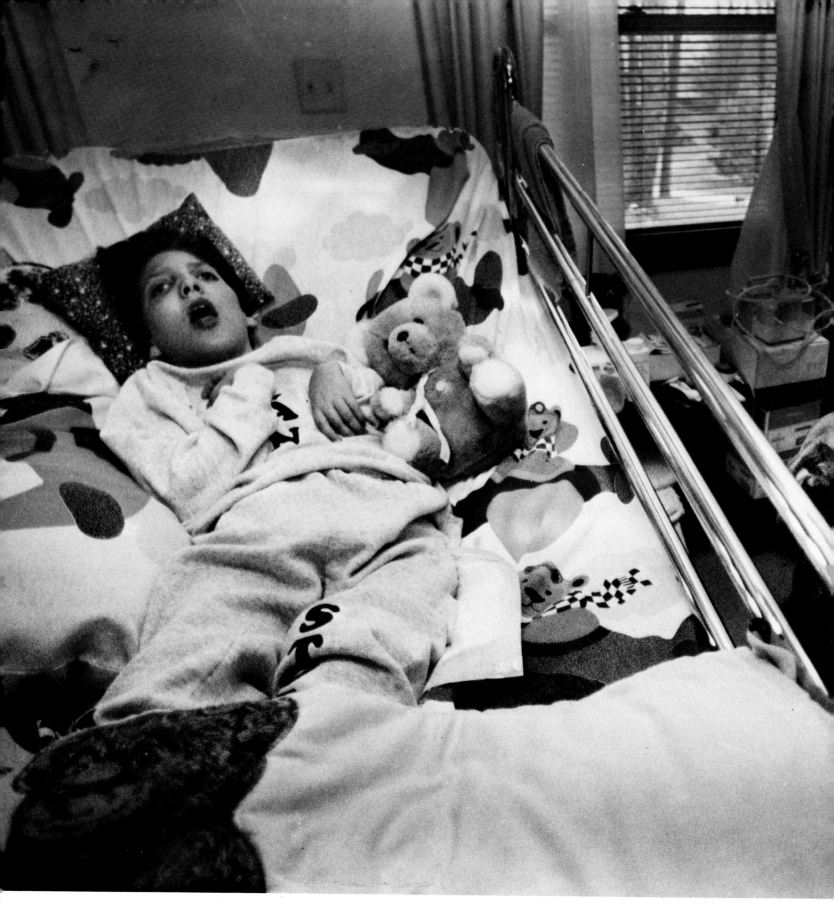

Linda Belanger rests near the bedside of her son, Ryan.

Pauline Lubens, Detroit Free Press

NEWSPAPER FEATURE PICTURE STORY, 3RD PLACE

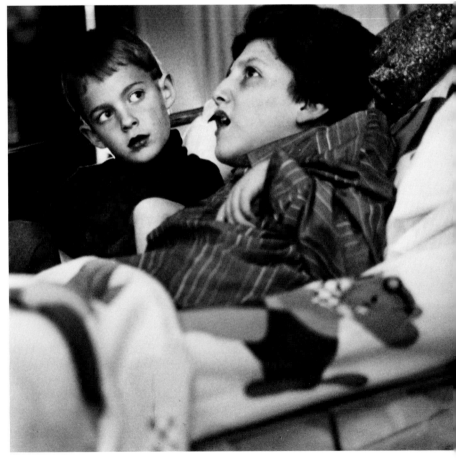

Chris watches his comatose brother.

Pauline Lubens, Detroit Free Press

Pauline Lubens, Detroit Free Press

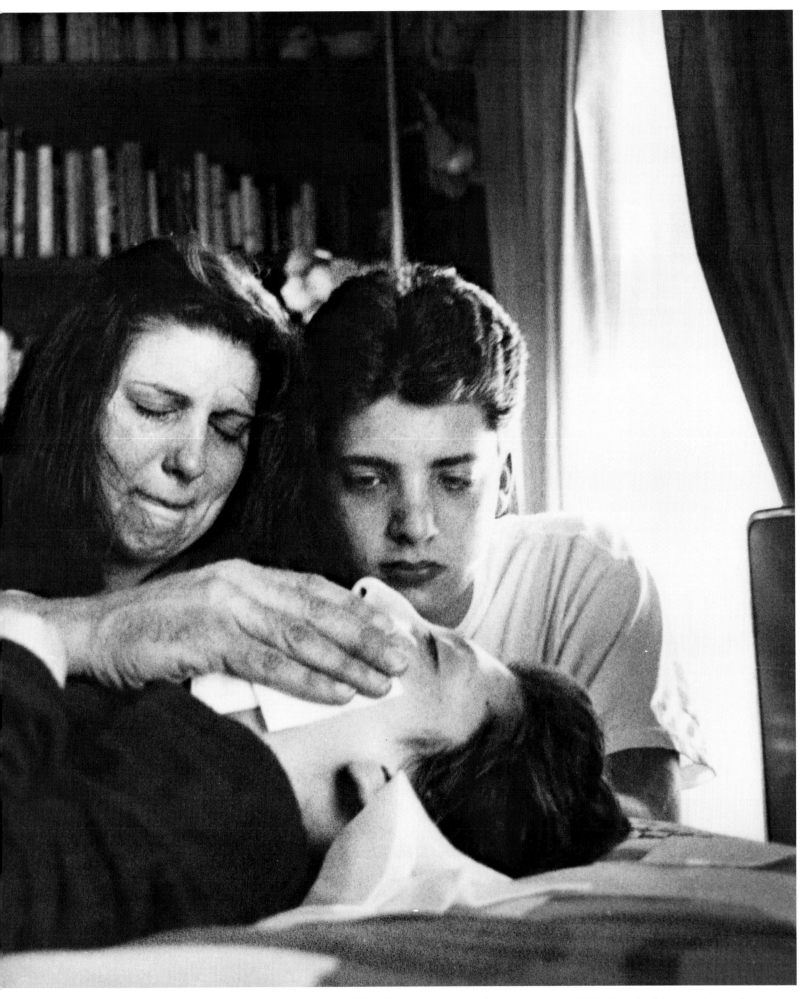

Lou Belanger, Linda and Eric gather at Ryan's bedside during the boy's final moments of life. Lou holds a moistened piece of gauze over Ryan's mouth, praying, "Take him, God."

Pauline Lubens, Detroit Free Press

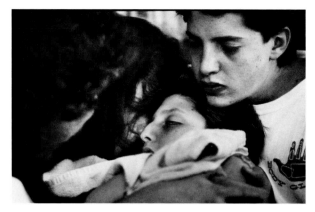

Ryan's body is cradled by his family moments
after his death.

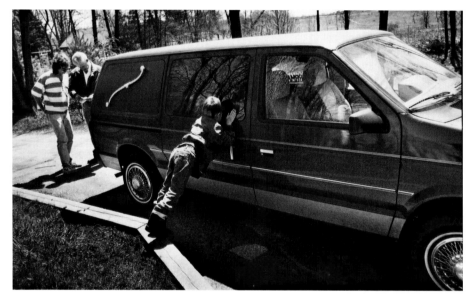

Christopher peers at Ryan's body while Lou talks to an employee of a
funeral home.

Linda watches the sun rise on the last day of Ryan's life.

Pauline Lubens, Detroit Free Press

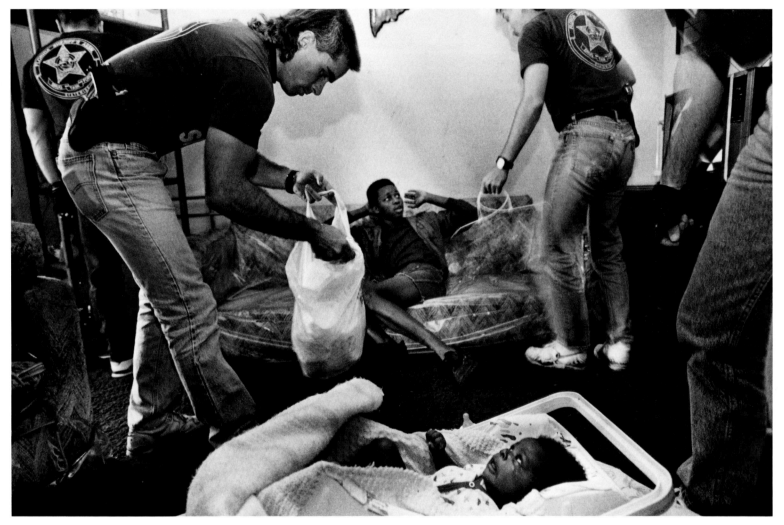

1ST PLACE
Joanne Rathe, The Boston Globe
Broward County Sheriff's deputies make a drug bust in a Fort Lauderdale, Fla., home.

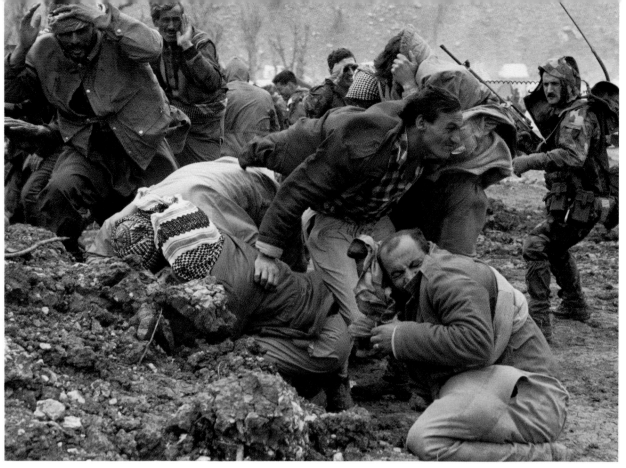

AWARD OF EXCELLENCE
Eric Mencher, The Philadelphia Inquirer
Kurdish refugees in a remote camp in the mountains of Turkey cower from the downdraft
of a helicopter bringing relief supplies.

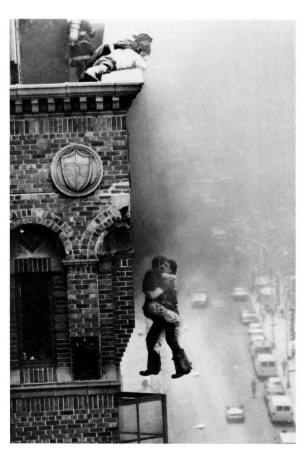

AWARD OF EXCELLENCE
Michael Norcia, New York Post
Firefighter Kevin Shea rescues Tony Lewis from
a burning high rise.

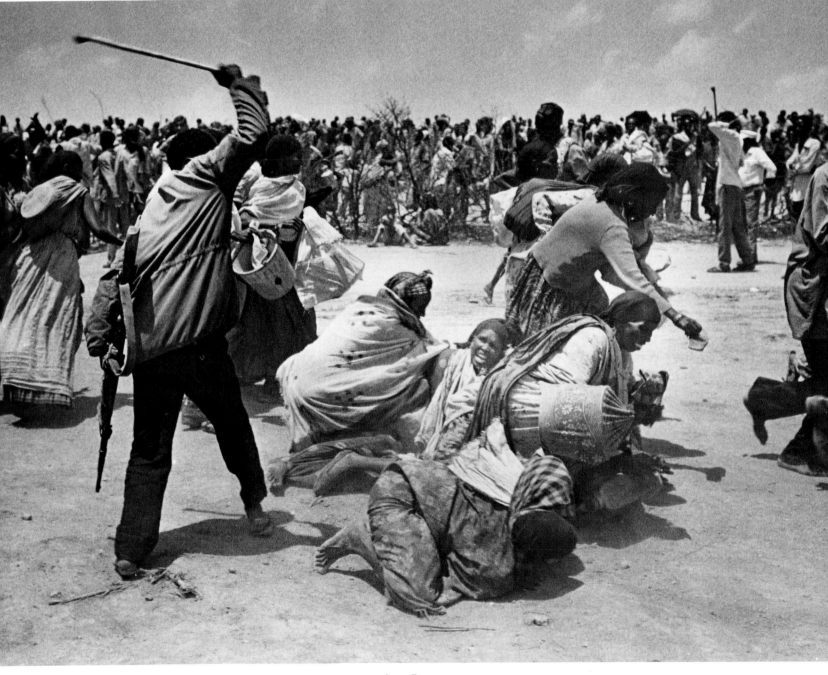

Ronald Cortes, The Philadelphia Inquirer
Somalian refugees in the Kebre Beyah camp in Ethiopia are beaten by a guard after trying to storm the food lines.

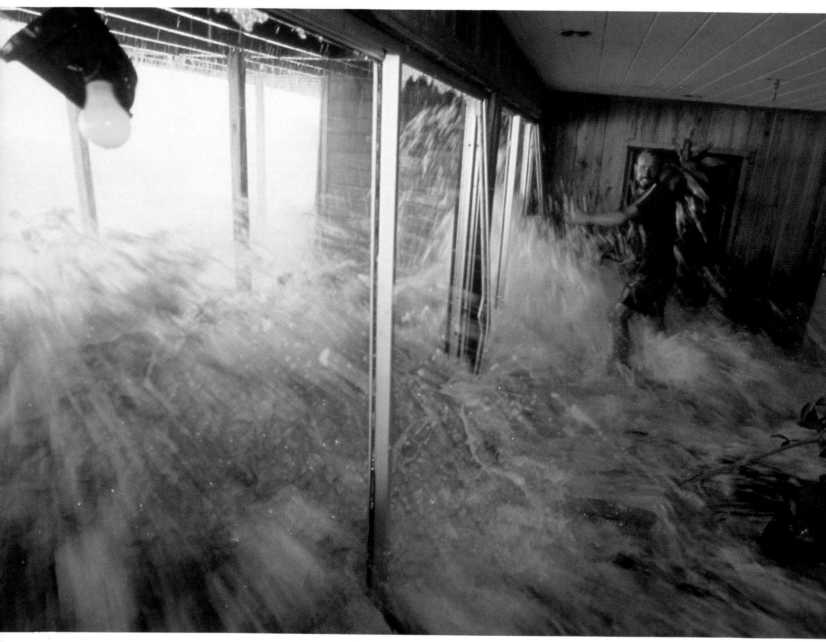

AWARD OF EXCELLENCE
David A. Lane, Palm Beach Post
Dave Foley of West Palm Beach is taken by surprise as a monstrous wave crashes through the plate glass windows of a beachfront home on Jupiter Island, Fla.

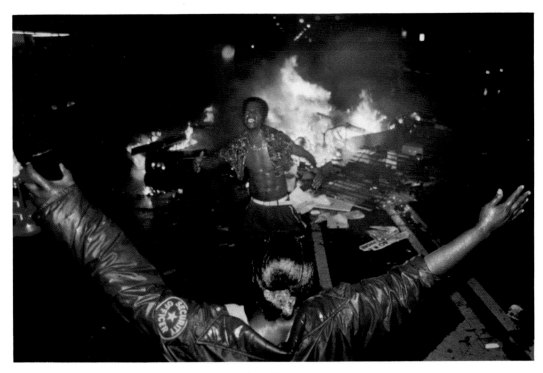

3RD PLACE
Charles Trainor Jr., The Miami Herald
Miami Haitians protest the arrest of Haiti President Jean-Bertrand Aristide.

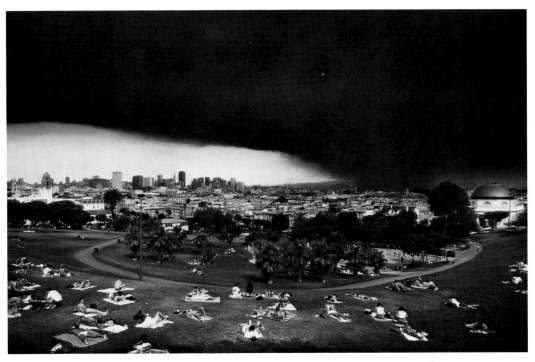

AWARD OF EXCELLENCE
Wendy Lamm, Oakland Tribune
Smoke rises from the Oakland Hills fire in the distance as sunbathers enjoy
the afternoon in San Francisco's Dolores Park.

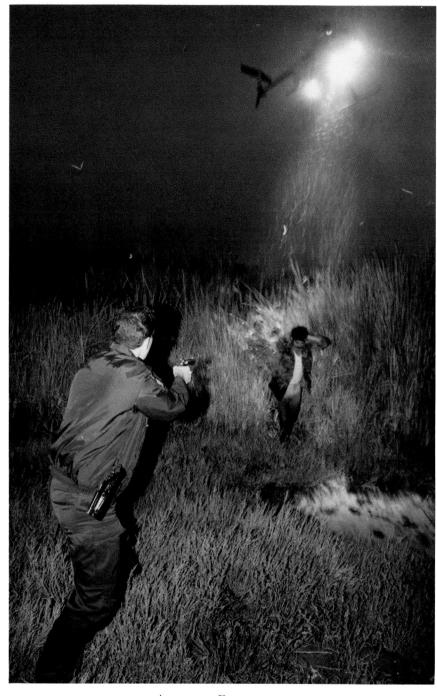

AWARD OF EXCELLENCE
Hayne Palmour IV, Blade-Citizen (Oceanside, Calif.)
Police Officer Damian Garcia trains his gun on two suspects as a
helicopter hovers above in Oceanside, Calif.

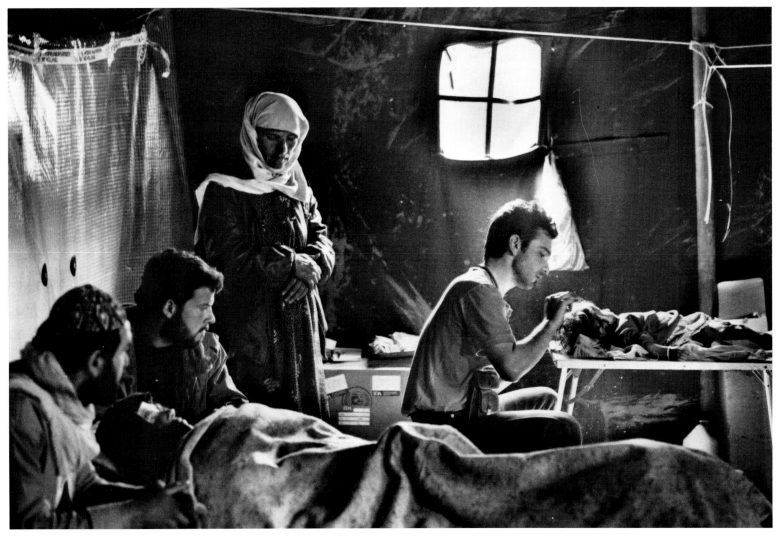

1ST PLACE
Bill Snead, The Washington Post
At a Kurdish refugee camp in Isikveren, Turkey, a nurse from Doctors Without Borders tends to a child as two brothers sit with their mother, whom they had carried to the camp. Both patients were among the thousands who died in the camp.

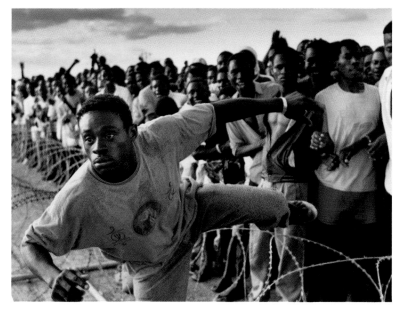

Patrick Farrell, The Miami Herald
A young Haitian refugee jumps the wire fence surrounding a
tent city in Guantanamo Bay, Cuba.

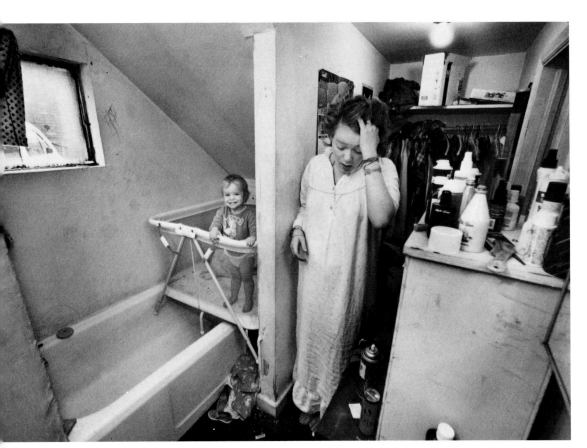

2ND PLACE
Drew Perine, The (Everett, Wash.) Herald
Long days and sleepless nights make mornings difficult for Randee Roylene Studdert.
The cocktail waitress keeps her baby in the bathroom because the apartment is crowded
with other tenants.

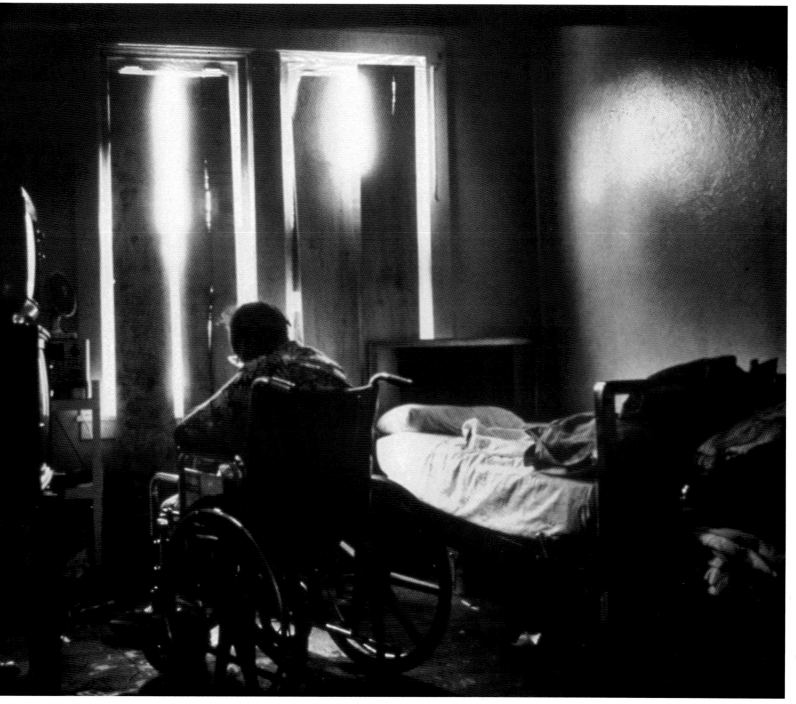

Steve Mellon, The Pittsburgh Press
An ongoing drug war outside prompted Arlie Clark, 73, to board her windows, despite the summer heat. Days earlier, bullets had crashed through the glass, narrowly missing members of her family.

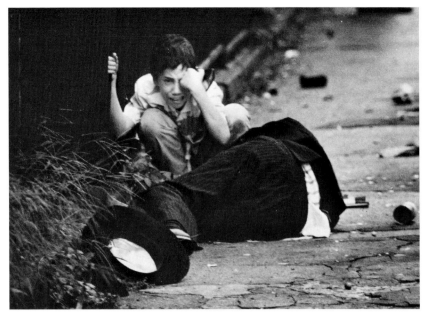

Robin Graubard, New York Post
Yechiel Bitton, 12, cowers near his father, Isaac, during violence
directed at Hasidic Jews in the Crown Heights section of New York.

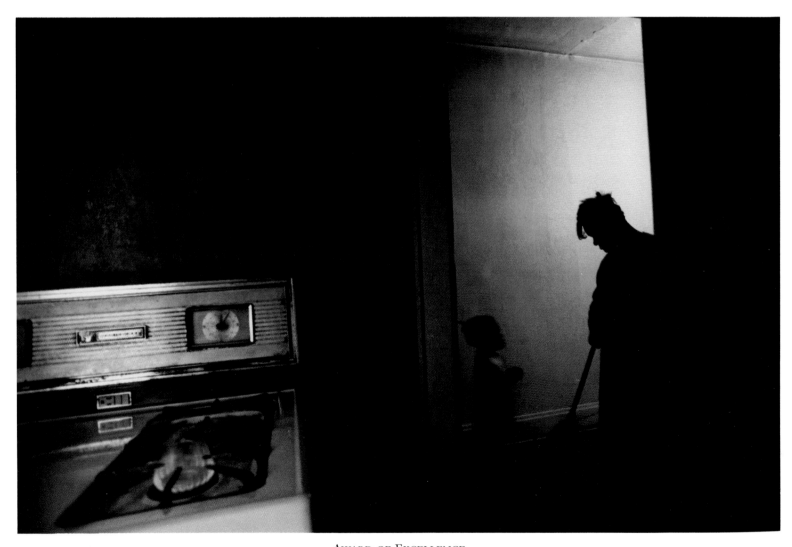

Eric Albrecht, The Columbus Dispatch
Yavonna Prophet sweeps her apartment as her daughter, Todae, watches. The only heat comes from a gas stove.

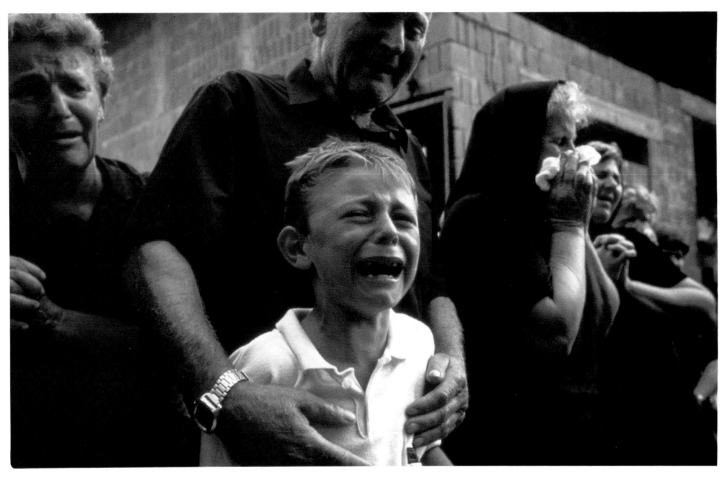

1ST PLACE
Christopher Morris, Black Star for Time
A boy grieves at the funeral of his father, a policeman slain during an ambush in Croatia.

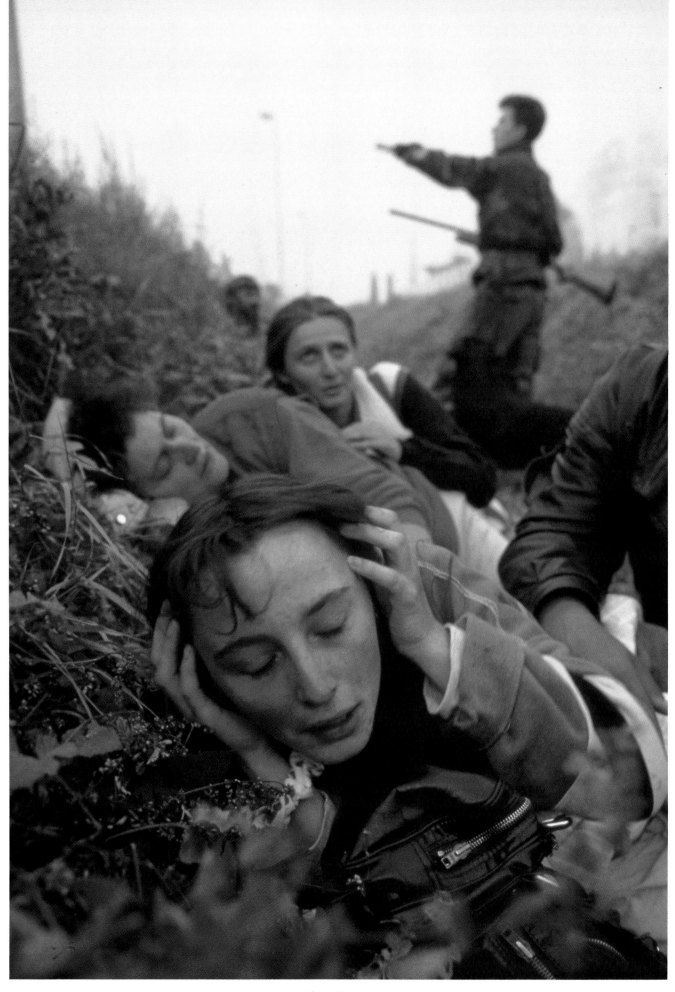

Jean-Claude Coutausse, Contact Press Images
Civilians huddle in a ditch to escape bombing during an air raid near Osijek in Croatia.

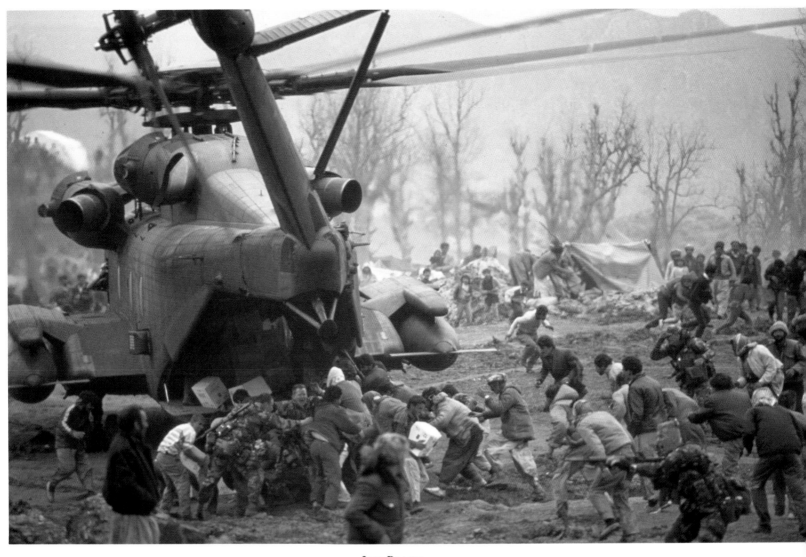

3RD PLACE
Les Stone, Sygma News Photo
Desperate Kurdish refugees in the mountains of Turkey rush the first American relief helicopter for food.

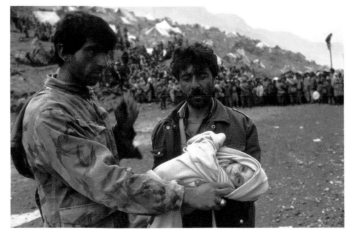

AWARD OF EXCELLENCE
Steven Rubin, JB Pictures for Newsweek
A man at Cukurca refugee camp buries his baby, a victim
of dysentery.

Terry Ashe, Life
Law Professor Anita Hill confers with an adviser during Senate confirmation hearings for Supreme Court nominee Clarence Thomas. Hill charged that Thomas had sexually harassed her in the early 1980s. The Senate ultimately confirmed Thomas, who denied Hill's charges.

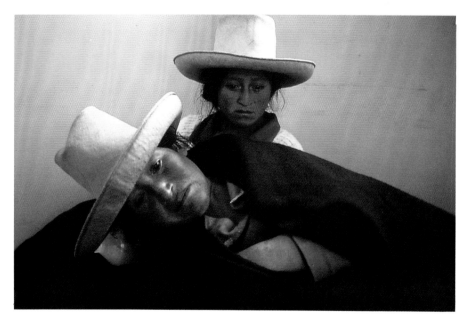

Gustavo Gilabert, JB Pictures for Newsweek
Two Peruvian women, ill with cholera, await medical attention at a Cajamarca hospital.

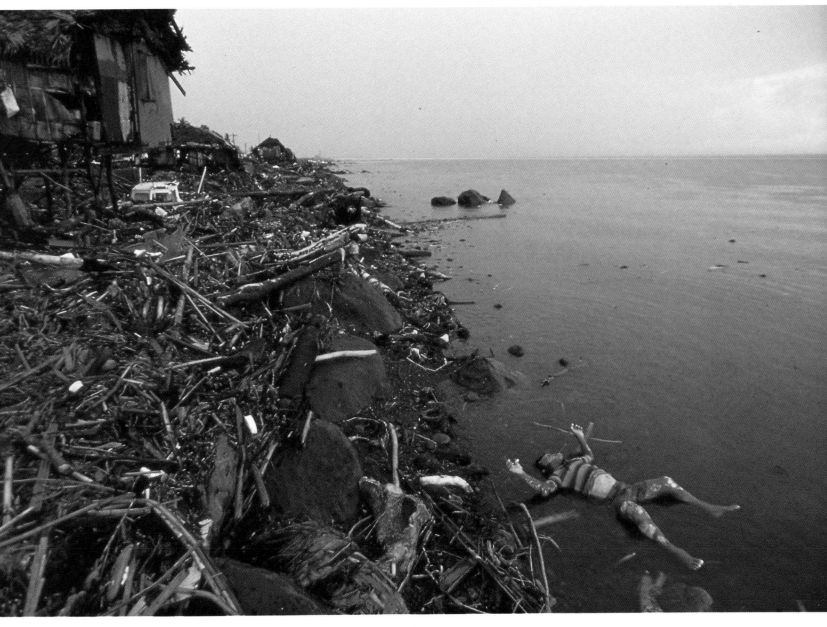

Les Stone, Sygma News Photo
The aftermath of a typhoon on the island of Leyte in the Philippines.

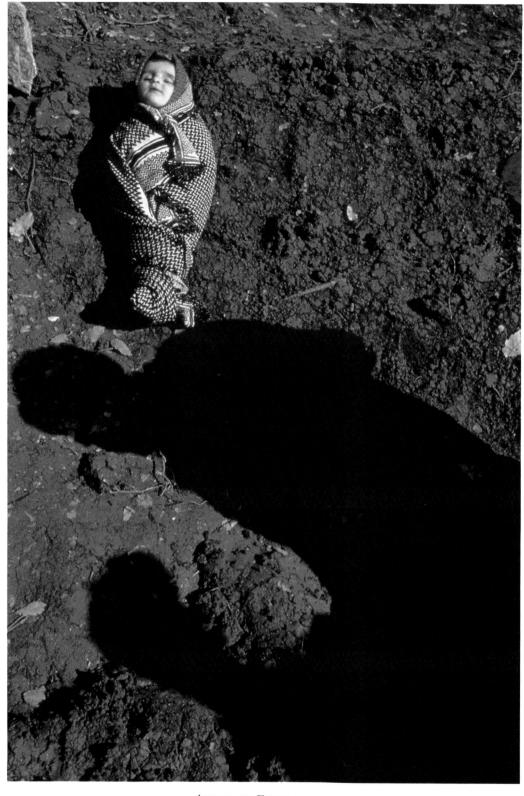

Anthony Suau, Black Star for Time
A child's body awaits burial at the Kurdish refugee camp in Isikveren, Turkey.
The Kurds fled Iraq in the wake of the Persian Gulf war; thousands died in camps.

Eugene Richards, Magnum Photos

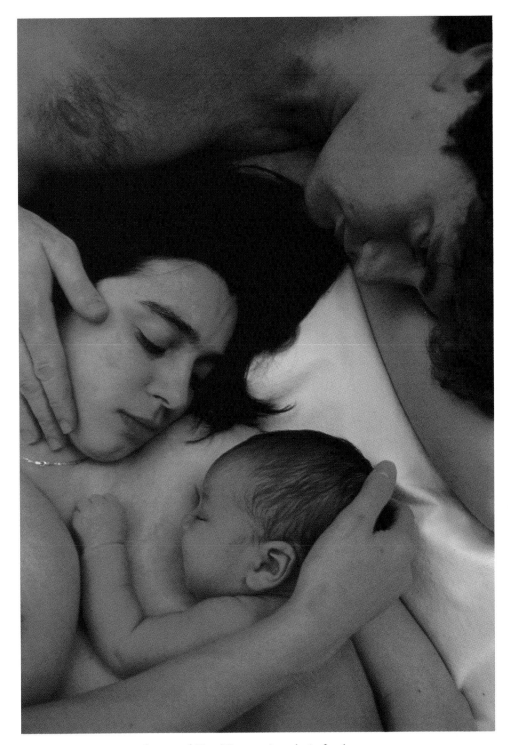

Sara and Jim Vogt enjoy their firstborn.

The Family of the '90s

A married couple enjoys their first child; a devout Franciscan teaches many of his 14 children at home; a woman works four jobs to support her children while insisting none of them accepts welfare; a teenager attends a school where all the students are mothers. Photojournalist Eugene Richards studied these people and others, in an attempt to display the variety of relationships that makes up the families of our time.

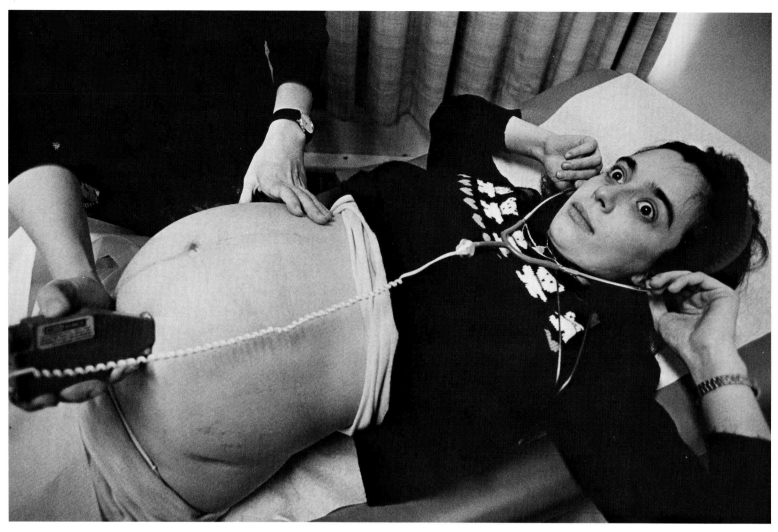

During a visit to the doctor, Sara hears her baby's heartbeat.

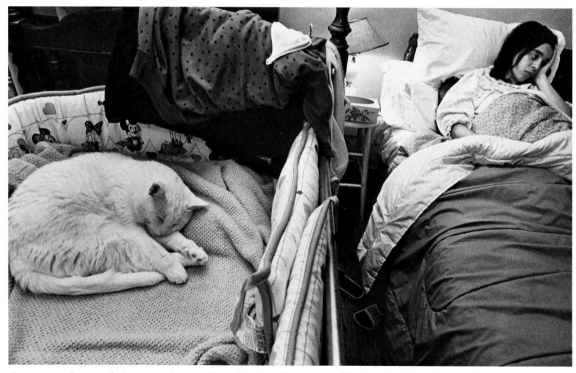

Sara, overdue and depressed, worries whether they can afford a child, and wonders what effect a baby will have on her marriage.

Eugene Richards, Magnum

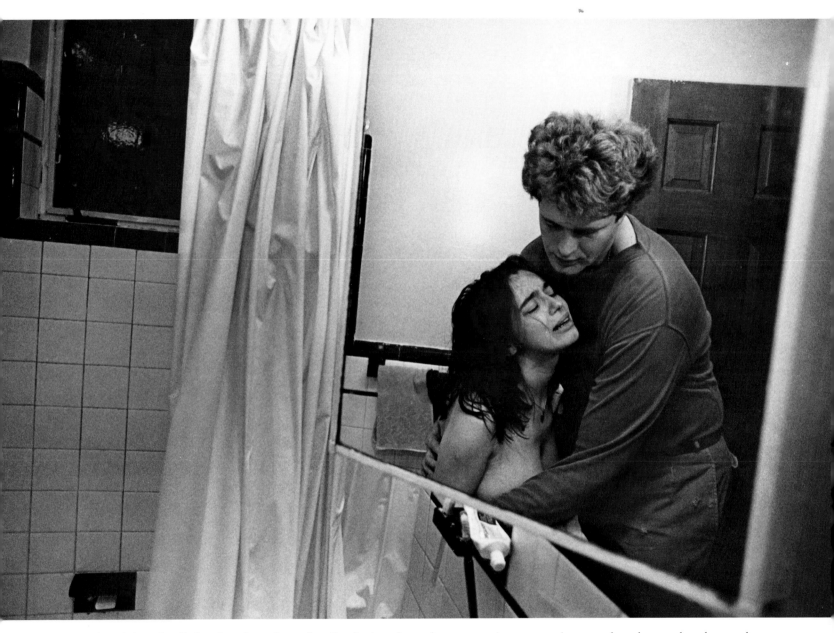

When labor finally begins, four days after Sara's due date, the contractions are so intense that she can barely stand.

Following page:
Labor was short but intense. Afterward, Sara's cries of pain turned to tears of joy.

Eugene Richards, Magnum

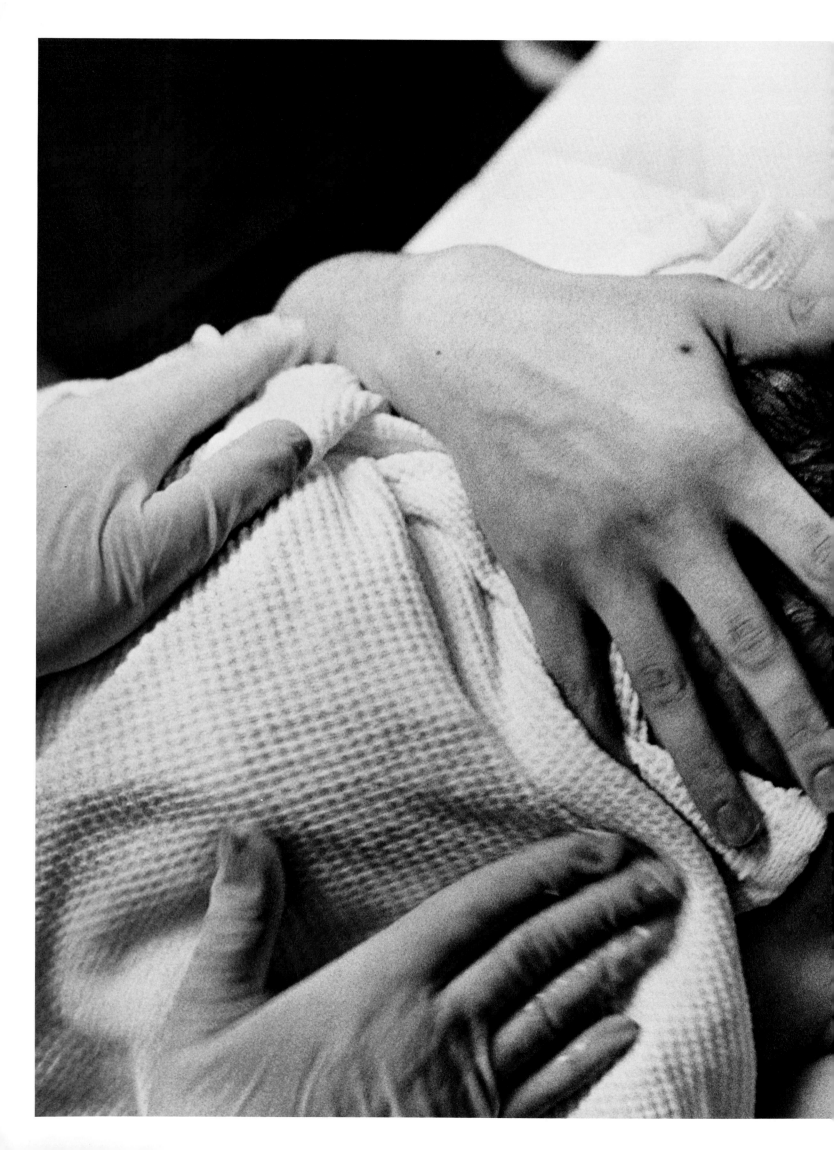

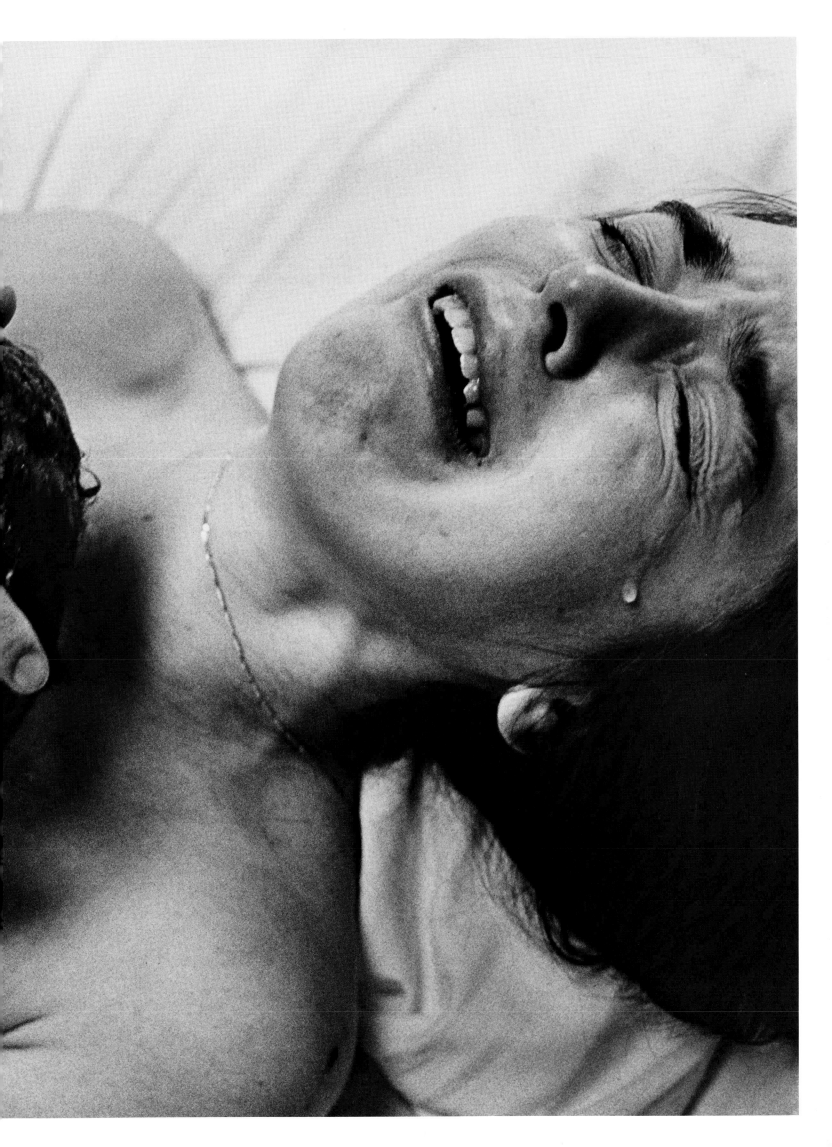

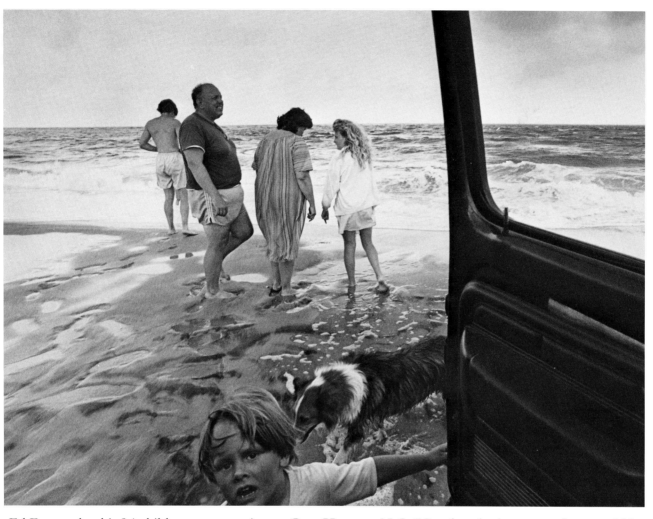

Ed Foran takes his 14 children on a vacation to Cape Hatteras, N.C. "One hundred percent of my world is my family," he says.

Eugene Richards, Magnum

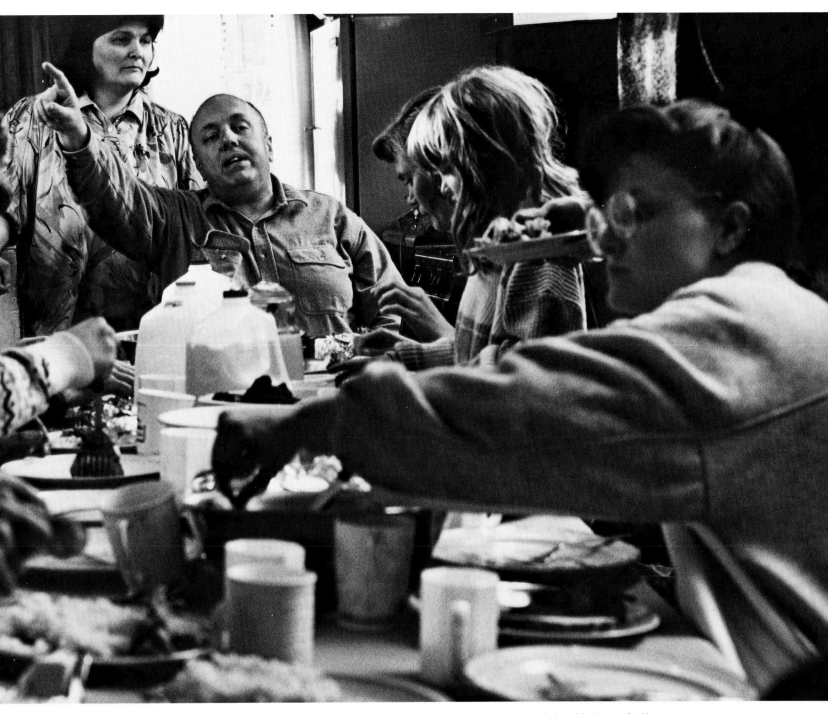

The Foran family gathers for a meal. Each day begins with prayers and the Pledge of Allegiance.

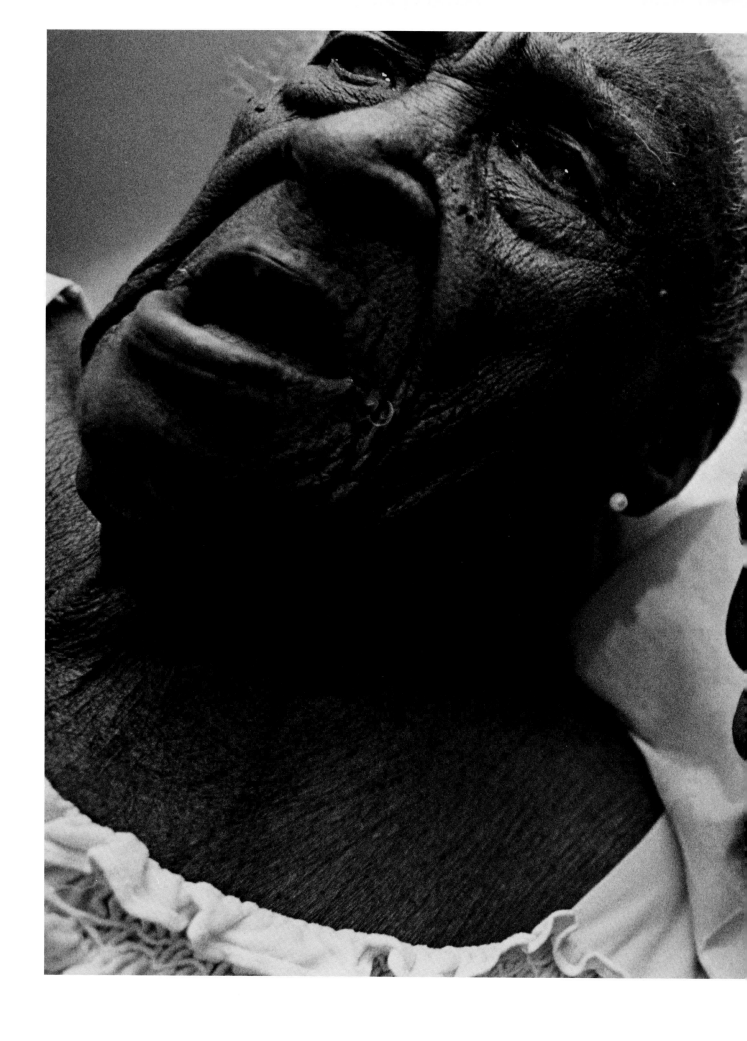

Eugene Richards, Magnum

CANON PHOTO ESSAY

Mary Toomer cares for 115-year-old Susie Brunson. Toomer, 54, who holds four jobs, refuses to allow her children to accept welfare.

Eugene Richards, Magnum

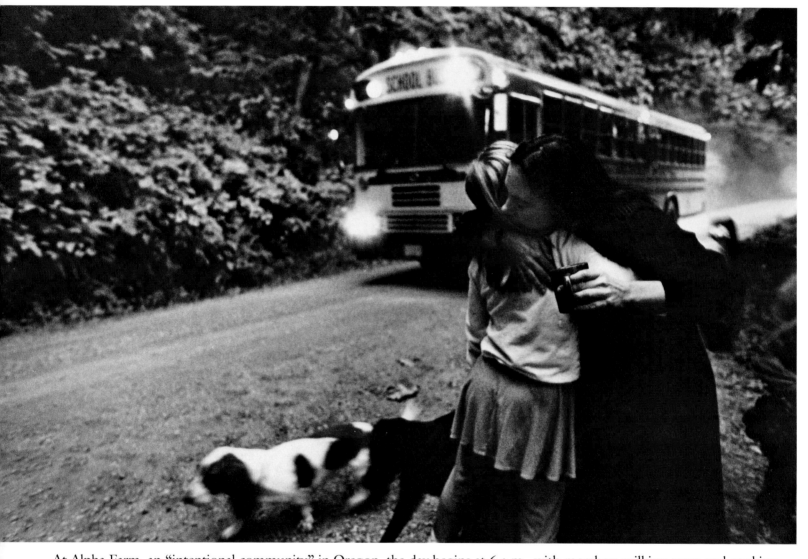

At Alpha Farm, an "intentional community" in Oregon, the day begins at 6 a.m., with members milking cows and cooking breakfast for the 11 adults and four children who reside there. Sally sees her child off to school at 7:15 a.m.

Eugene Richards, Magnum

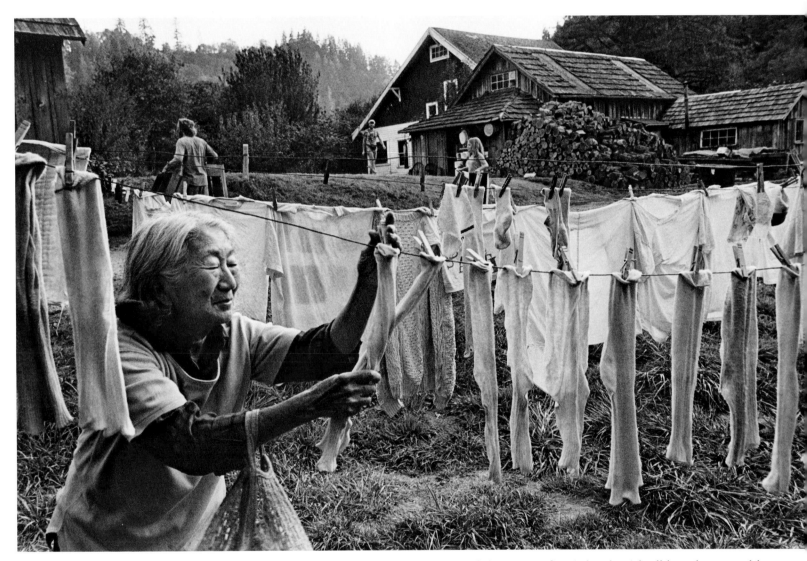

May, the stepmother of a member, hangs the wash out to dry. The work at Alpha Farm often is hard, with all but the very old or very young working nine-hour days.

Eugene Richards, Magnum

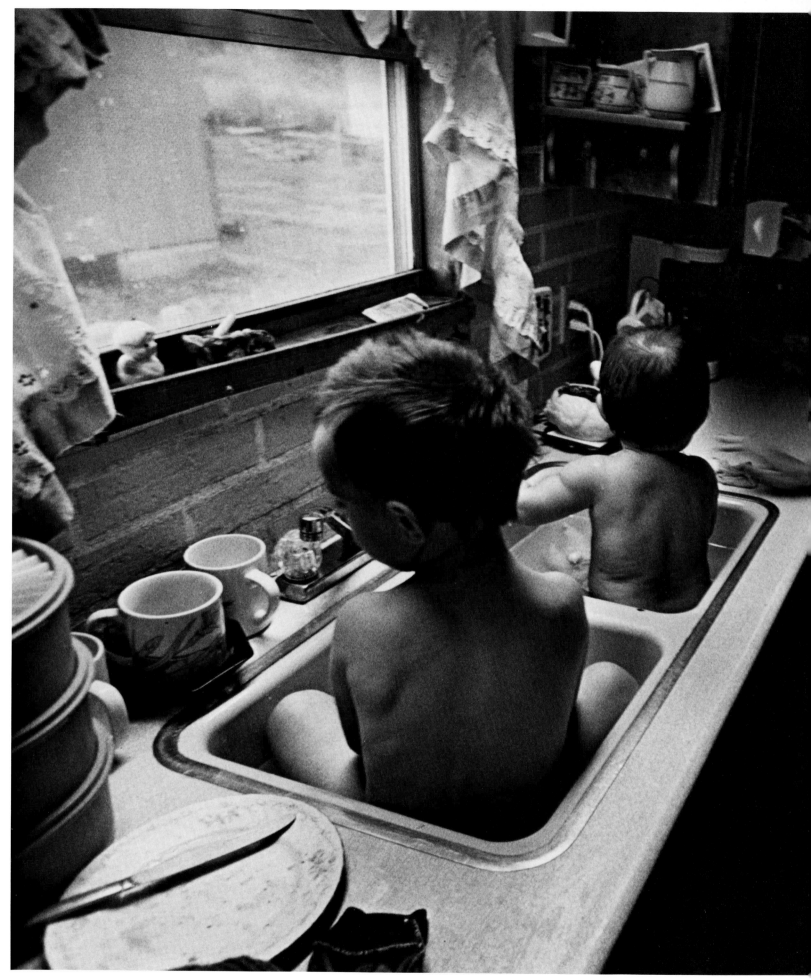

Shenan, a 17-year-old mother of two, bathes her children in the sinks before going to school.

Eugene Richards, Magnum

Eugene Richards, Magnum

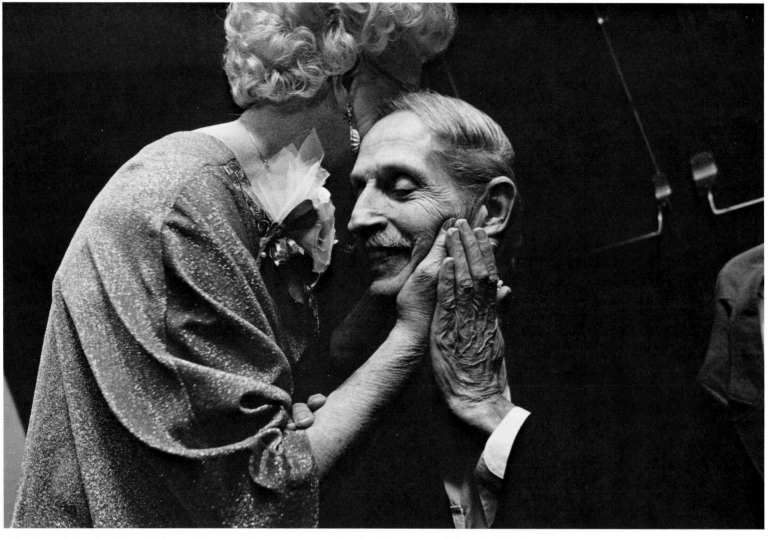

Paula, celebrating her 50th wedding anniversary, greets her hairdresser and friend of 15 years. Despite being ill with cancer, the man wanted to attend the party for Paula and her husband.

Eugene Richards, Magnum

Eugene Richards, Magnum Photos

J.D., an intravenous drug user, considers himself lucky: His latest blood test was HIV negative, and he's still alive after an overdose that turned his lips blue and nearly stopped his heart. (1986)

'They Still Make It Cool'

Eugene Richards has done several photo essays on the world of drug users, dealers, and enforcers. His first series on crack, *Below the Line*, was published in 1986. "All the advertisement (against drug use) doesn't work," he says, adding, "There's some wonderful fiction that's been done, but they still make it cool. Addiction is still terribly pathetic." Richards is the winner of the 1991 Kodak Crystal Eagle Award for Impact in Photojournalism for his studies of what he calls "a runaway problem."

Delia, an AIDS victim who lives in New York's Shantytown, asked that a photograph of her be taken to dissuade her young daughter from taking drugs. (1988)

After using his photographic talents to document teenage crack dealers, mothers who bring their children along while prostituting for drug money, and countless overdose victims, Richards says he believes drug abuse has its roots in poverty. "To me, the drugs are just a manifestation of the poverty. It has hit hardest the poor people. Especially because we don't have solutions, we don't want to address the problem." Richards says he would like to do a series of videos to get across this message: "If you take drugs, you're gonna be ugly."

Eugene Richards, Magnum

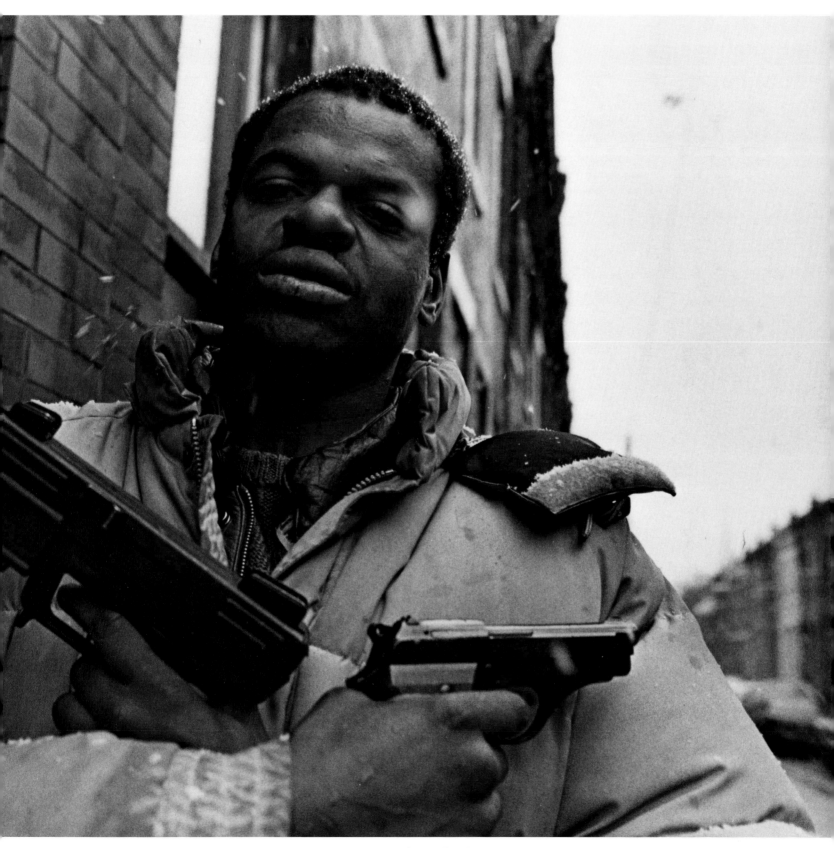

His name is Sam, but they call him "Ruthless." He is an enforcer for the Ninth Street Posse, a gang in North Philadelphia. (1990)

Eugene Richards, Magnum

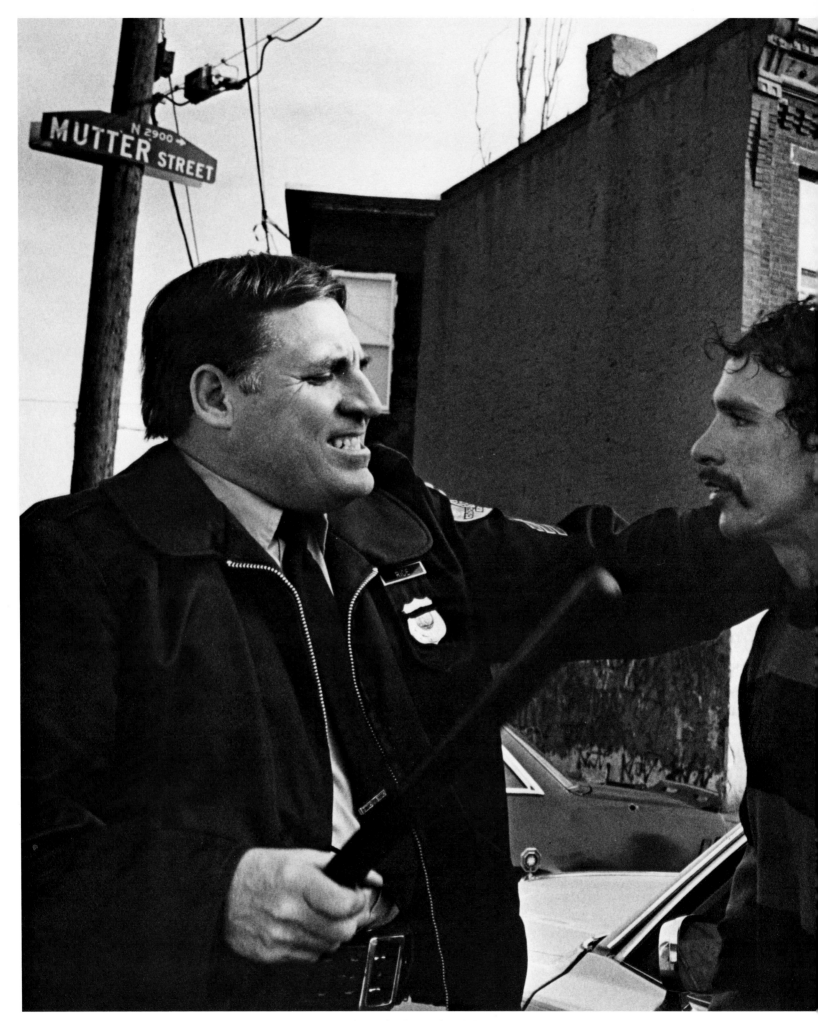

A police officer is angry with a drug addict who brought children along on a drug deal. (1989)

Eugene Richards, Magnum

KODAK CRYSTAL EAGLE

Eugene Richards, Magnum

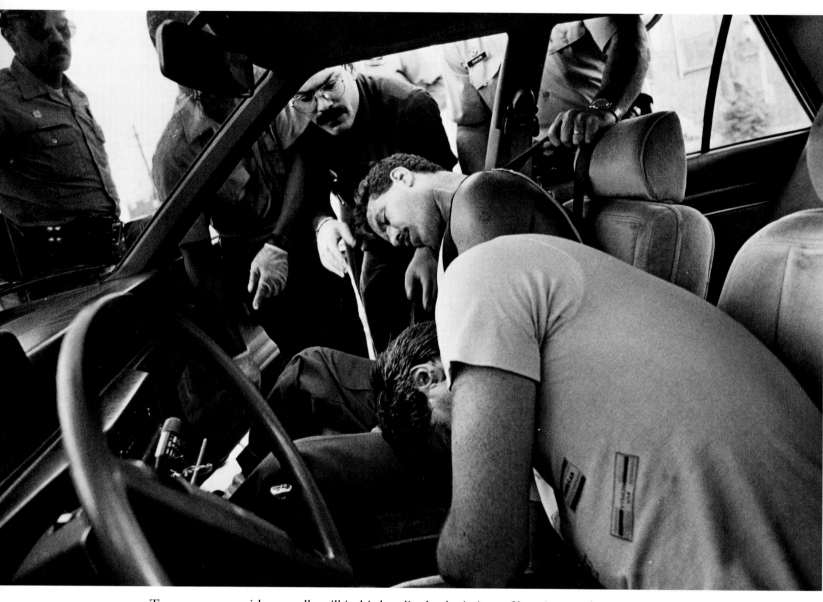

Two men, one with a needle still in his leg, lie dead, victims of heroin overdoses. (1989)

Eugene Richards, Magnum

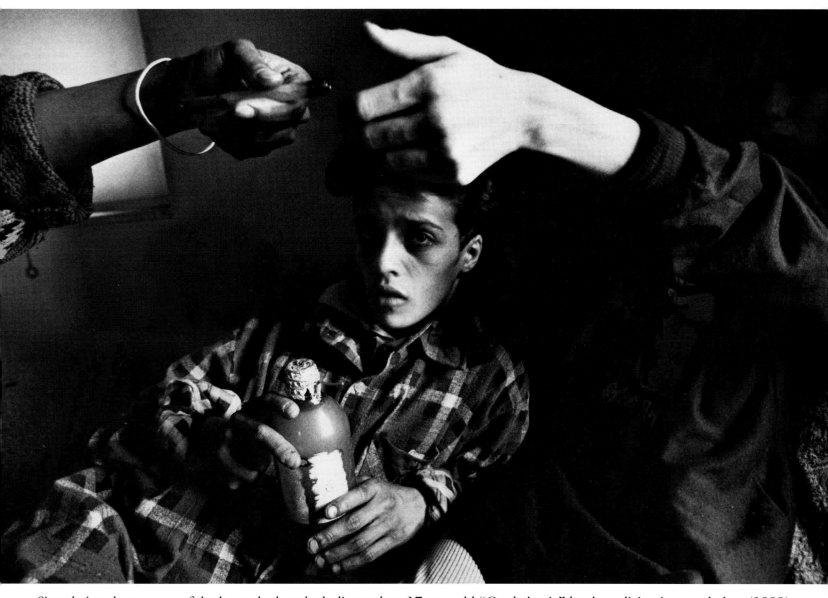

Since being thrown out of the house by her alcoholic mother, 17-year-old "Crack Annie" has been living in a crack den. (1988)

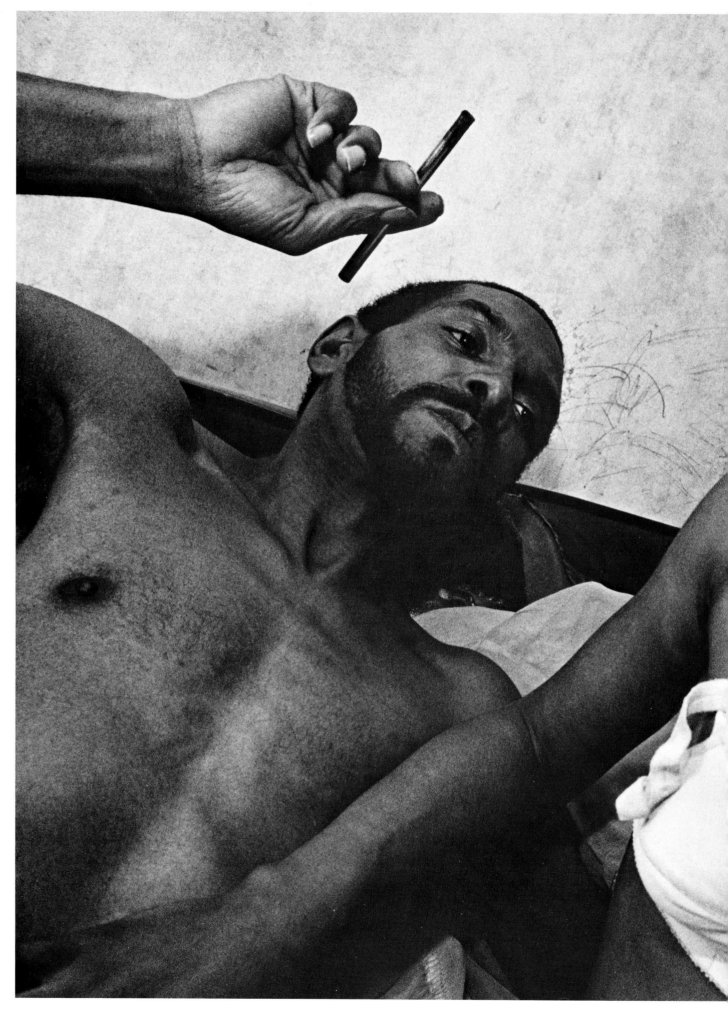

A 15-year-old turns to prostitution to earn drug money in North Philadelphia. (1990)

Eugene Richards, Magnum

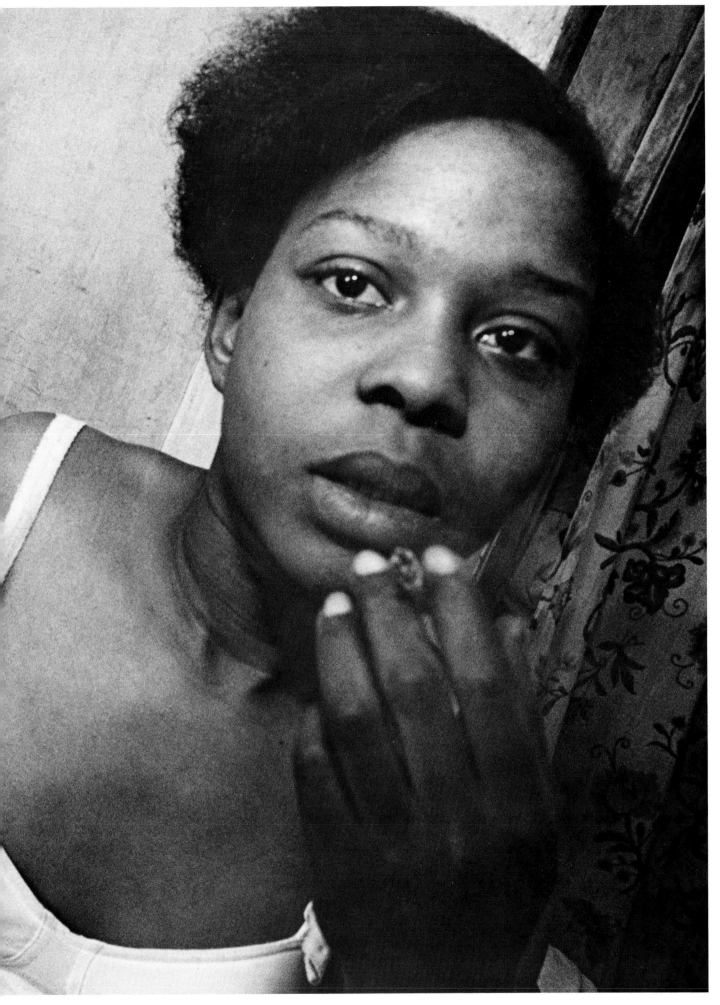

Following page:
An addict screams during treatment for a heroin overdose at Denver General Hospital. (1984)

Eugene Richards, Magnum

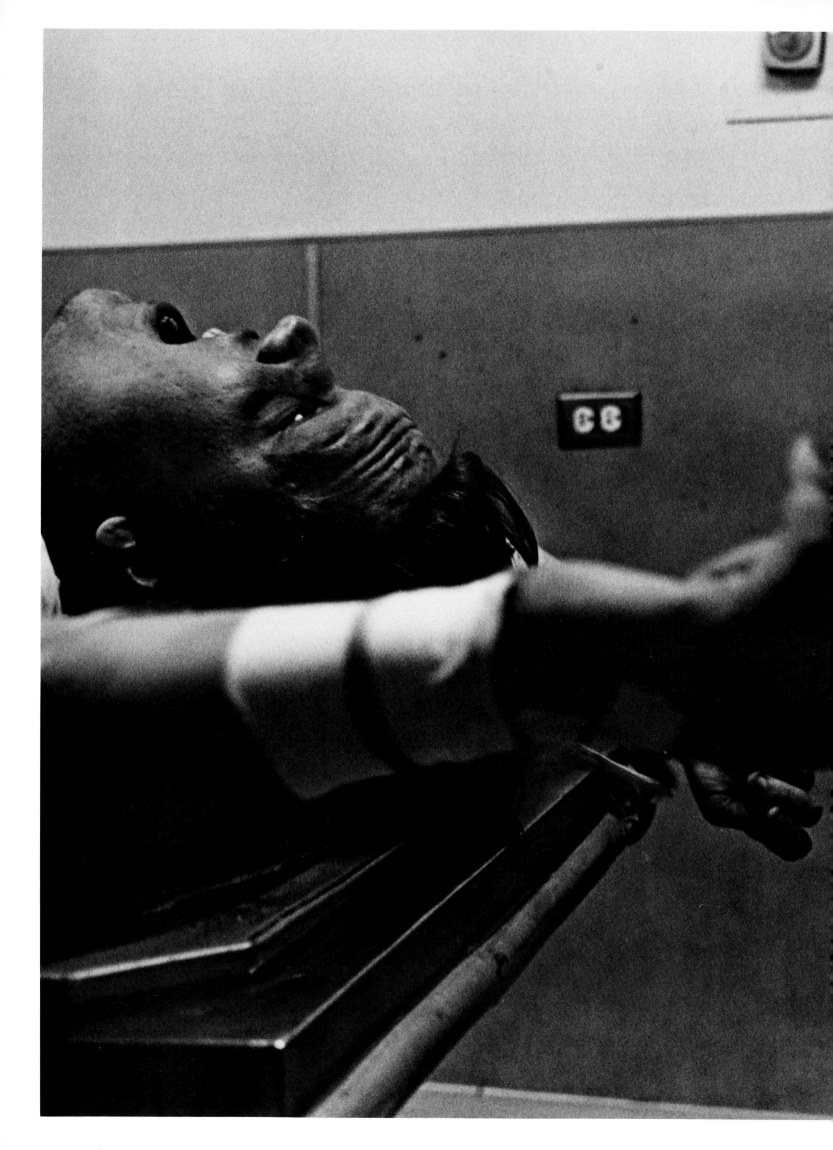

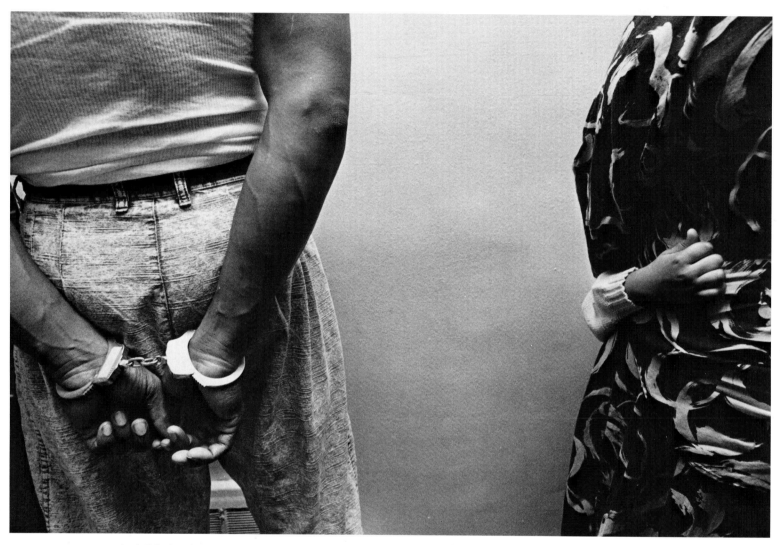

A child clutches her mother as her father is handcuffed during a drug bust in Detroit. (1988)

Eugene Richards, Magnum

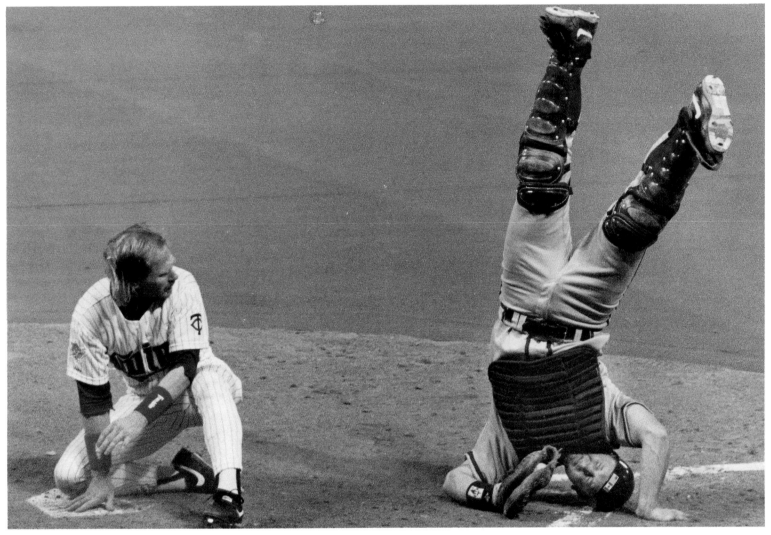

1ST PLACE
Eric Miller, Reuters
Atlanta Braves catcher Greg Olson flips after colliding with Minnesota Twins runner Dan Gladden at home plate
during the 5th inning of World Series Game 1. Olson got the last laugh, though: Gladden was out.
(See Page 150 for a split-second difference.)

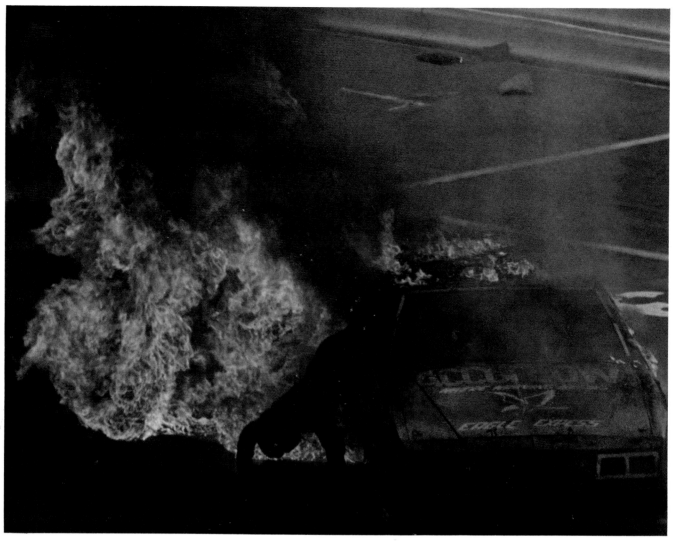

2ND PLACE
Tom Copeland for The Associated Press
Phillip Ross of Greer, S.C., dives from a fiery race car during a Sportsman Division qualifying race
at Charlotte Motor Speedway. Ross suffered burns over much of his body and later quit racing.

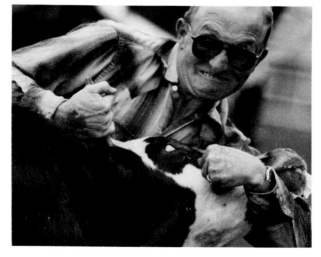

AWARD OF EXCELLENCE
Mike Sturk, Calgary (Alberta) Herald
Lonnie Olson wrestles with a steer at the Calgary
Stampede. He managed to get the animal to the
ground, but did not win the $50,000
prize money for the event.

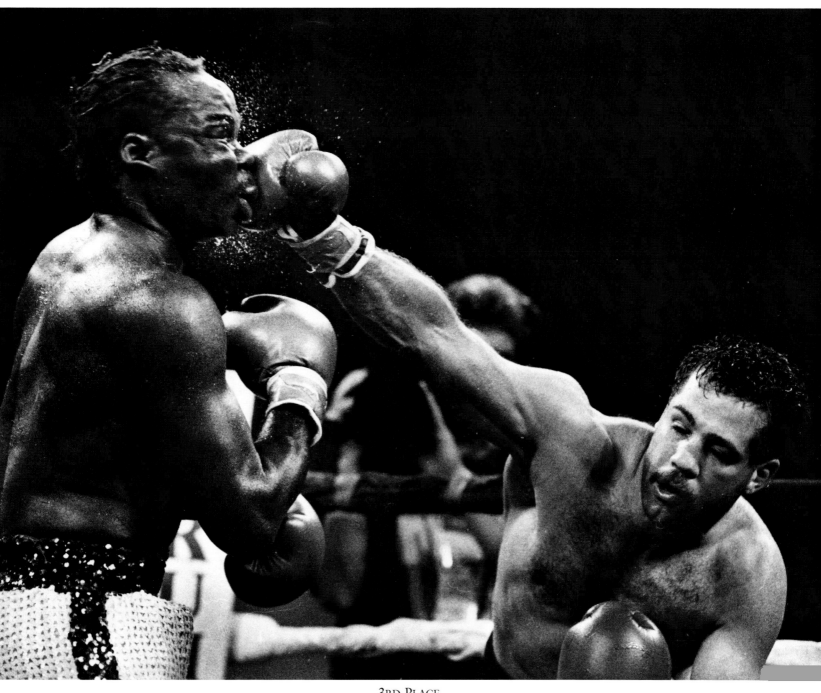

Ron Cortes, The Philadelphia Inquirer
Bobby Czyz makes a quick statement to Bash Ali during a 12-round World Boxing Association cruiserweight championship
match in Atlantic City, N.J. Czyz won by decision.

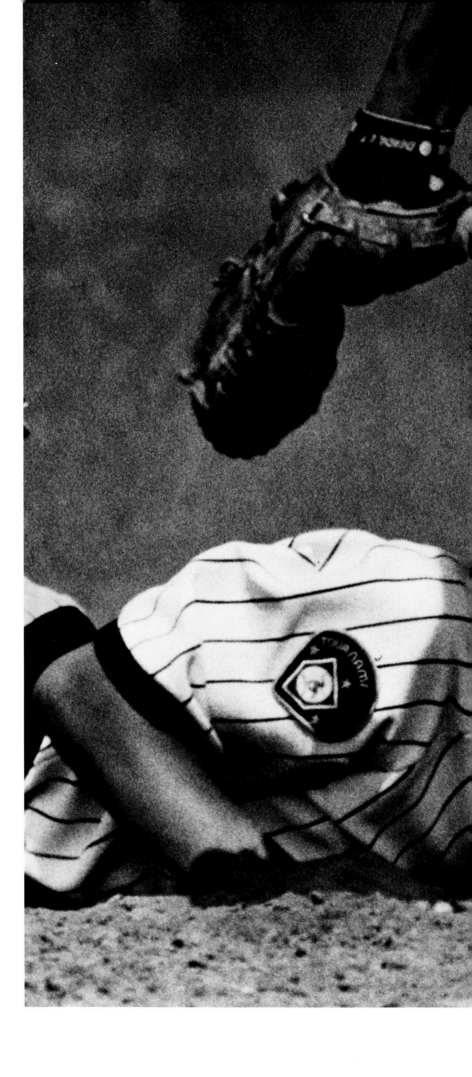

NEWSPAPER SPORTS ACTION

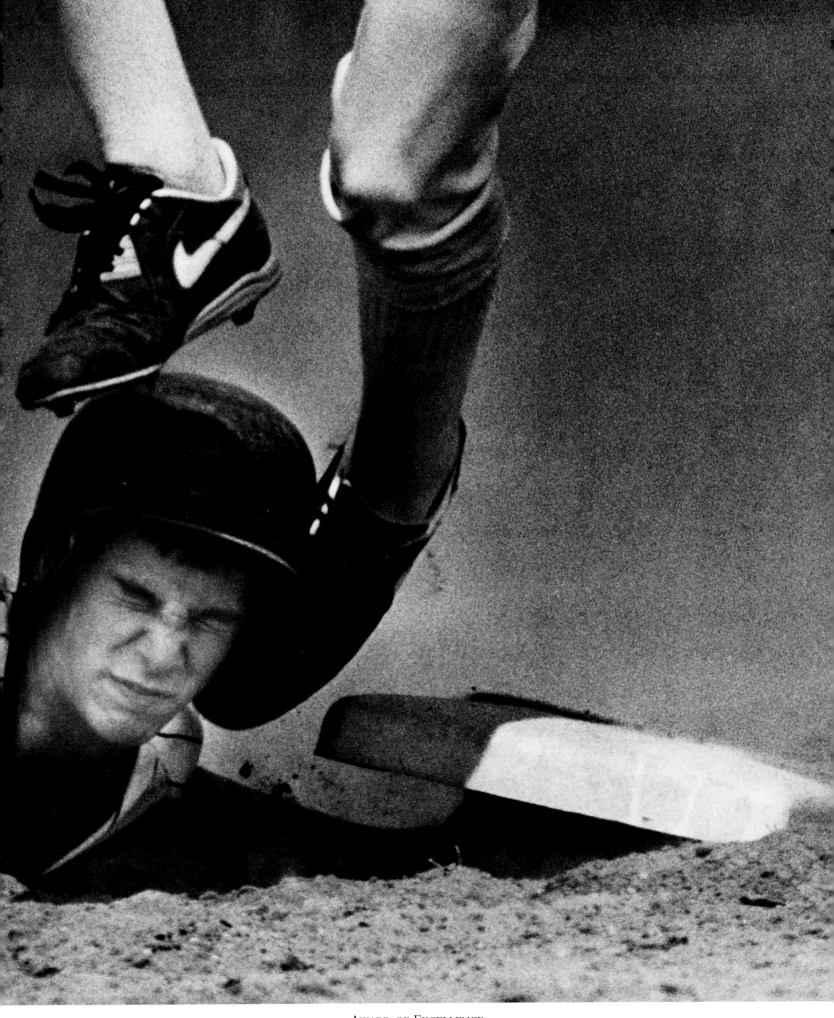

Bill Wade, The Pittsburgh Press
Upper St. Clair's Brian Celedonia slides safely back to second during a pickoff attempt by Ronald Nopwasky of Eastern Greene.
The Pittsburgh-area teams were playing in the Pony League World Series Host Area Tournament.

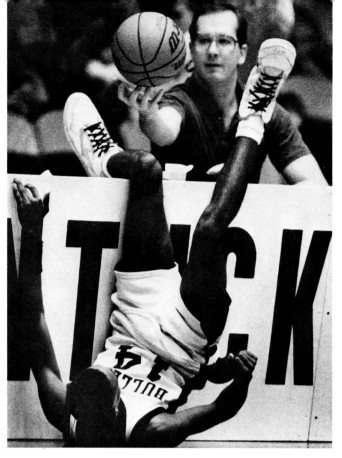

Tim Sharp, Lexington (Ky.) Herald-Leader
Maysville, Ky., basketball player Orlando Myrick slides
into the scorer's table after chasing a loose ball.

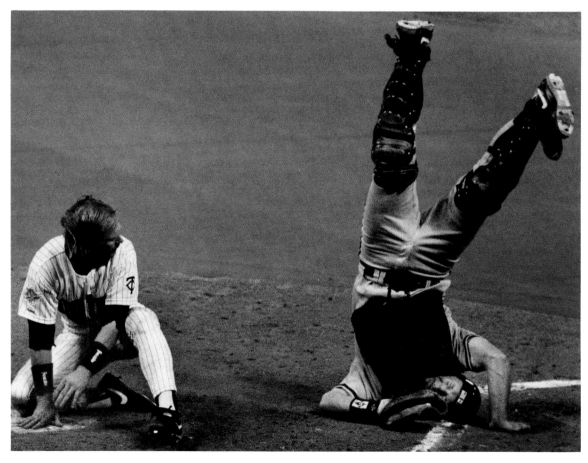

Jonathan Newton, The Atlanta Journal-Constitution
Atlanta Braves catcher Greg Olson flips after colliding with Minnesota Twins runner
Dan Gladden at home plate during the 5th inning of World Series Game 1. Gladden was out.

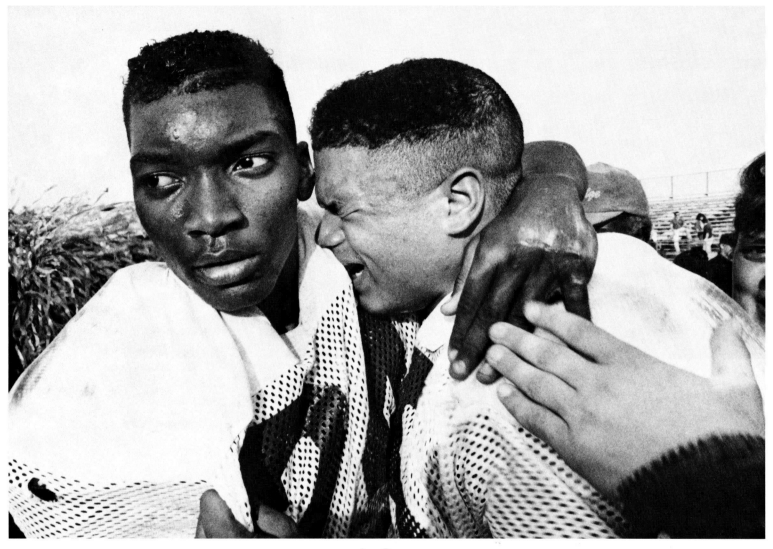

Mark Garfinkel, freelance
After winning a high-school football game dedicated to four teammates who had recently died in a traffic accident,
Lex Thornton (left) and James Rezendes-Ball of Lynn, Mass., share a private moment in the midst of the team's celebration.

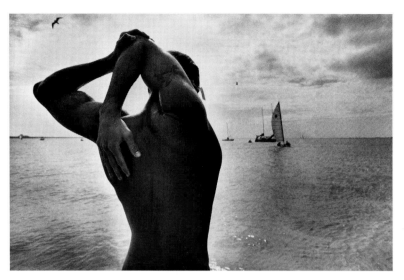

3RD PLACE
Jeffery A. Salter, Miami Herald
Crew member Sergio Rocha of Brazil prepares for the Cup
of Miami sailing race. The race features a "Le Mans start" in
which participants run from the beach, dive into Biscayne Bay
and swim to the sailboat to begin.

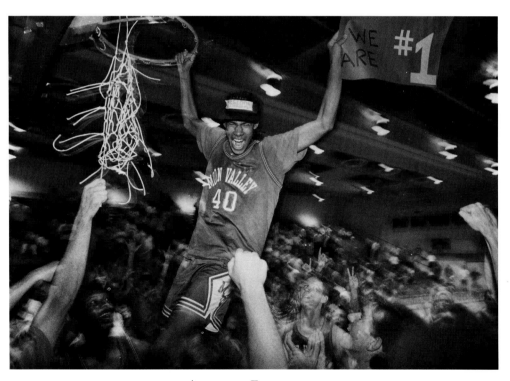

AWARD OF EXCELLENCE
David G. McIntyre, The Phoenix (Ariz.) Gazette
Moon Valley High School basketball player Anthony Ray rejoices after his team
upset sixth-ranked Apollo High School in the Class 5-A Fiesta Region title game
in Phoenix, Ariz.

2ND PLACE
Michael Chow, The Phoenix (Ariz.) Gazette
Arizona State University forward Dwayne Fontana (No. 31) is introduced at the ASU Activity Center before
"Midnight Madness," the school's first basketball practice of the season. It is held at 12:01 a.m. on the first day the team
is allowed to hold practice.

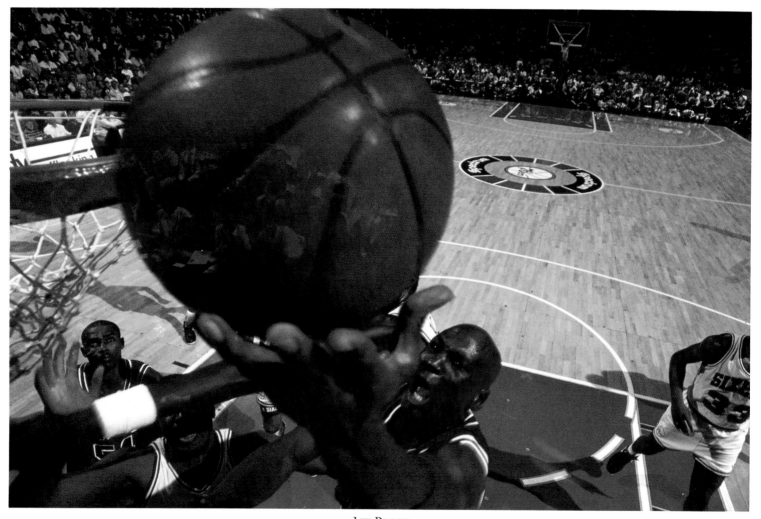

Manny Millan, Sports Illustrated
Michael Jordan of the Chicago Bulls scores against the Philadelphia 76ers during an NBA playoff game in Philadelphia.

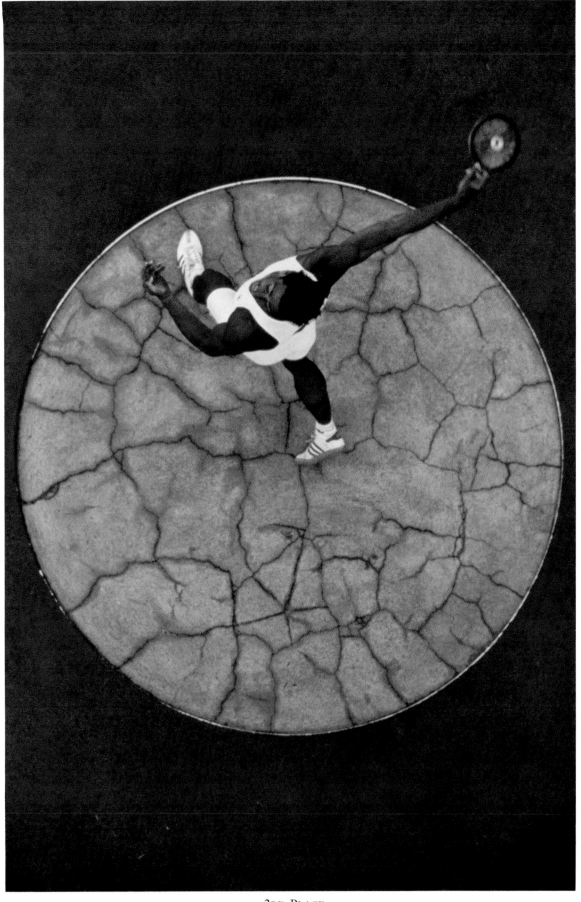

3RD PLACE
Stefan Warter, Sports Illustrated
Decathlete Christian Schenk of Germany practices throwing a discus.

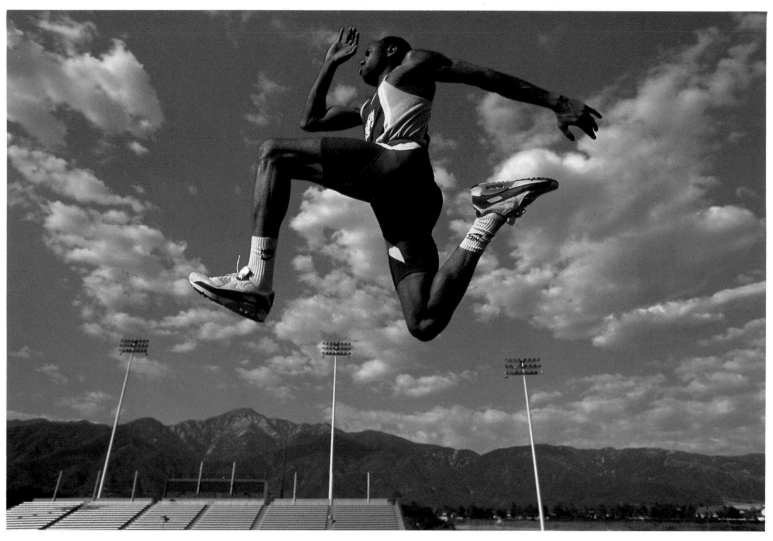

2ND PLACE
Mike Powell, Allsport Photography for Time
Long jumper Mike Powell practices at a track in Rancho Cucamonga, Calif. On Aug. 30, 1991, Powell smashed the standing world record for the long jump with a leap of 29 feet, 4-1/2 inches, at the World Track and Field Championships in Tokyo.

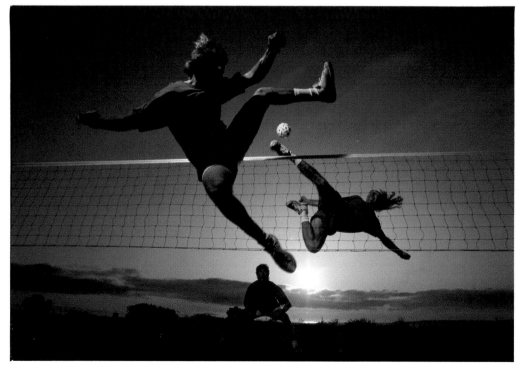

AWARD OF EXCELLENCE
Mike Powell, Allsport Photography
Asian foot volleyball comes to the West.

Ronald Cortes, The Philadelphia Inquirer

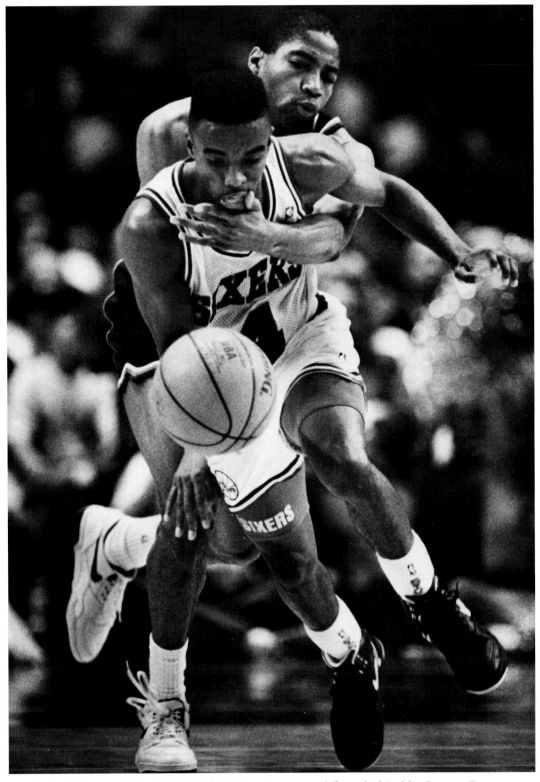

Andre Turner of the Philadelphia 76ers is mugged from behind by Lester Connors of the Milwaukee Bucks during an NBA playoff game.

The Philadelphia Phillies' ground crew holds down a tarp during a game delayed by heavy wind and rain.

During a football game between Penn Charter and Germantown Academy, a group of Penn fans ran through the Germantown sidelines. Good-natured pushing and shoving nearly escalated into violence, but was curtailed before anyone was seriously hurt.

Ronald Cortes, The Philadelphia Inquirer

Three hours before the George Foreman-Evander Holyfield championship bout in Atlantic City, N.J., a solitary fan watches a preliminary match.

The Main Event

On April 19, 1991, heavyweight boxing champion Evander Holyfield defended his title against former champ George Foreman at the Atlantic City Convention Center in New Jersey. Although Foreman, attempting a comeback at age 42, was not expected to win, he surprised fight fans by going the distance with the younger, better-conditioned champion. Holyfield won the 12-round fight by unanimous decision.

Ronald Cortes, The Philadelphia Inquirer

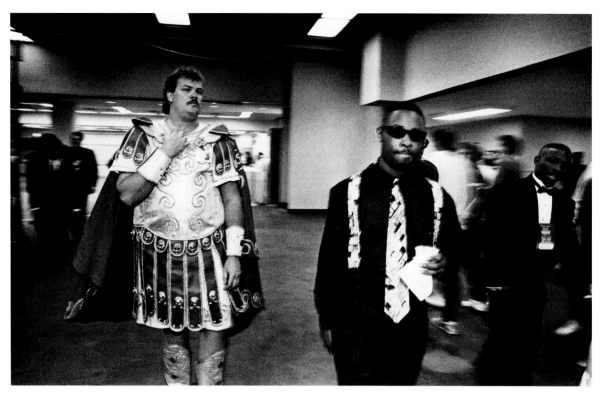

A centurion from Caesar's Palace circulates among fight fans before the heavyweight championship bout.

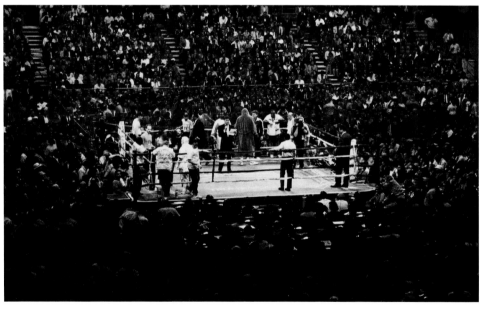

A packed house awaits the start of the Holyfield-Foreman match.

Ronald Cortes, The Philadelphia Inquirer

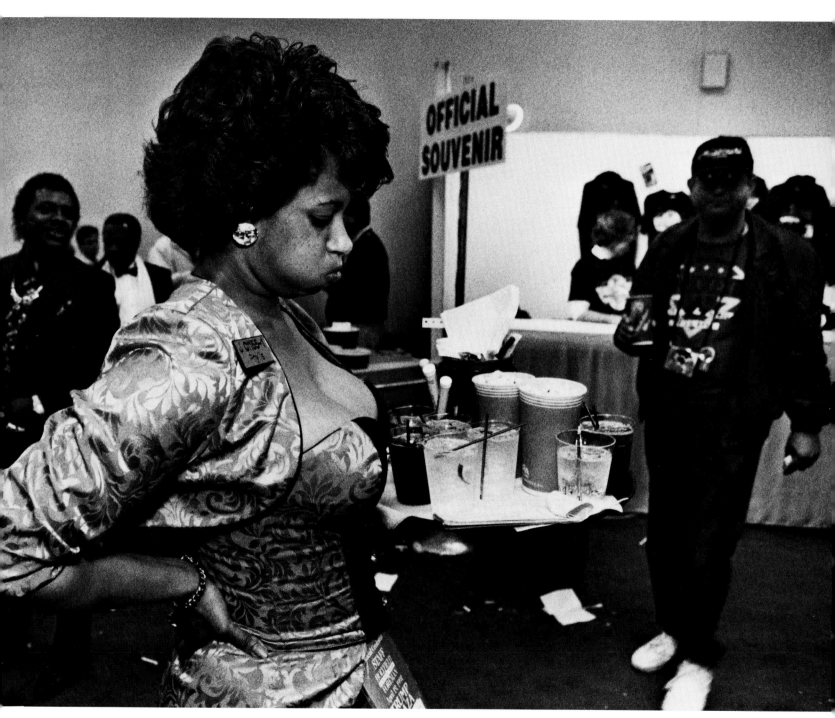

A cocktail waitress serves fans as the start of the fight nears.

Ronald Cortes, The Philadelphia Inquirer

NEWSPAPER SPORTS PORTFOLIO, 1ST PLACE

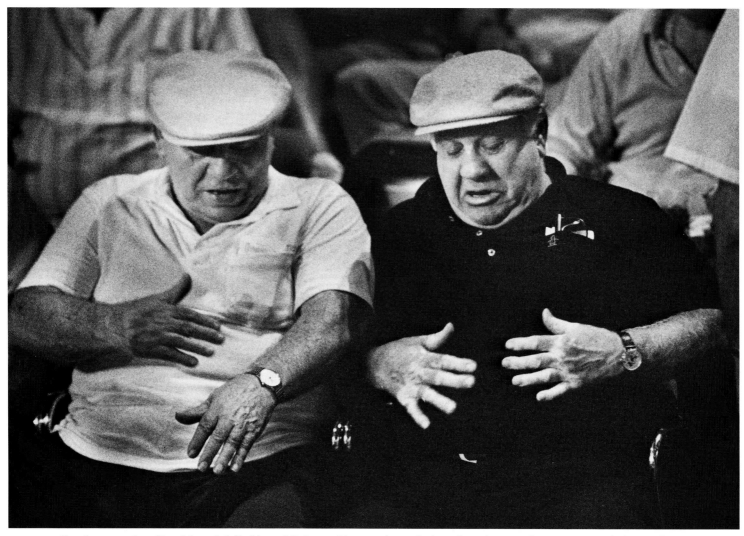

Boxing regulars Pat Mangini (left) and Johnny Forte acknowledge that they no longer are in fighting form.

Ronald Cortes, The Philadelphia Inquirer

NEWSPAPER SPORTS PORTFOLIO, 1ST PLACE

Gerard Michael Lodriguss, The Philadelphia Inquirer

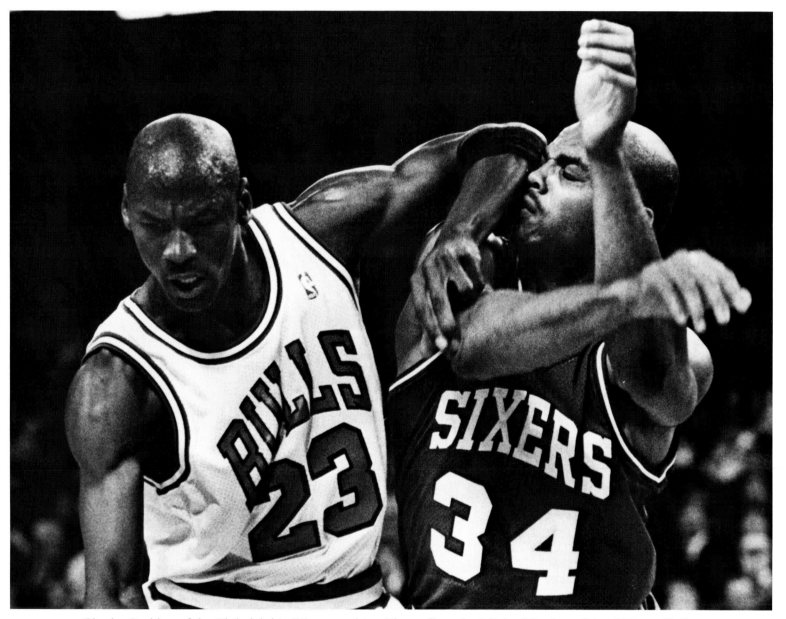

Charles Barkley of the Philadelphia 76ers gets hit with an elbow by Michael Jordan of the Chicago Bulls.

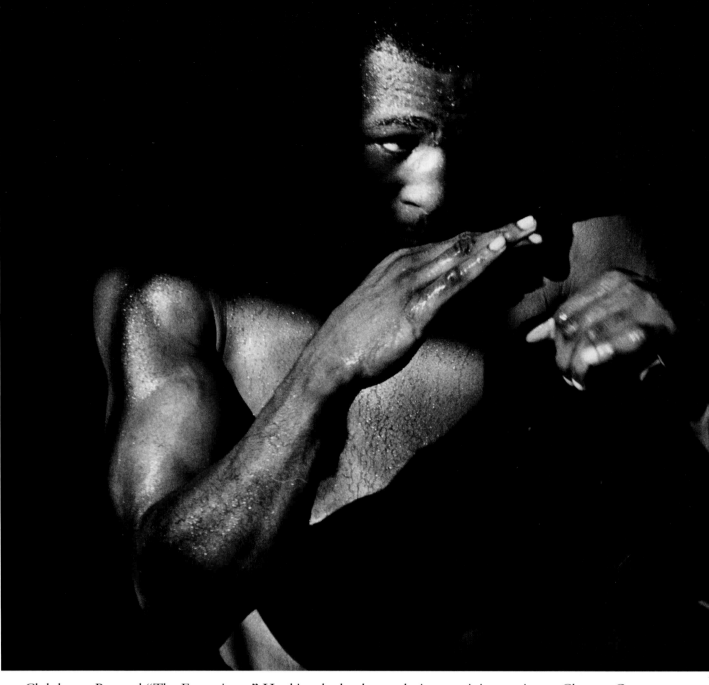

Club boxer Bernard "The Executioner" Hopkins shadowboxes during a training session at Champs Gym.

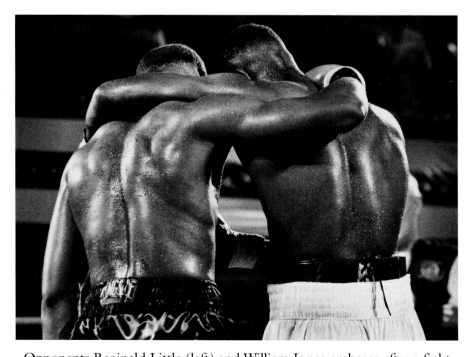

Opponents Reginald Little (left) and William Jones embrace after a fight.

Gerard Lodriguss, The Philadelphia Inquirer

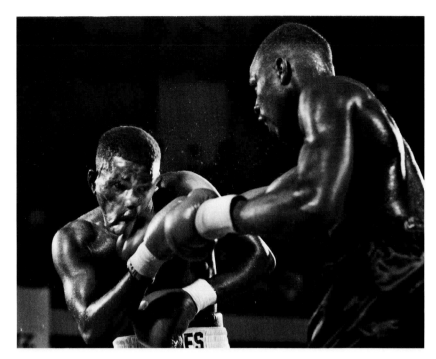

William "The Hammer" Jones takes a punch on the jaw during a bout with Reginald Little at the Blue Horizon Boxing Club in Philadelphia. Jones won the match, maintaining his unbeaten record.

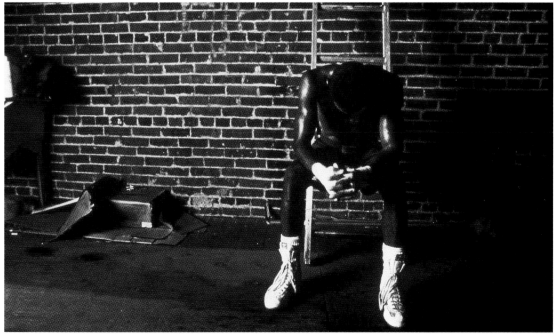

Tony "Dynamite" Green rests after a workout at Champs Gym in Philadelphia.

Gerard Lodriguss, The Philadelphia Inquirer

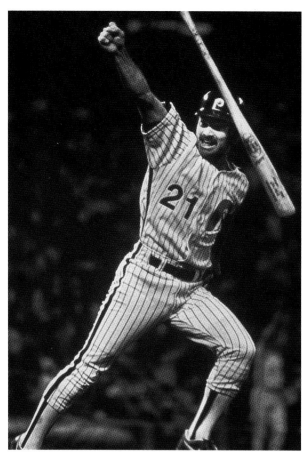

Dickie Thon of the Philadelphia Phillies is
jubilant after hitting a two-run home run to beat
the Pittsburgh Pirates.

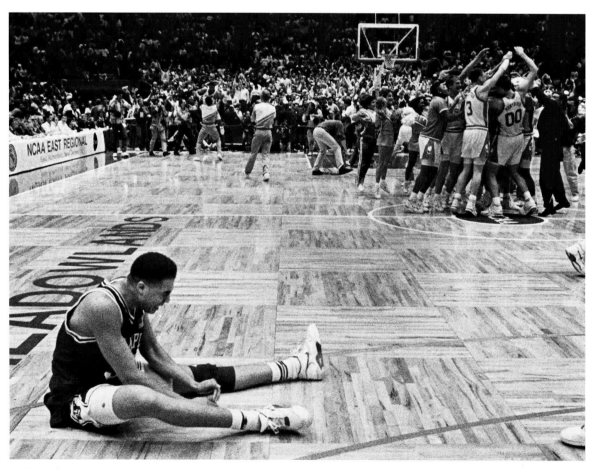

Temple University's Donald Hodge sits dejectedly on the court as North Carolina celebrates in
the background. North Carolina beat Temple in the NCAA Eastern Regional finals.

Gerard Lodriguss, The Philadelphia Inquirer

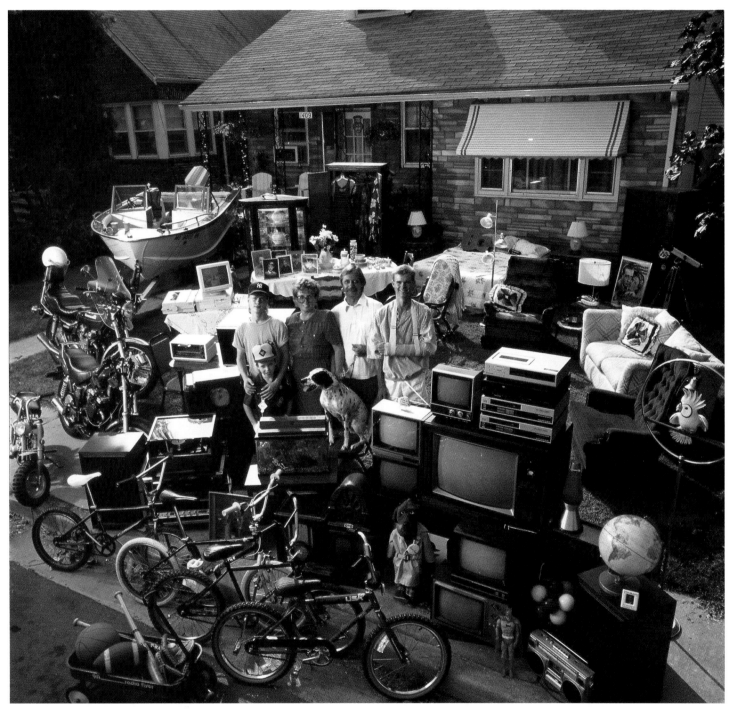

3RD PLACE
John Abbott, freelance for Fortune
The Bouxsein family agreed to gather their possessions in their yard to illustrate "How the average American lives."

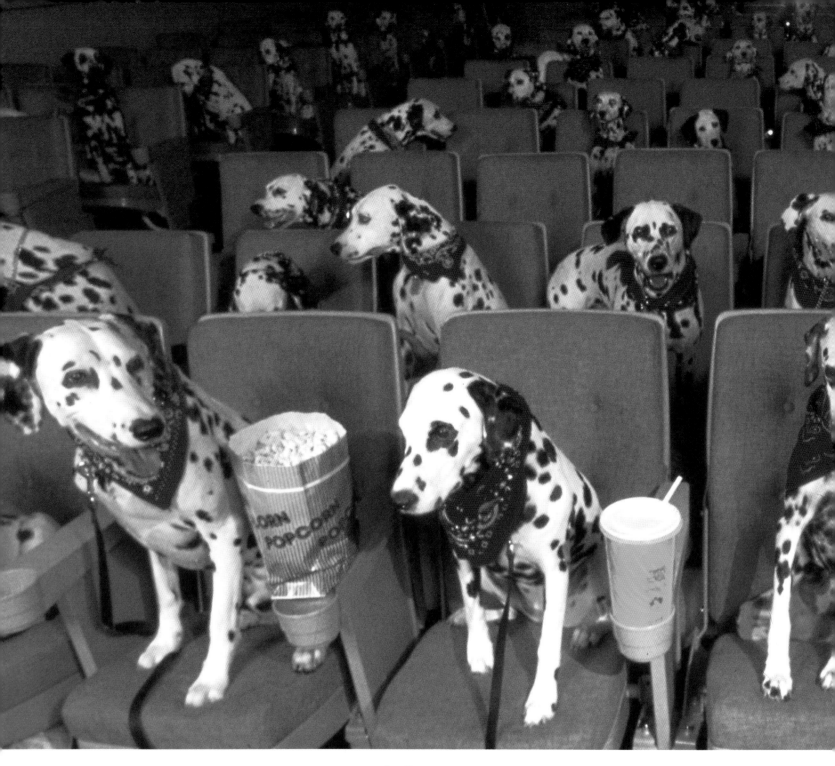

Melanie Rook D'Anna, Mesa (Ariz.) Tribune
Dog day at the movie *101 Dalmatians.*

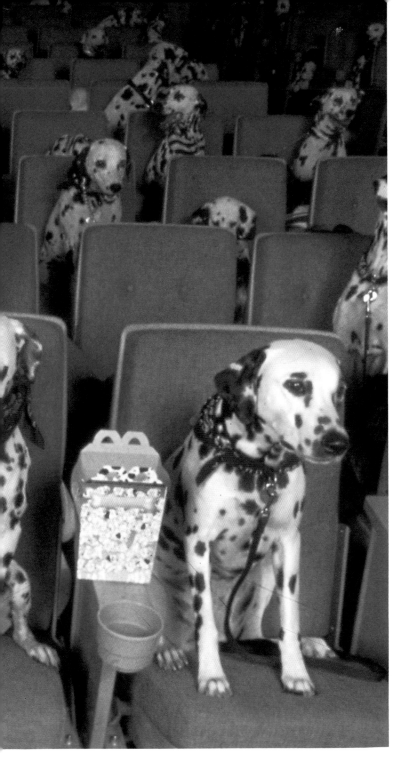

2ND PLACE
Pat McDonogh, Quill Magazine
Multiculturalism in the news business.

AWARD OF EXCELLENCE
Red Huber, The Orlando (Fla.) Sentinel
A "mermaid" for the Weeki Wachee show in Florida models a new swimsuit.

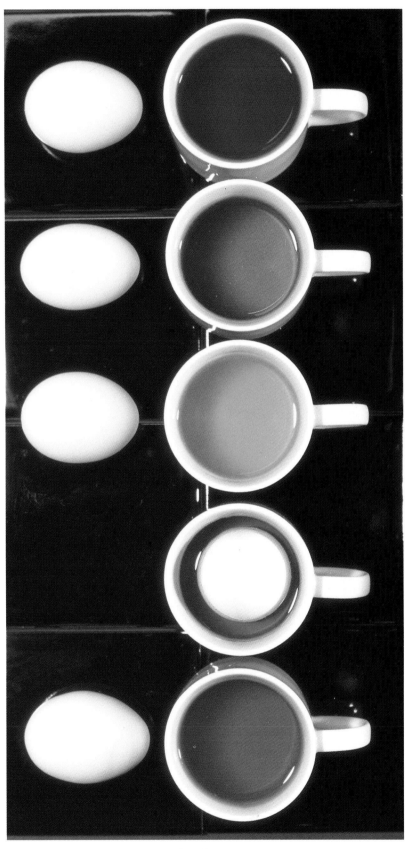

3RD PLACE
Kevin Swank, The Evansville (Ind.) Courier
Eggs of a different color.

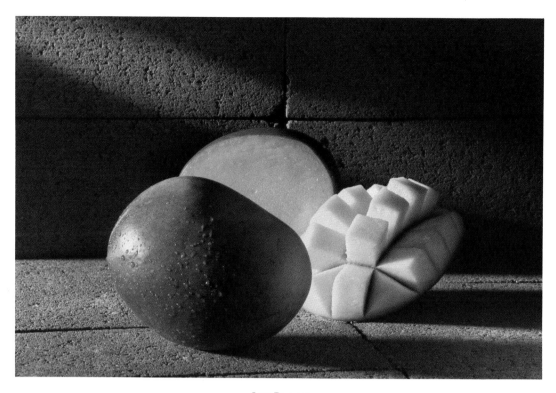

1ST PLACE
Peter Battistoni, Vancouver (B.C.) Sun
Mango magic.

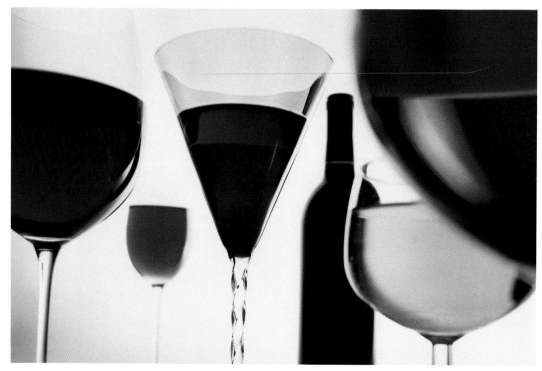

2ND PLACE
John Luke, Detroit Free Press
Glasses of wine.

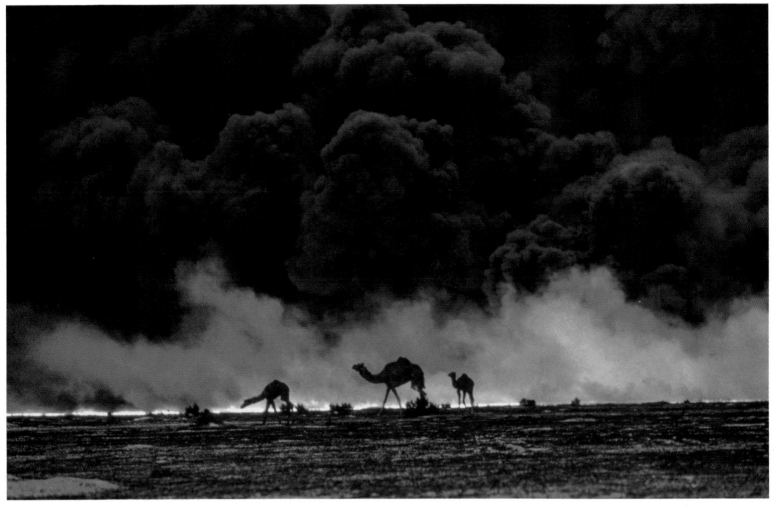

1ST PLACE
Steve McCurry, National Geographic
Camels search for untainted shrubs and water in the burning oil fields of southern Kuwait after the Persian Gulf war.

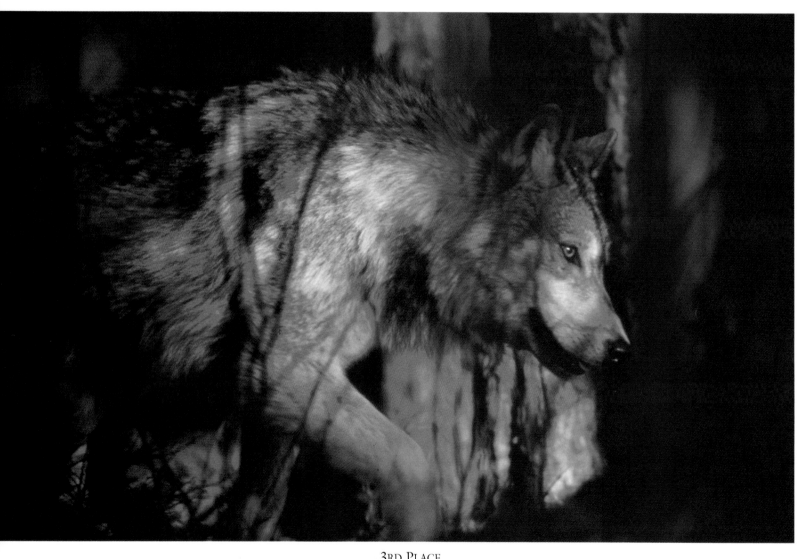

Jim Brandenburg, National Geographic
The grey wolf is considered the spirit of the forest by some Native Americans.

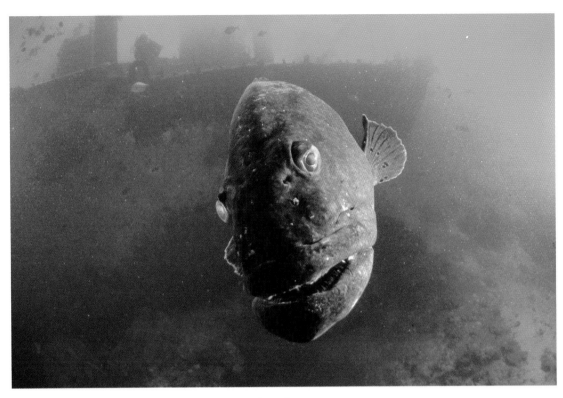

2ND PLACE
David Doubilet, National Geographic
A 150-pound black cod lives in a sunken Japanese fishing ship at Middleton Reef,
150 miles north of Lord Howe Island.

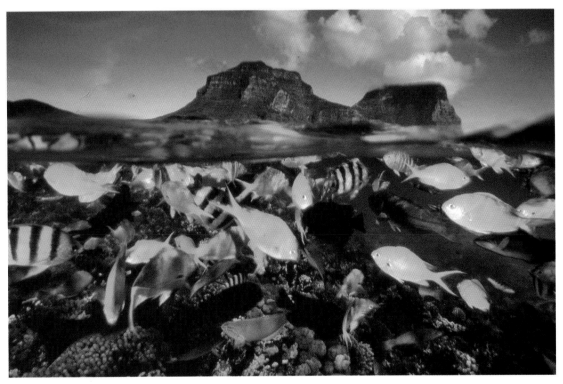

AWARD OF EXCELLENCE
David Doubilet, National Geographic
Fish swim in a lagoon at Lord Howe Island, 300 miles east of New South Wales, Australia.

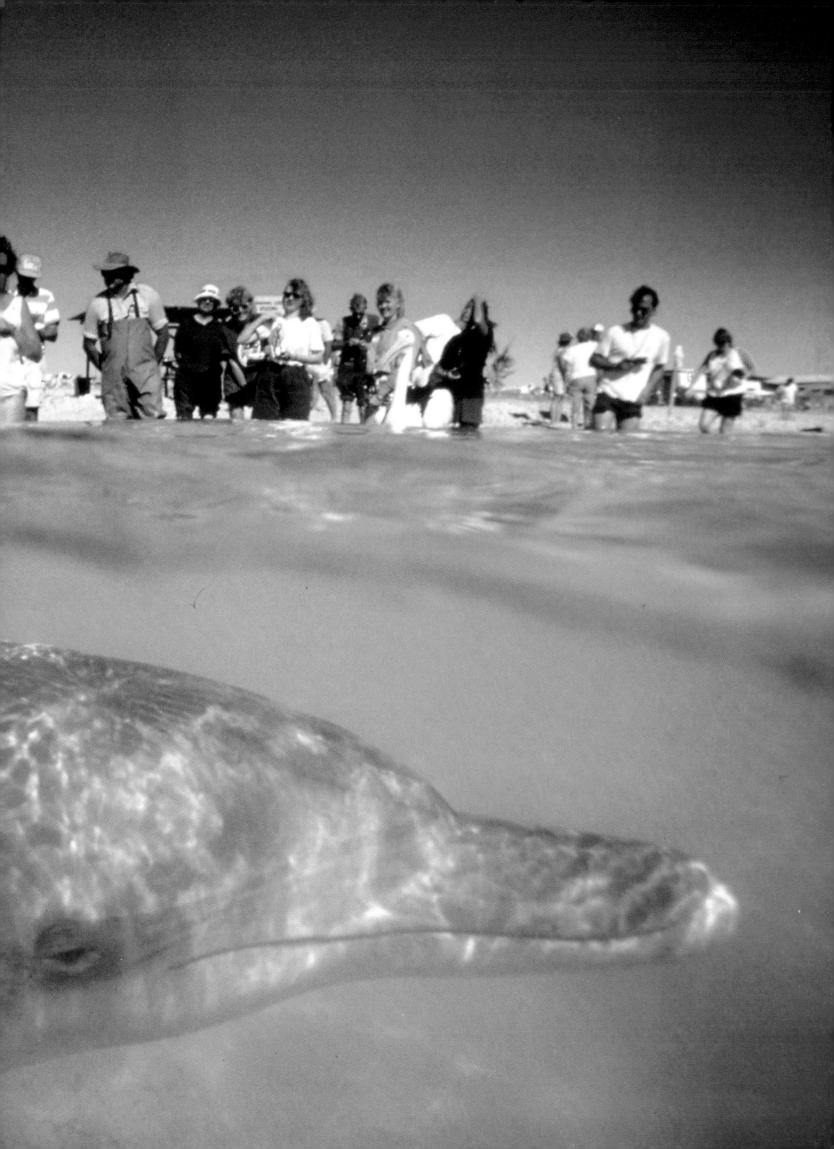

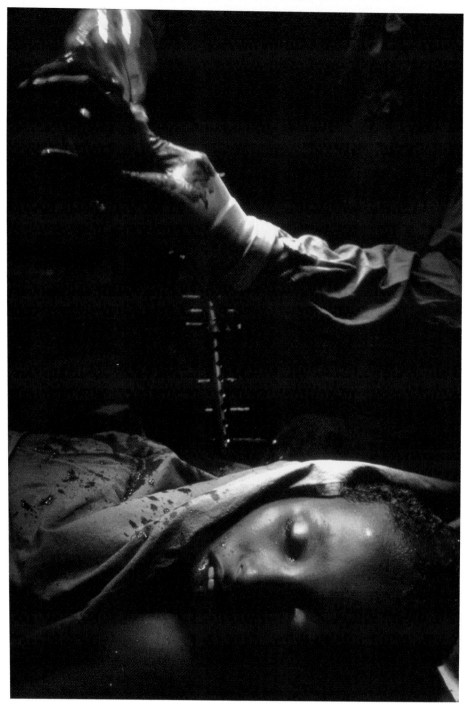

Frank Fournier, Contact Press Images
Dr. Pierre Bernard-Griffiths of the international relief organization Doctors
Without Borders works to save the arm of a child in Mogadishu, Somalia. The
child was wounded by a bullet during violence that followed the ouster of
dictator Mohammed Siad Barre.

Previous page:
David Doubilet, National Geographic
A dolphin swims near people at Monkey Mia, a
fishing community in Shark Bay, Western Australia.

Anthony Suau, Black Star for TIME Magazine

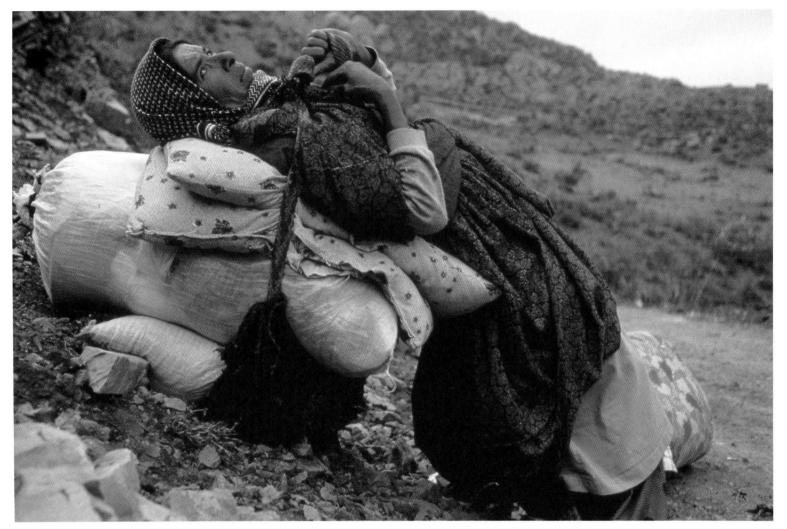

A Kurdish woman takes a break from her arduous journey to the mountain camp at Isikveren, Turkey.

Kurdish Saga

At the end of the Persian Gulf war, ethnic Kurds living in Iraq rebelled against President Saddam Hussein, believing allied troops would support their effort. With no outside help, the rebellion soon was defeated by soldiers loyal to Saddam. More than 1 million Kurds fled Iraq, some to the Iranian border and others to the Turkish border. But the Turkish government did not want the huge mass of people and would not allow the refugees farther than border camps. Conditions in the refugee camp at Isikveren, Turkey, were deplorable, and thousands died before Turkish President Turgut Ozal relented his position and moved the refugees farther into his country, where they could be cared for.

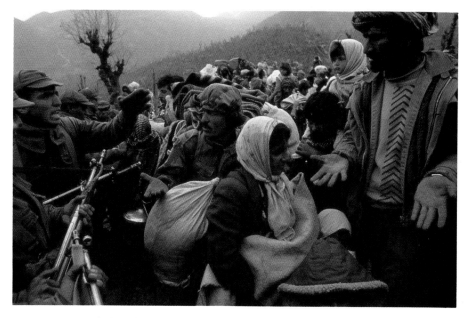

Kurdish refugees are kept in a camp by Turkish soldiers.
Harsh conditions at Isikveren (below) made it difficult to survive.

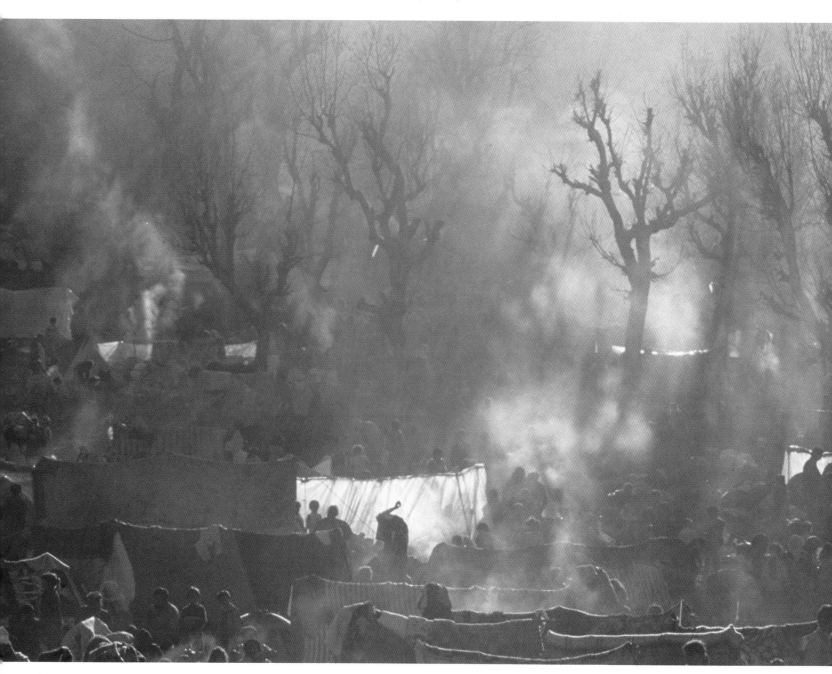

Anthony Suau, Black Star for Time

MAGAZINE PICTURE STORY, 1ST PLACE

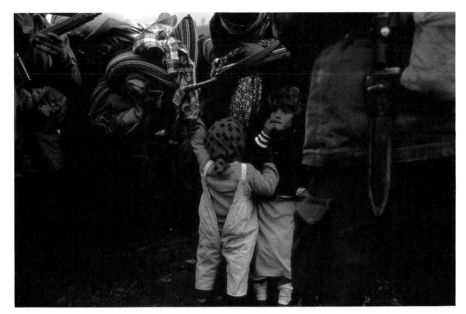

Compounding the miseries of the refugees was the harsh treatment they received from Turkish soldiers.

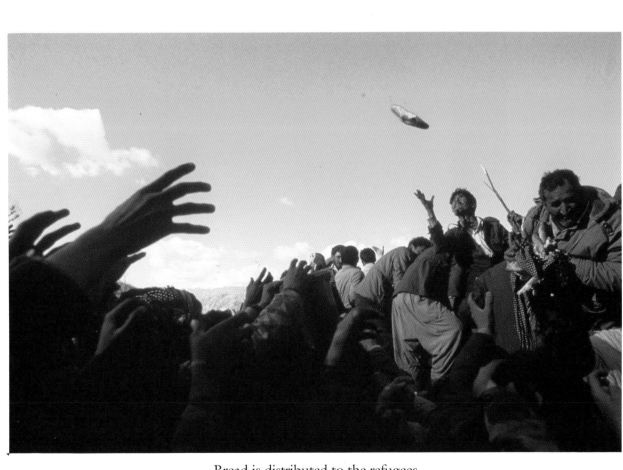

Bread is distributed to the refugees.

Anthony Suau, Black Star for Time

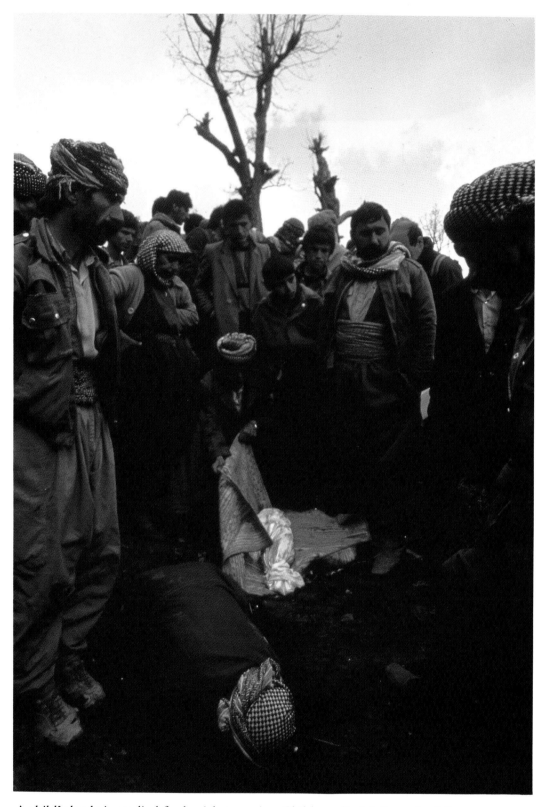

A child's body is readied for burial at sunrise. Children died daily at the Isikveren camp.

Anthony Suau, Black Star for Time

MAGAZINE PICTURE STORY, 1ST PLACE

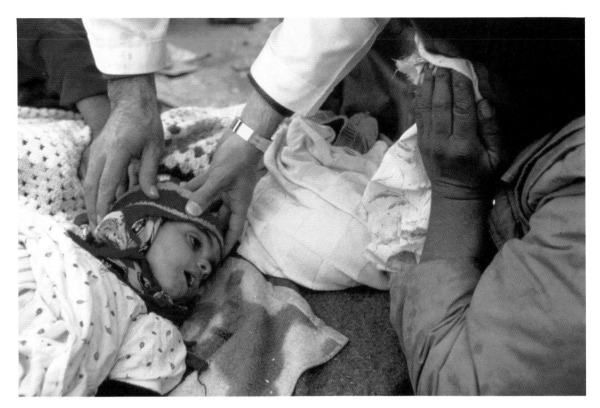

A doctor pronounces a child dead in front of her mother at the camp.

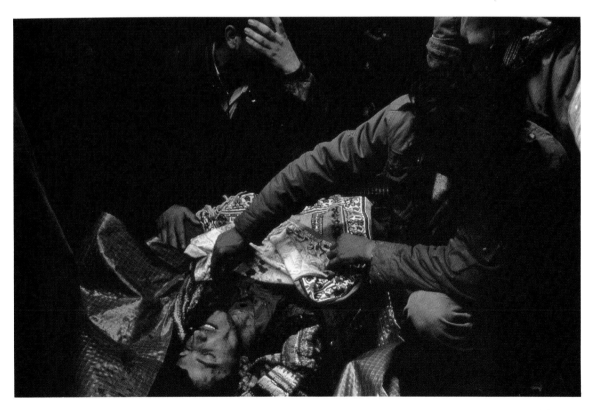

A Kurdish father sees his dead son moments after he was shot in the neck by Turkish soldiers while fighting for food dropped by British relief planes.

Anthony Suau, Black Star for Time

MAGAZINE PICTURE STORY, 1ST PLACE

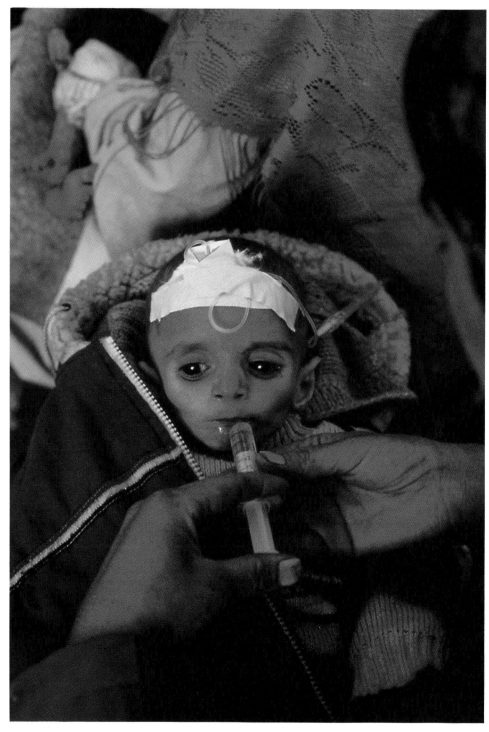

A Kurdish child is treated for dehydration.

Anthony Suau, Black Star for Time

Christopher Morris, Black Star for TIME Magazine

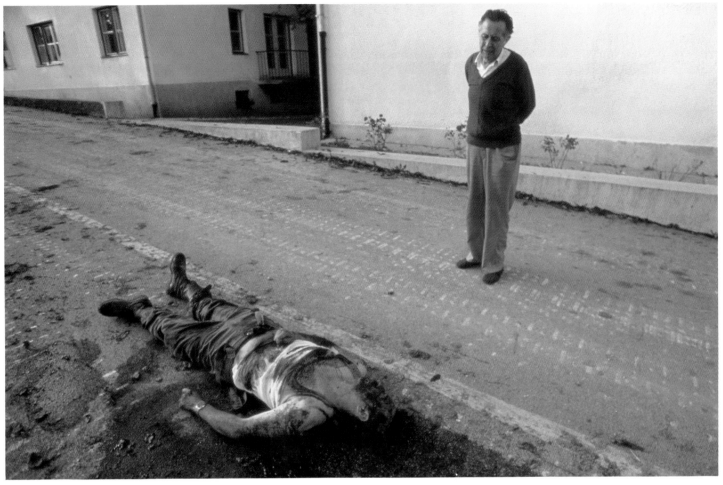

A resident of Bjelovar, Croatia, stares at the body of a Yugoslav army commander who was executed by Croatian soldiers.

Civil War in Croatia

On June 25, 1991, Croatia and Slovenia declared independence from Yugoslavia. Ethnic Serbs living in Croatia were opposed to the move, and fighting soon broke out. In the clashes that followed between Croatian militias, ethnic Serbs and Yugoslav federal troops, thousands of people died.

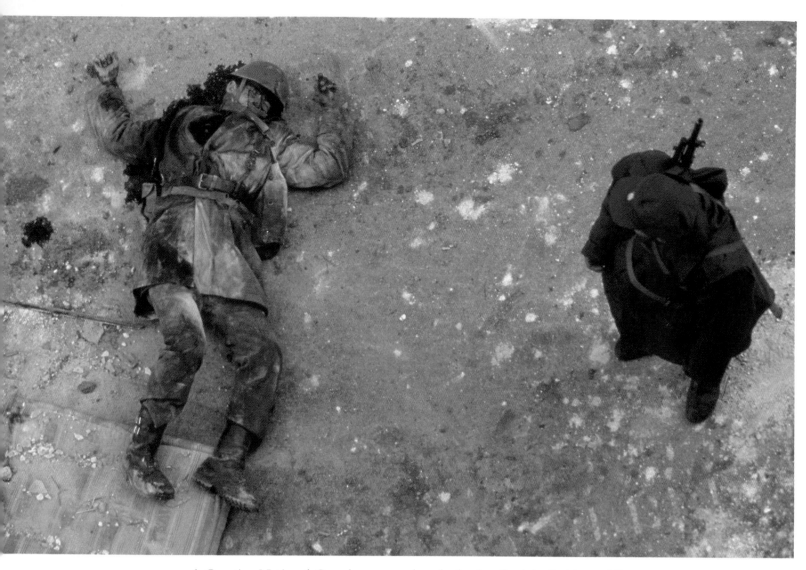

A Croatian National Guardsman watches the body of a slain Serbian soldier.
Two Croatian soldiers (below) battle Serbian snipers in the village of Borovo.

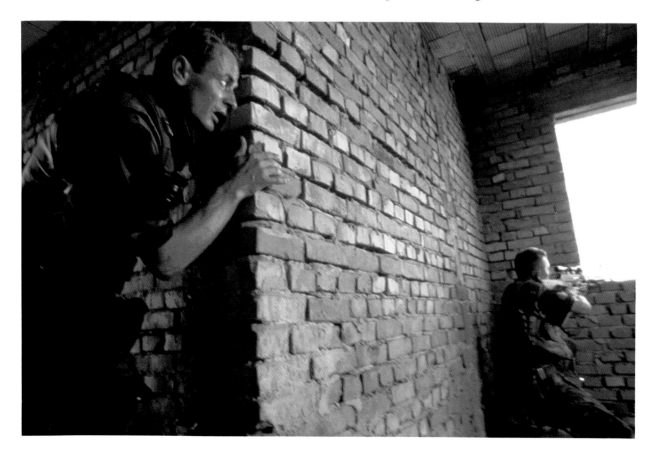

Christopher Morris, Black Star for Time

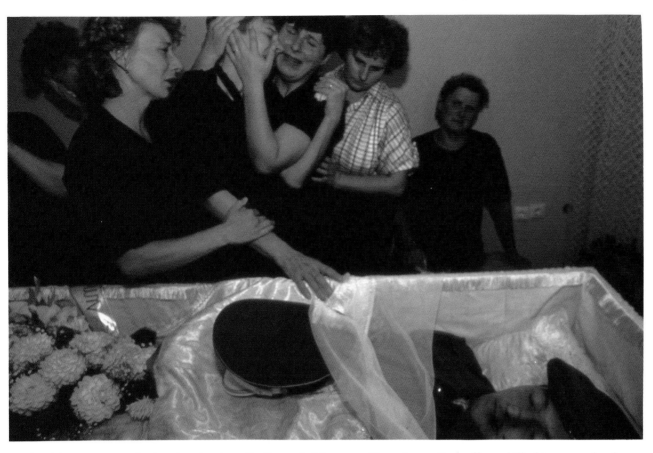

A widow mourns during her husband's funeral. He was a Croatian police officer, killed in an ambush.

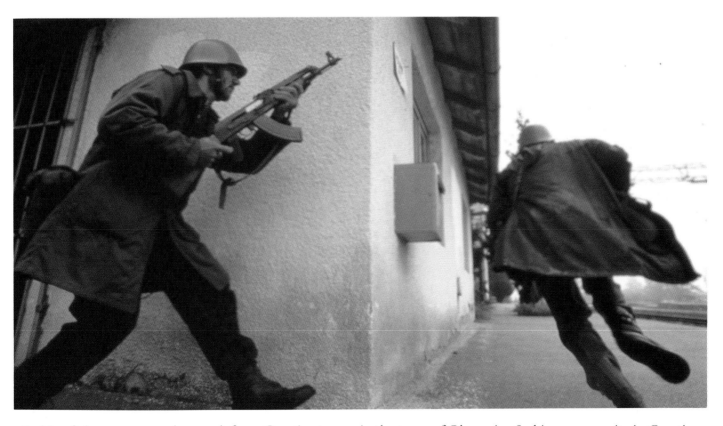

Serbian fighters come under attack from Croatian troops in the town of Okucani, a Serbian community in Croatia.

Christopher Morris, Black Star for Time

A priest talks to a young Croatian fighter before he leaves for duty.

Christopher Morris, Black Star for Time

Eugene Richards, Magnum Photos

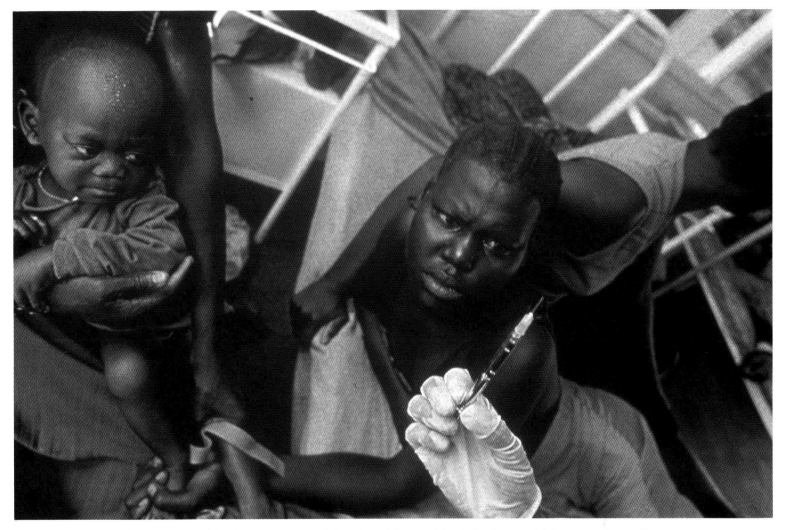

Arsenic is used in the treatment of sleeping sickness. The injections, which cause discomfort and sometimes death, are greatly feared.

Sleeping Sickness

Once called the "Pearl of Africa" by Winston Churchill, Uganda has become a nightmare of poverty and ruin. Per capita income is less than $300 per year. Proper health care is lacking, and the life expectancy is only 53 years. Endemic to the area is sleeping sickness, an often fatal disease transmitted by the tsetse fly. In 1980, Doctors Without Borders began lending medical assistance to the country, and the hospital in Moyo now is the largest treatment center in Africa for sleeping sickness.

At Moyo Hospital, medical students perform surgery under the
supervision of a certified physician.

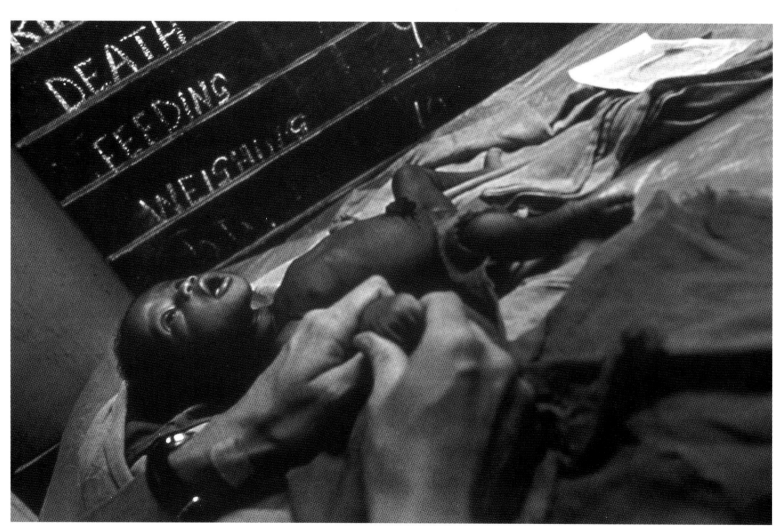

An infant suffering from malnutrition and sleeping sickness is treated in the pediatrics ward.

Eugene Richards, Magnum Photos

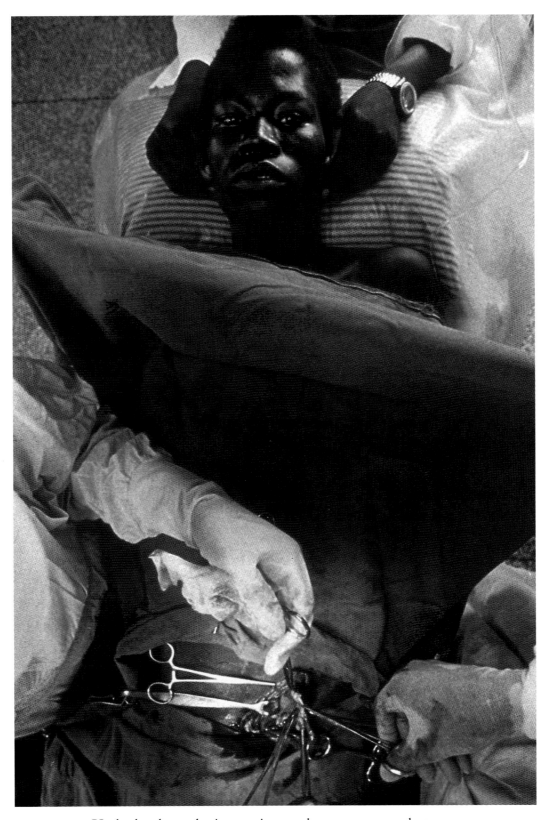

Under local anesthesia, a patient undergoes an appendectomy.

Eugene Richards, Magnum Photos

MAGAZINE PICTURE STORY, 3RD PLACE

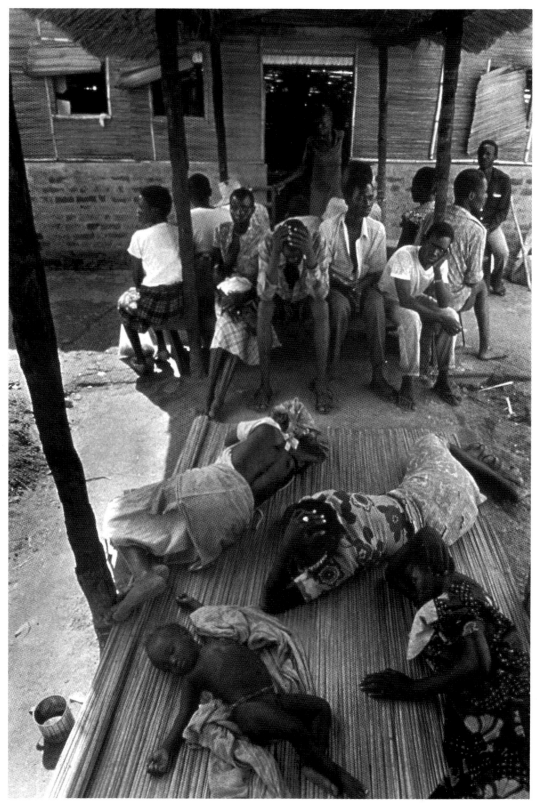

At the entrance to the sleeping-sickness ward of Moyo Hospital, patients wait for blood tests and treatment.

Eugene Richards, Magnum Photos

MAGAZINE PICTURE STORY, 3RD PLACE

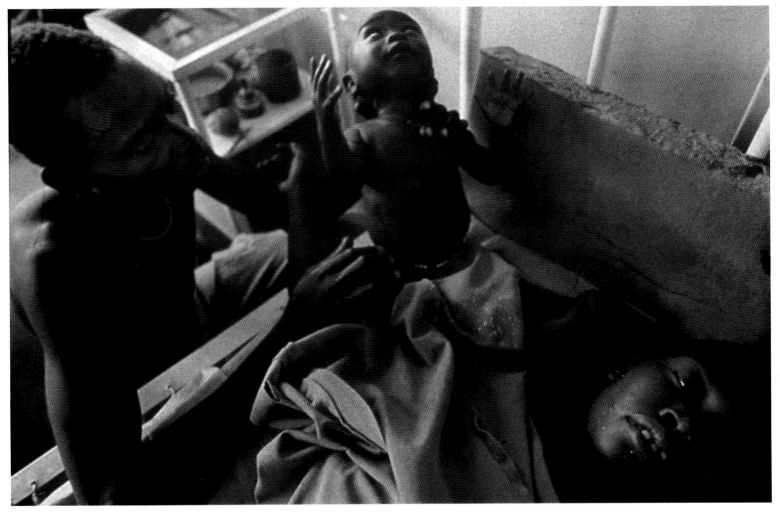

<div align="center">

1ST PLACE
Eugene Richards, Magnum Photos
At Moyo Hospital in Uganda, the mother of a 2-month-old suffers from meningitis and sleeping sickness.
Her husband visits with her 10 hours a day, bringing food from home.
(A photo by Eugene Richards won 2nd Place in this category. It is part of a photo essay and is shown on page 122.)

</div>

Following Page:
3RD PLACE
Sebastiao Salgado, Magnum for
The New York Times Magazine
Workers in a Kuwait oil field install
a new wellhead that will enable
them to inject a mudlike mixture
into a well to "kill" the fire.

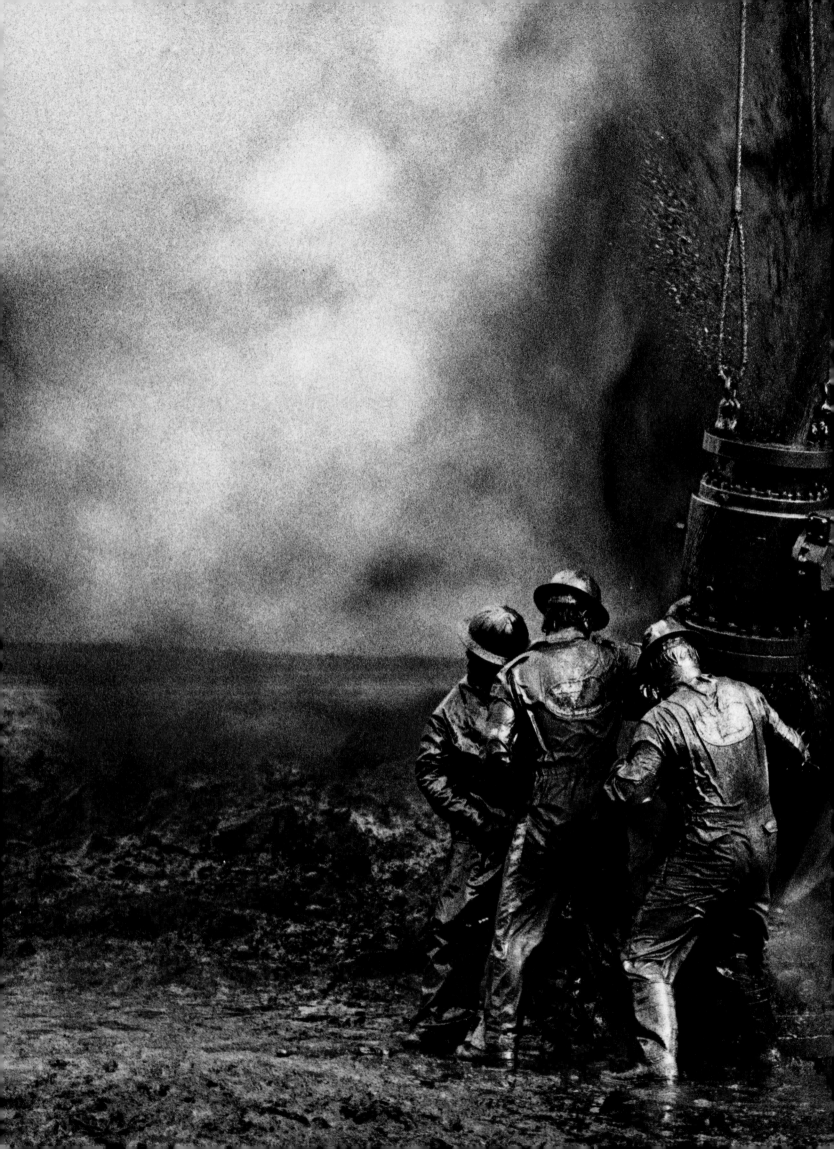

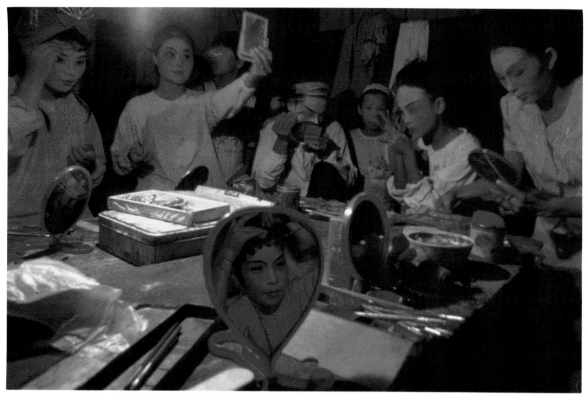

James L. Stanfield, National Geographic
Actors prepare to perform in the Quanzhou Chinese Opera.

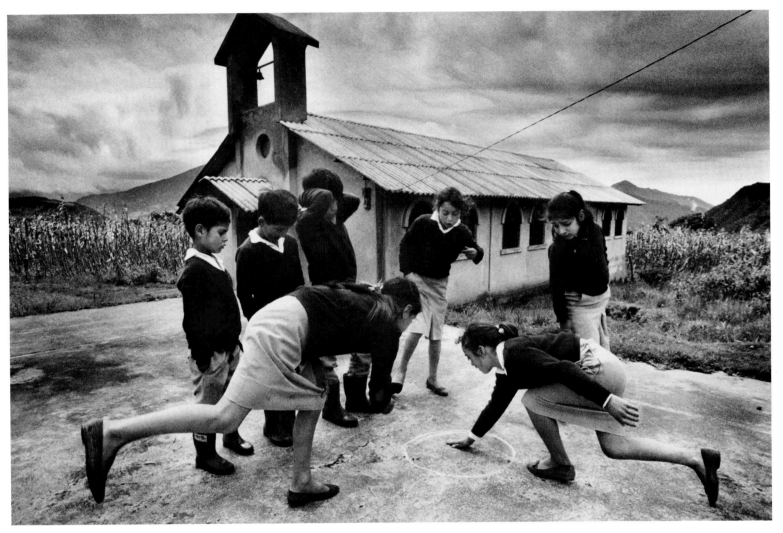

Candace B. Barbot, The Miami Herald
Village schoolchildren in Ecuador play a coin-toss game during recess.

3RD PLACE
Suzanne Kreiter, The Boston Globe
Mentally retarded adults, residents of a care home in Arlington, Mass., play basketball
in a neighborhood park.

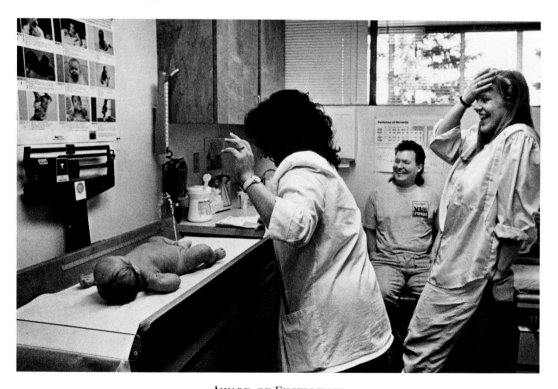

AWARD OF EXCELLENCE
Jim Bates, Seattle Times
Nurse Velma Riling steps out of the way as 6-week-old Matthew Marlow catches
everyone by surprise during a routine exam at the Community Health Center for
Snohomish County, Wash. Also present are Matthew's parents, Veronica De Gier
and Ed Marlow.

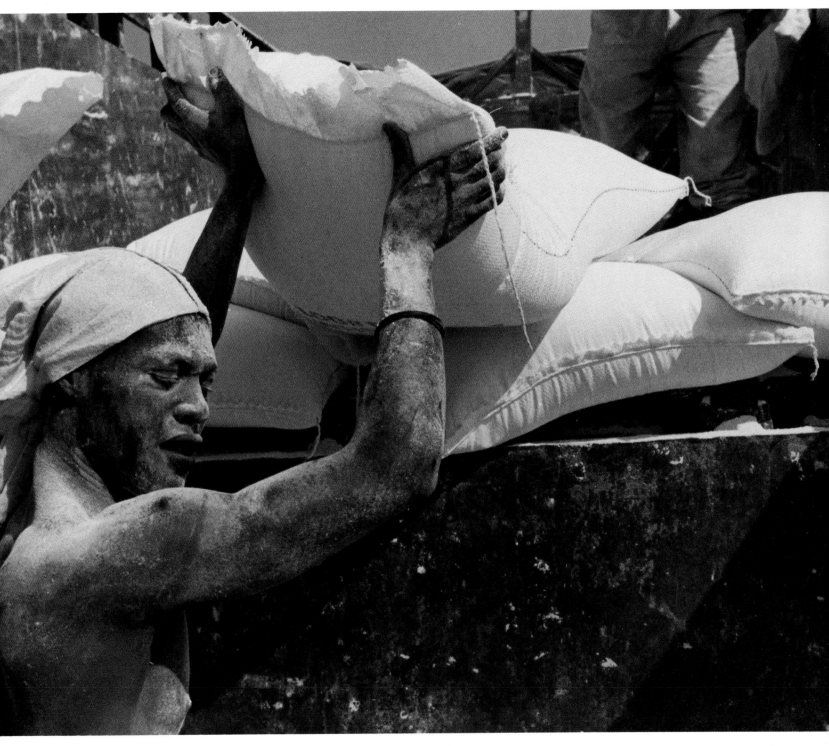

John Moore, The Associated Press
A worker for a flour-distribution company in Port-au-Prince, Haiti, unloads cargo.

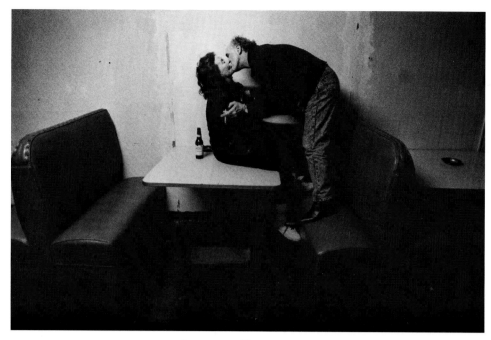

AWARD OF EXCELLENCE
Brian Plonka, Beaver County (Pa.) Times
Bob and Jane Jenkins make themselves at home in the Freedom, Pa., Hotel.

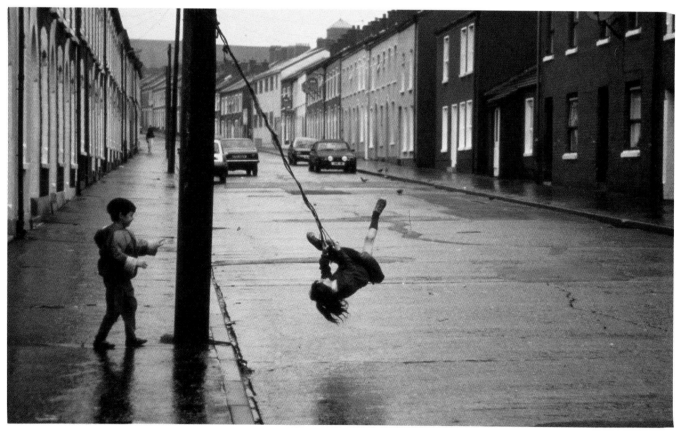

AWARD OF EXCELLENCE
R. Norman Matheny, The Christian Science Monitor
Children in Belfast, Northern Ireland, swing from a cord on a power-line pole.

Rod Mar, Seattle Times

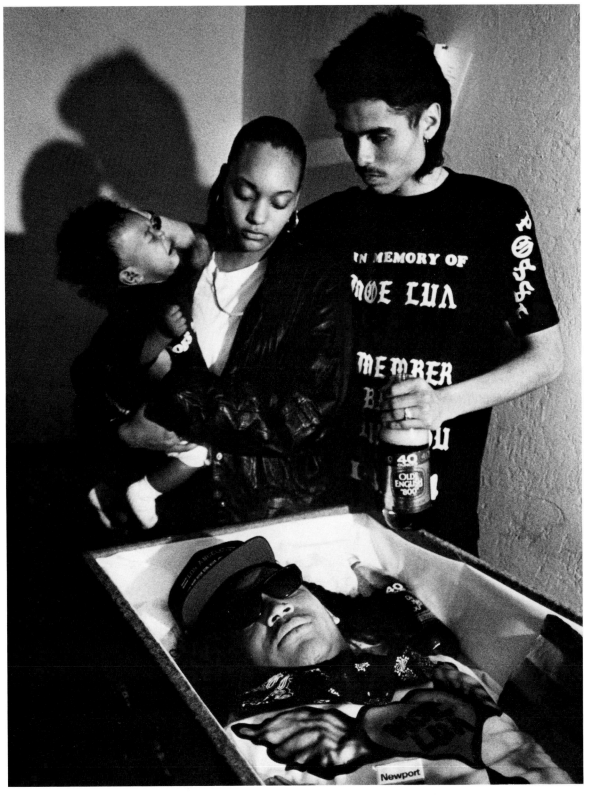

A family grieves for 17-year-old Moe Sterling, a gang member who was the victim of a drive-by shooting in Seattle.

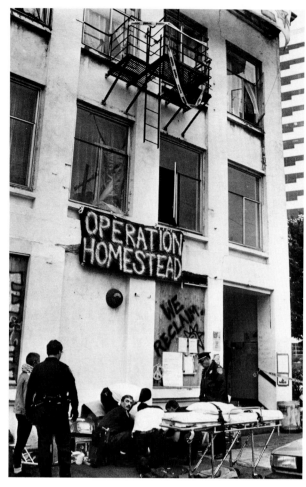

Paramedics assist a transient who fell from the third floor of the Arion Building in Seattle after homeless people took over the vacant structure.

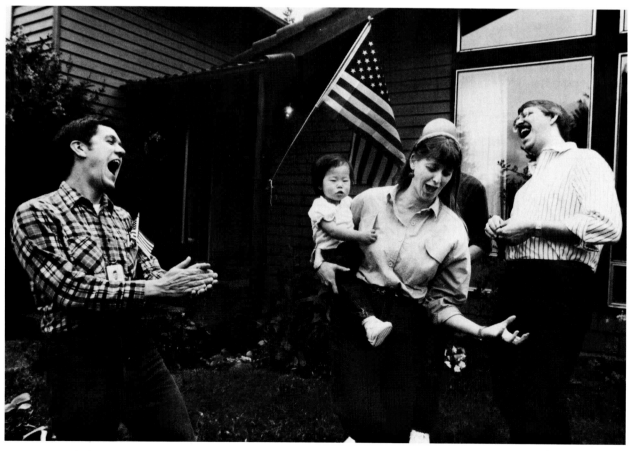

Joe Gregg (left), a Navy reservist who was called to duty during the Persian Gulf war, returns to find that his neighbors painted his house.

Rod Mar, Seattle Times

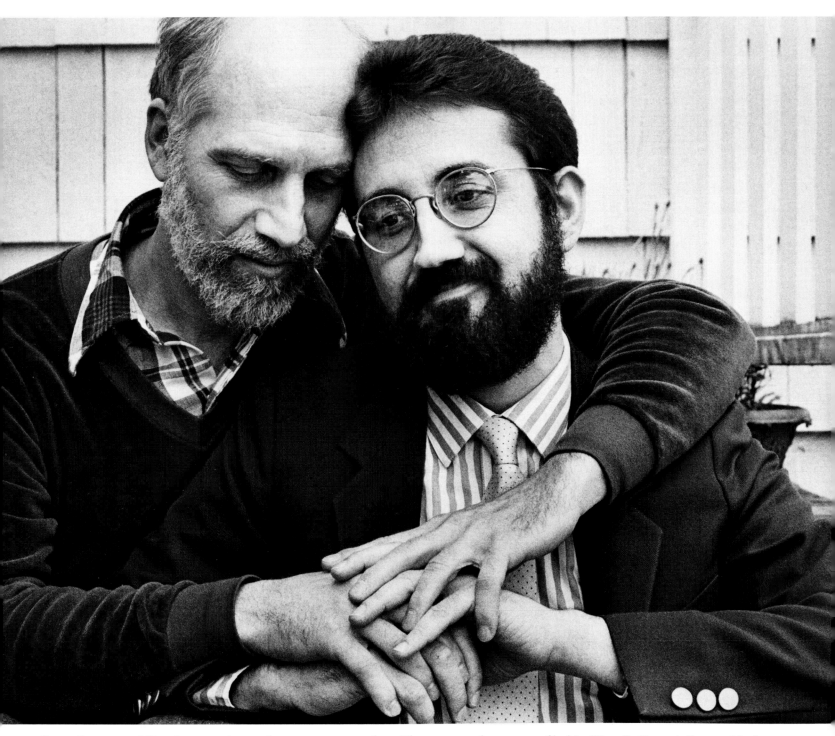

Steve Bryant and Demian spend a tender moment together. The gay couple were profiled in "Family Portrait," a weekly feature of the *Seattle Times*.

Rod Mar, Seattle Times

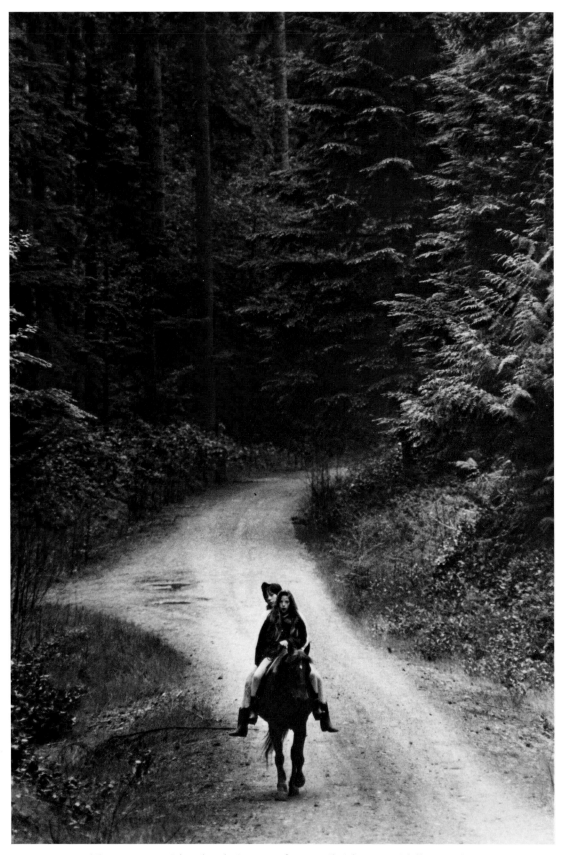

Two young girls take their pony for a trail ride near Olalla, Wash.

Rod Mar, Seattle Times

NEWSPAPER ONE WEEK'S WORK, 1ST PLACE

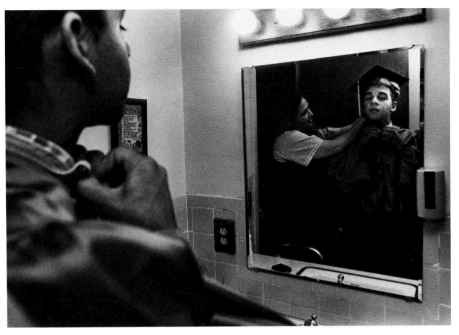

With a little help from his mother, home-schooled student John Lindsey
prepares for his high-school graduation.

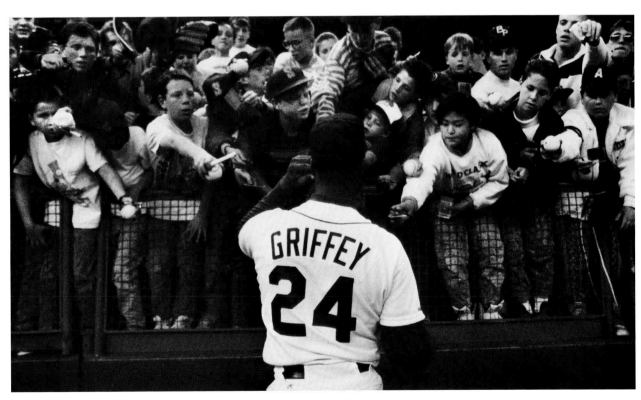

Baseball superstar Ken Griffey Jr. signs autographs before a Seattle Mariners game at the Kingdome.

Rod Mar, Seattle Times

Ruben Perez, The Providence Journal-Bulletin

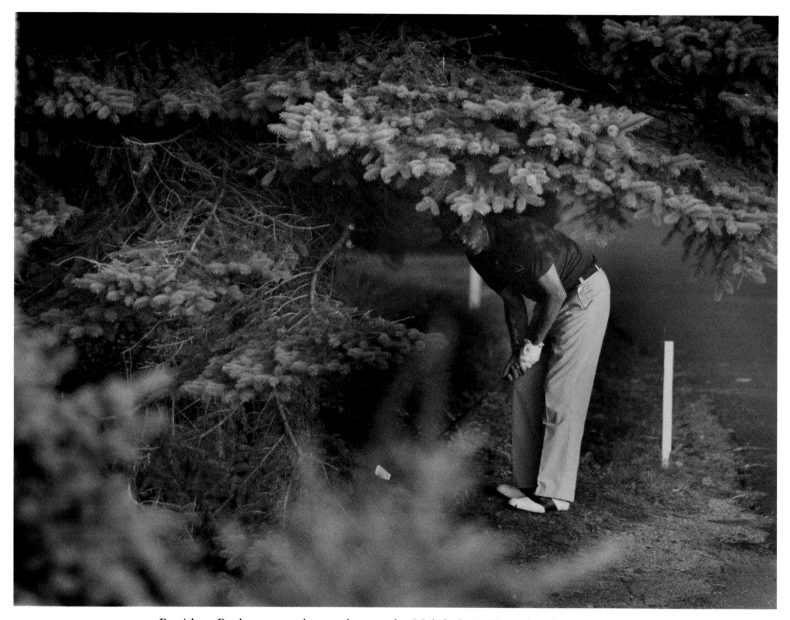

President Bush contemplates a shot on the 18th hole in Kennebunkport, Maine.

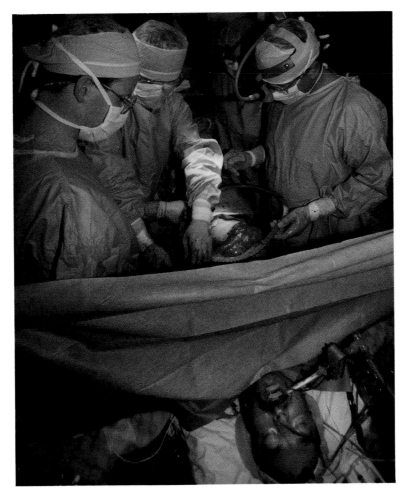

Doctors perform surgery in Providence, R.I.

Students in a scuba-diving class take their first open-water dive.

Ruben Perez, The Providence (R.I.) Journal-Bulletin

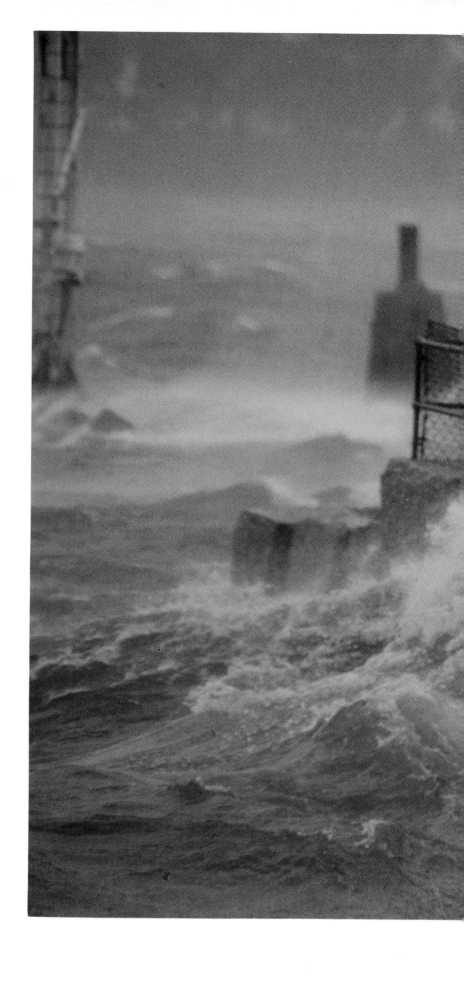

Ruben Perez, The Providence (R.I.) Journal-Bulletin

NEWSPAPER ONE WEEK'S WORK, 2ND PLACE

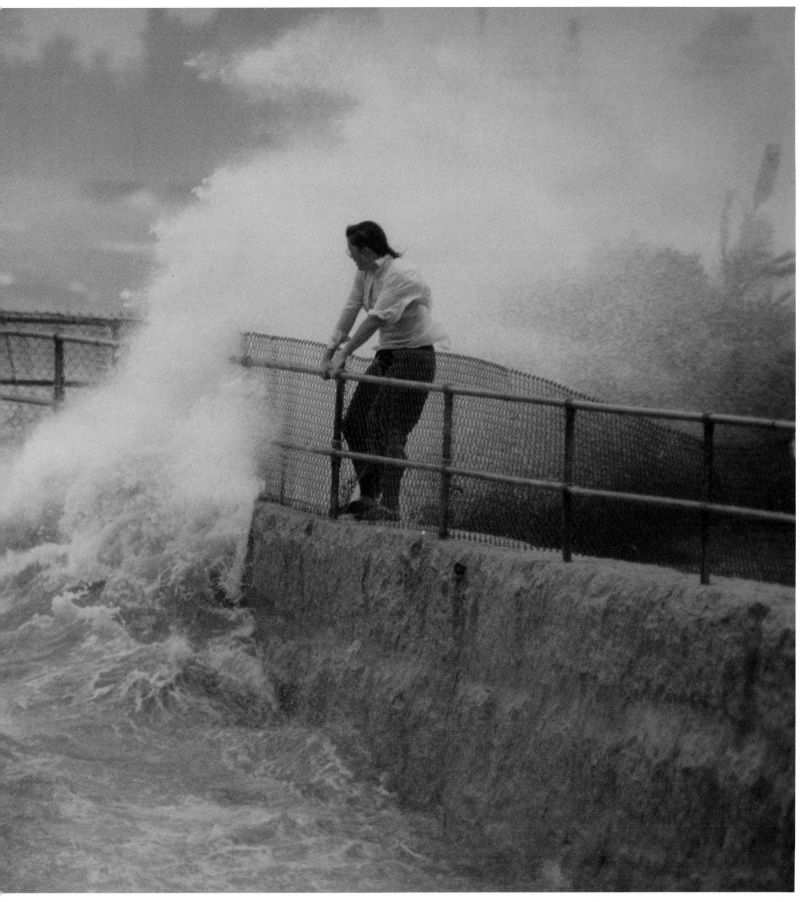

Gwen Littelberg grabs hold of a fence to keep from being swept away by waves in Woods Hole, Mass., during Hurricane Bob.

Ruben Perez, The Providence (R.I.) Journal-Bulletin

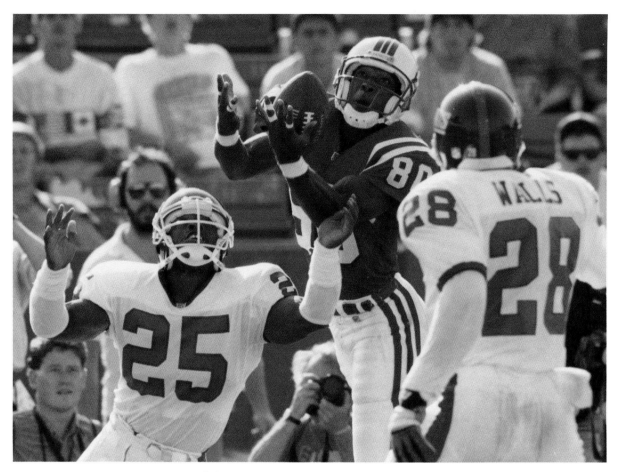

Irving Fryar of the New England Patriots makes a fingertip catch as New York Giants Mark Collins (25) and Everson Walls defend.

Ruben Perez, The Providence (R.I.) Journal-Bulletin

NEWSPAPER ONE WEEK'S WORK, 2ND PLACE

Bill Snead, The Washington Post

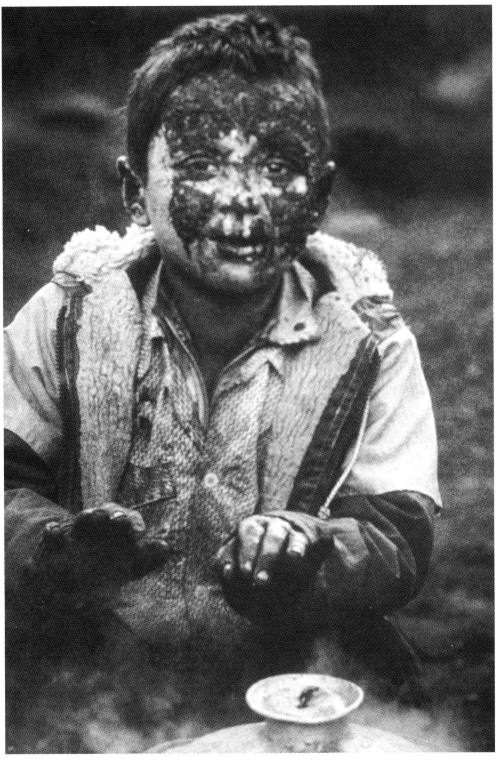

A Kurdish boy, his face burned by chemicals used in an Iraqi attack, warms his hands over a fire in a Turkish refugee camp.

Following page:
Refugees in Isikveren, Turkey, hang clothes to dry during a lull between storms.

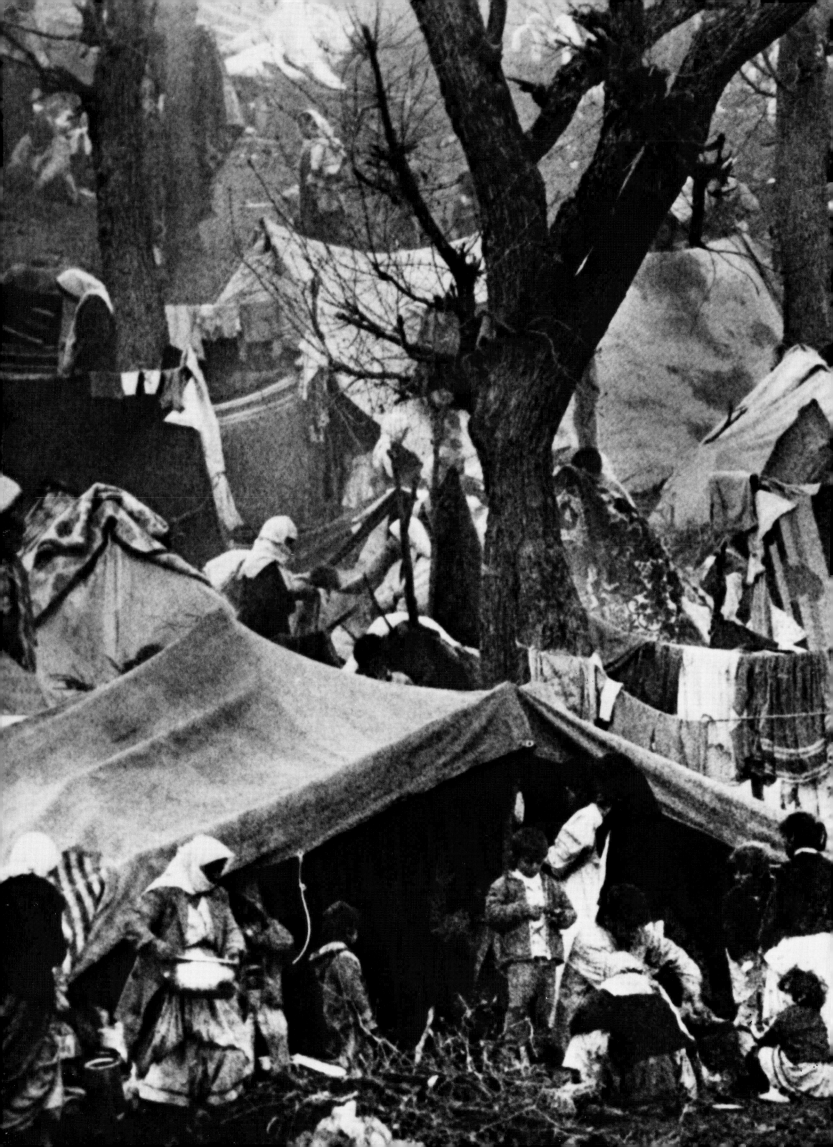

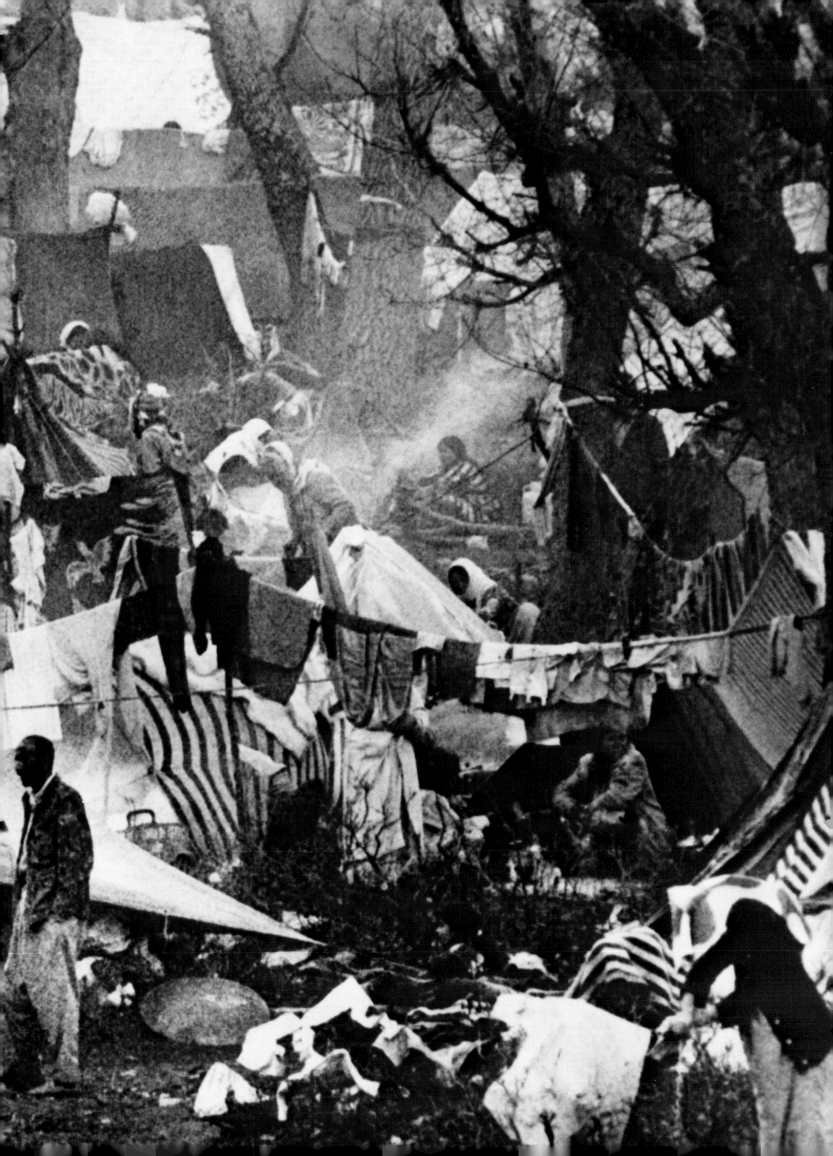

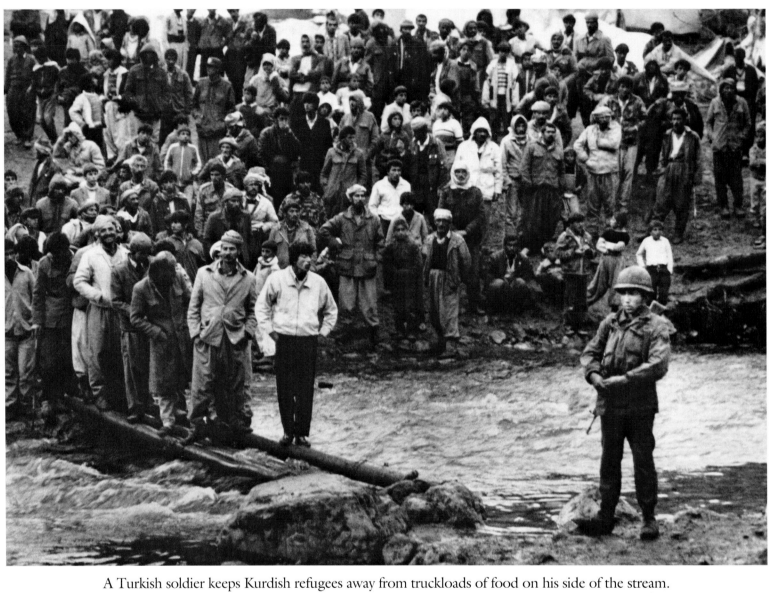

A Turkish soldier keeps Kurdish refugees away from truckloads of food on his side of the stream.

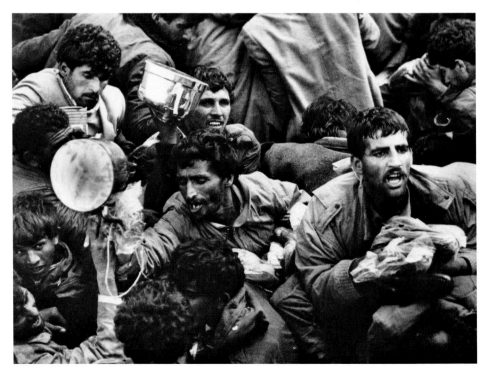

Kurds holds supplies they grabbed from a relief truck.

Bill Snead, The Washington Post

NEWSPAPER NEWS PICTURE STORY, 1ST PLACE

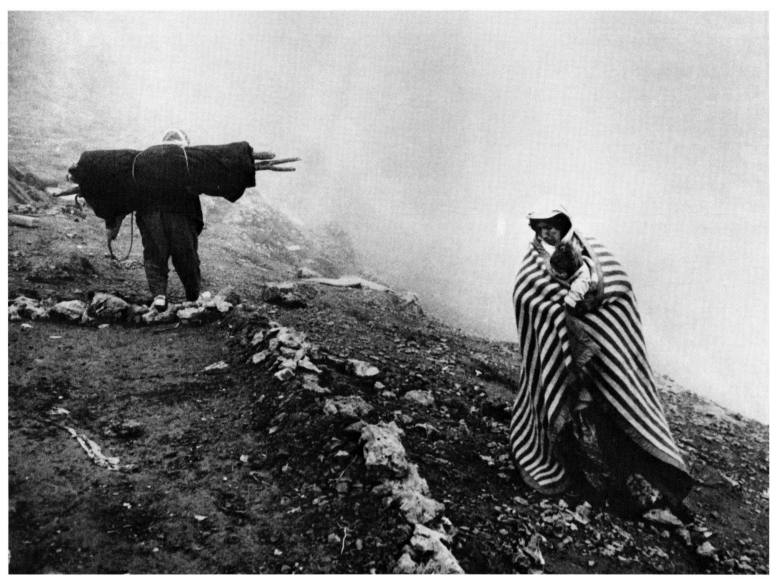

A mother carries a small child toward the Isikveren refugee camp in Turkey. Behind her, a man heads back to Iraq, willing to take his chances there rather than suffer the inhumanities of the camp.

No Sanctuary

I n the wake of the Persian Gulf war, hundreds of thousands of Kurds fled to the mountains separating Iraq from Turkey after Iraqi President Saddam Hussein's troops thwarted a Kurdish rebellion. In the Turkish village of Isikveren, high in the mountains, refugees lived in a makeshift camp, with snow for water and very little of anything for food. Relief efforts were crippled by the rugged terrain. Trucks were unable to get closer than two miles from the camp, and supplies were carried up steep, muddy slopes by tractor. Relief workers along the Turkish border said that up to a thousand Kurds died daily of exposure, dehydration and dysentery.

Bill Snead, The Washington Post

NEWSPAPER NEWS PICTURE STORY, 1ST PLACE

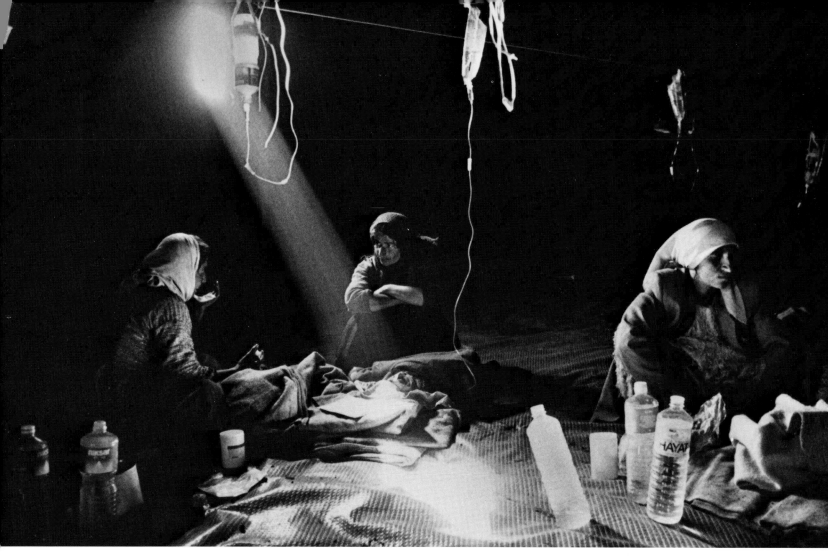

Women sit in a tent, watching their children as they are treated for malnourishment and dehydration with intravenous fluids.

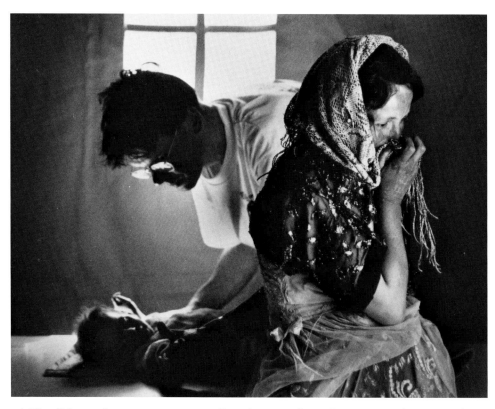

A Kurdish mother turns away as a Dutch nurse from Doctors Without Borders examines her child.

Bill Snead, The Washington Post

NEWSPAPER NEWS PICTURE STORY, 1ST PLACE

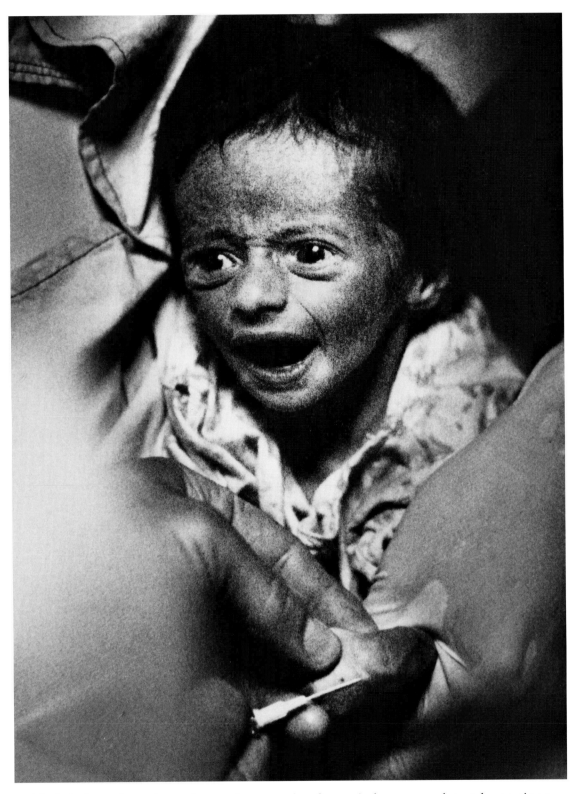

A baby's face mirrors her pain as a doctor probes for a vein large enough to take a syringe.

Bill Snead, The Washington Post

NEWSPAPER NEWS PICTURE STORY, 1ST PLACE

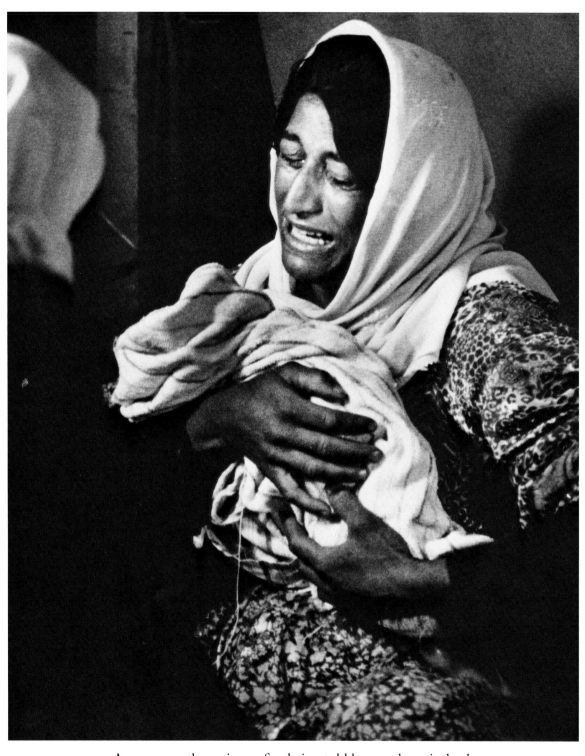

A young mother grieves after being told her newborn is dead.

NEWSPAPER NEWS PICTURE STORY, 1ST PLACE

NEWSPAPER NEWS PICTURE STORY
SECOND PLACE

Bradley Clift, The Hartford Courant

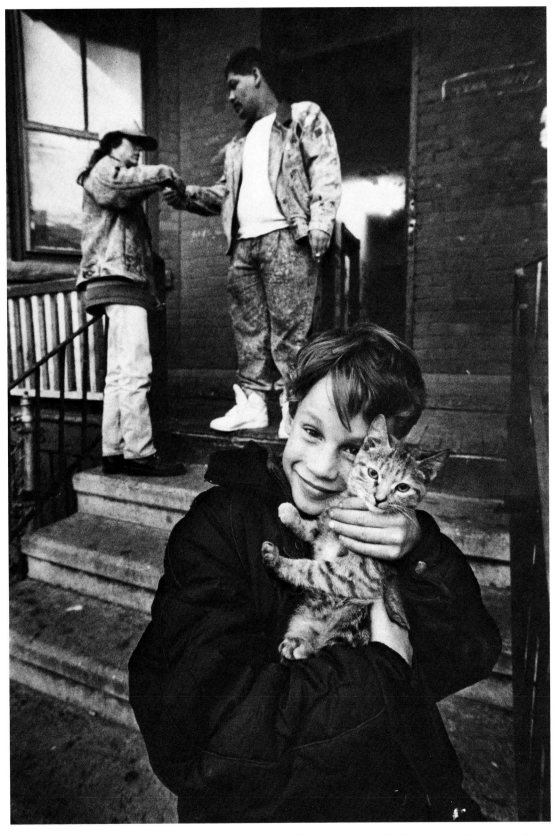

Christopher, 11, holds a cat, Christy, in front of his house. In the background, his mother, an addict, buys something from a neighbor.

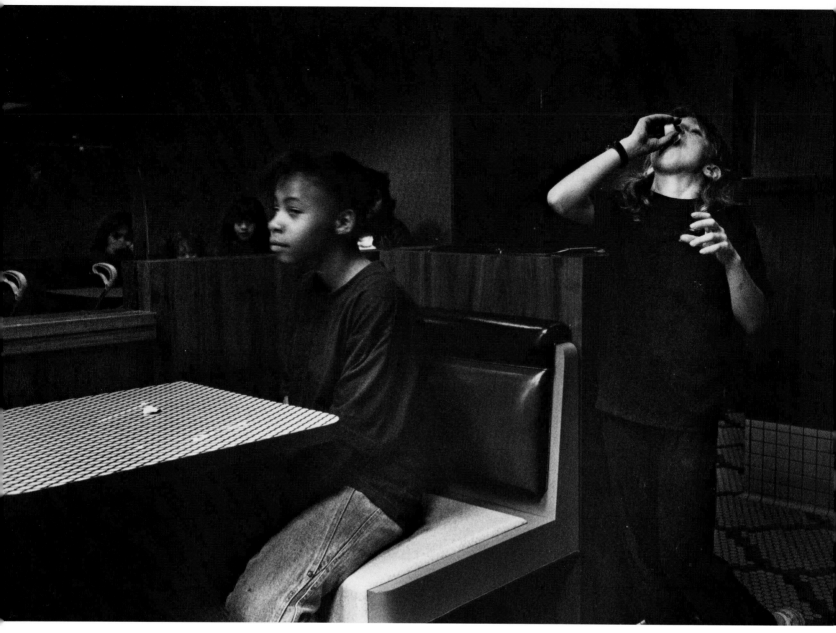

Jessica, 9, drinks leftover creamer she found in a trash can at McDonald's. Hours after most children are tucked into bed, she and her friend, Brandy, are out searching for food.

'Our House'

For Jessica and Christopher, home is hardly a haven. Since their father left a few years ago, their mother has become addicted to drugs. Their home has become a "shooting gallery" where addicts can come for a fix; their mother is known as the "nurse." A 2-year-old child was stuck by a discarded needle in the hallway of the building. On busy nights, scores of junkies visit the apartment, sometimes using the children's bedroom because that room has the heater. Christopher has taken to sleeping in a closet, preferring the comfort and quietness of the small space. "It's safe in here," he explains.

Bradley Clift, The Hartford Courant

NEWSPAPER NEWS PICTURE STORY, 2ND PLACE

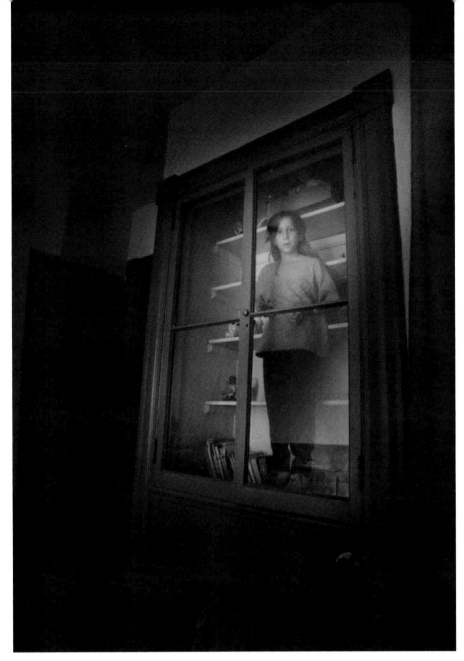

From this china cabinet, Jessica sometimes watches as her mother and neighbors shoot up. In the hallway (below), Jessica takes out her frustration on the cat, Christy. Soon afterward, the cat ran away.

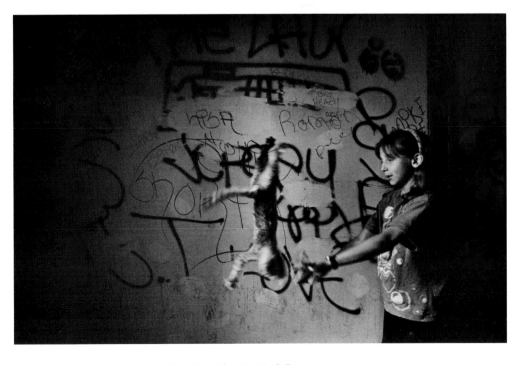

Bradley Clift, The Hartford Courant

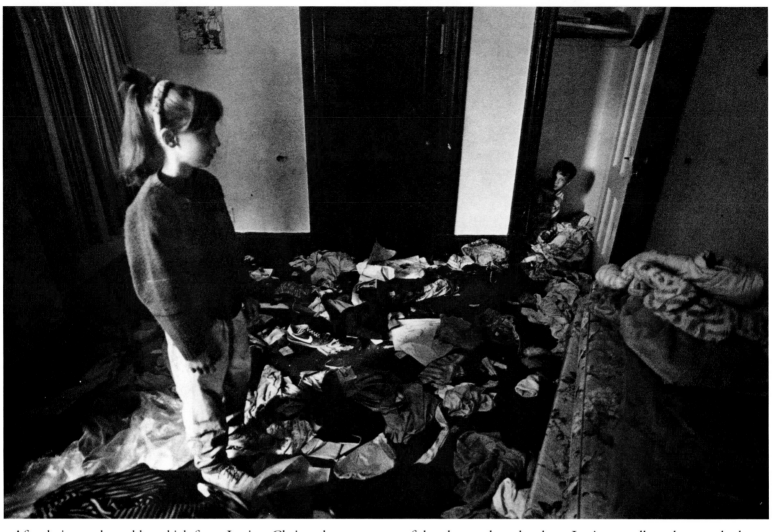

After being wakened by a kick from Jessica, Christopher peers out of the closet where he slept. Jessica usually wakens early, but has trouble getting her brother up for school.

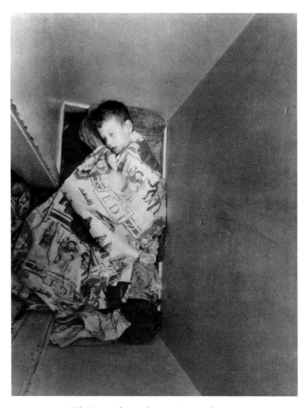

Christopher sleeps in a closet.

Bradley Clift, The Hartford Courant

NEWSPAPER NEWS PICTURE STORY, 2ND PLACE

Steve Mellon, The Pittsburgh Press

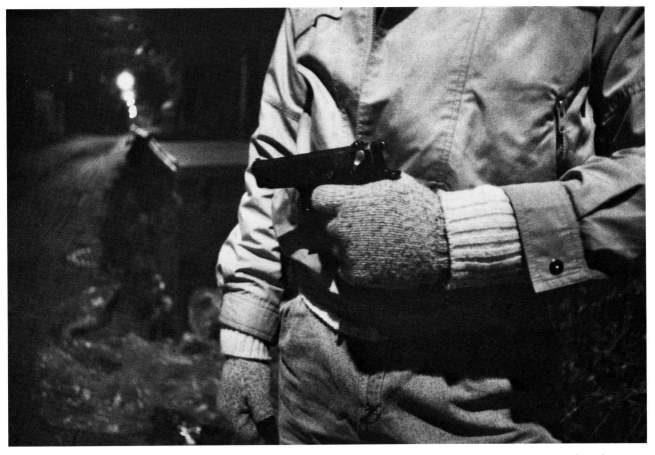

Violence in the Homewood section of Pittsburgh is on the rise. This resident always carries a handgun when he ventures outside.

The Violent City

Residents of the Homewood section of Pittsburgh noticed a startling increase in violent crime during 1991. Police blamed the greater availability of weapons and turf wars over drugs. The violence prompted a police crackdown in Homewood and surrounding communities. The high visibility of the anti-drug "task force" caused dealers to retreat into back alleys and abandoned buildings. Residents boarded windows and began carrying weapons for protection.

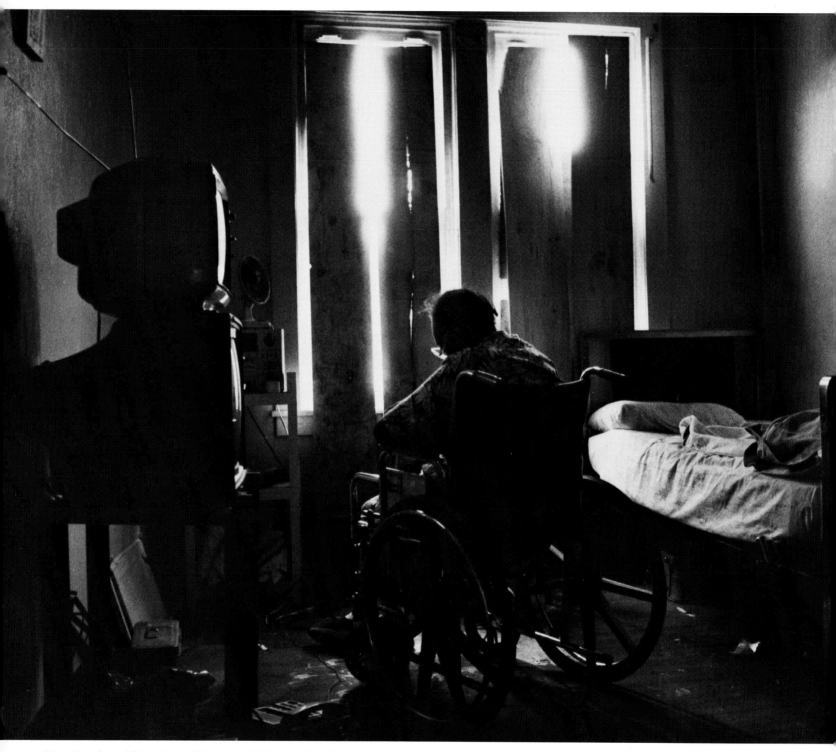

Despite the stifling heat, 73-year-old Arlie Clark keeps her windows boarded for protection from an ongoing drug war. A few days earlier, bullets crashed through the glass, narrowly missing members of her family.

Steve Mellon, The Pittsburgh Press

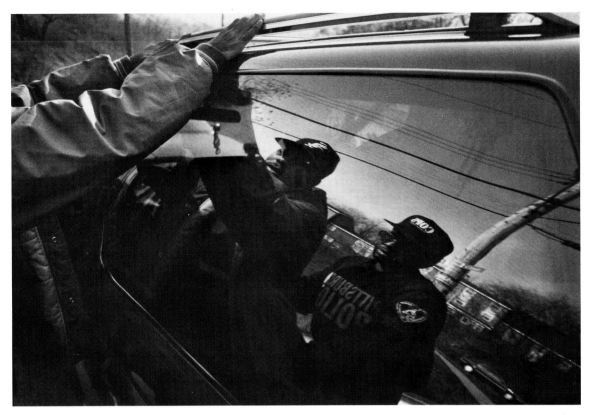

A police officer on the anti-drug task force searches a suspect.

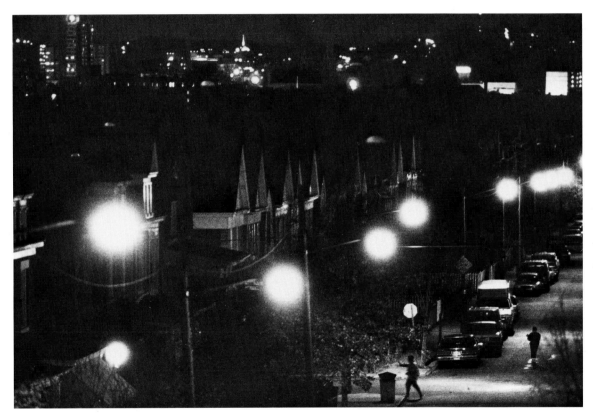

Although this street is well-lighted, it was the scene of a drive-by shooting.

Following page:
James Wilson was beaten and
robbed by two young men on
his way home from work.

Steve Mellon, The Pittsburgh Press

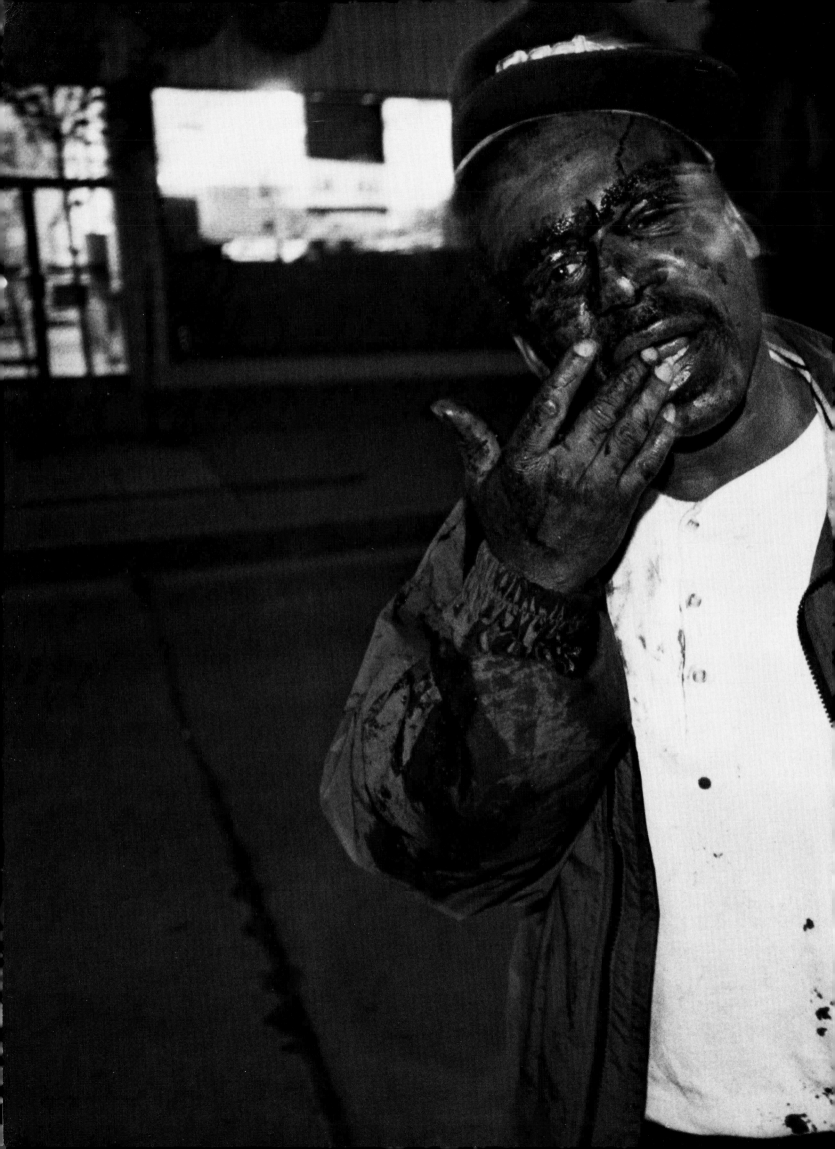

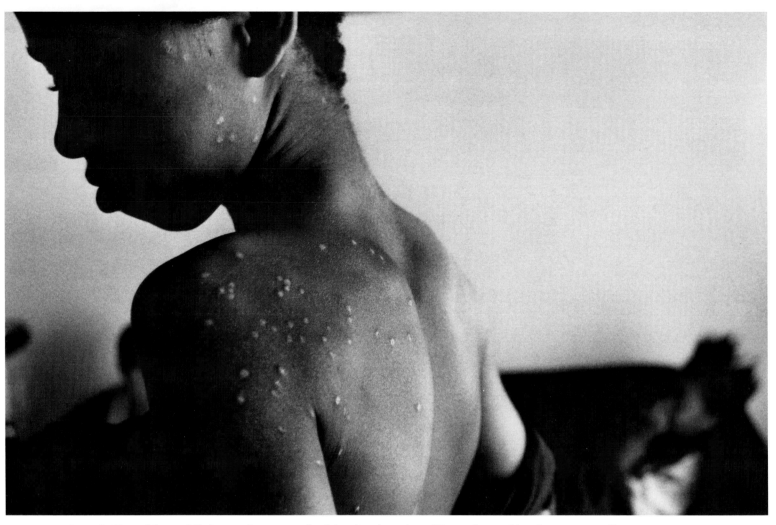

Lonnie Donaldson, 15, bears the scars of a drive-by shooting. He and two friends were standing on a corner when someone fired a shotgun.

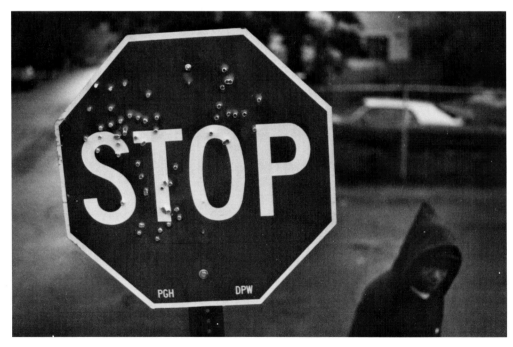

A bullet-riddled stop sign at Rosedale and Susquehanna streets in Homewood.

Steve Mellon, The Pittsburgh Press

THE WINNERS

FORTY-NINTH ANNUAL
PICTURES OF THE YEAR COMPETITION

Judged February 17 through 26 at the University of Missouri–Columbia. Sponsored by the National Press Photographers Association, The University of Missouri School of Journalism.

THE JUDGES

Vincent J. Alabiso/Associated Press; Paul Kuroda/Orange County Register; David Leeson/Dallas Morning News; Michele McDonald/Boston Globe; Michele McNally/Fortune Magazine; Daniela Mrazkova/Fotographie Magazine of Prague, Czechoslovakia; John Rumbach/The Herald of Jasper, Ind.; Michele Stephenson/TIME Magazine; David Sutherland/Syracuse University; and Junmin Yu/Photojournalism Society of China.

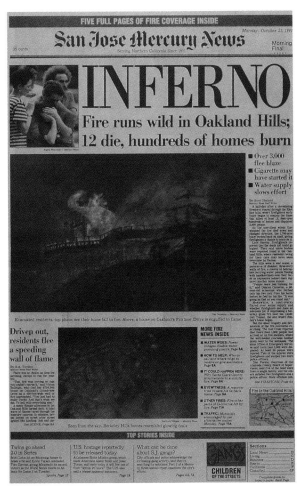

San Jose Mercury News
1st Place, Best use of photos in newspapers, circulation over 150,000.

NEWSPAPER PHOTOGRAPHER OF THE YEAR

Randy Olson, First Place, Newspaper Photographer of the Year, The Pittsburgh Press

Steve Mellon, Second Place, Newspaper Photographer of the Year, The Pittsburgh Press

Bradley Clift, Third Place, Newspaper Photographer of the Year, The Hartford Courant

MAGAZINE PHOTOGRAPHER OF THE YEAR

Christopher Morris, First Place, Magazine Photographer of the Year, Black Star for TIME Magazine

Peter Essick, Second Place, Magazine Photographer of the Year, freelance

CANON PHOTO ESSAYIST AWARD

Eugene Richards, Canon Photo Essayist Award, Magnum Photos, "The Family of the '90s"

Ken Light, Judges' Special Recognition, Canon Photo Essayist Award, JB Pictures, "The Mississippi Delta: Land That Time Forgot"

Christopher Morris, Judges' Special Recognition, Canon Photo Essayist Award, Black Star for TIME Magazine, "Civil War, Yugoslavia"

Miso and Lida Suchy, Judges' Special Recognition, Canon Photo Essayist Award, freelance, "Survivors — Photographs of Gypsies in Slovakia"

KODAK CRYSTAL EAGLE AWARD

Eugene Richards, Kodak Crystal Eagle Award, Magnum Photos, "Crack is Killing Us"

ANGUS McDOUGALL OVERALL EXCELLENCE IN EDITING AWARD FOR NEWSPAPERS

Mark Morris, The Sacramento Bee

NEWSPAPER SPOT NEWS

Joanne Rathe, First Place, Newspaper Spot News, The Boston Globe, "Busted"

Ronald Cortes, Second Place, Newspaper Spot News, The Philadelphia Inquirer, "Fighting for Food"

Charles Trainor, Jr., Third Place, Newspaper Spot News, The Miami Herald, "Streets of Fire"

Candace Barbot, Award of Excellence, Newspaper Spot News, The Miami Herald, "Helping Hands"

John Haeger, Award of Excellence, Newspaper Spot News, Oneida Daily Dispatch, "Dramatic Rescue"

Kit King, Award of Excellence, Newspaper Spot News, Spokesman Review, "Out of Control"

Wendy Lamm, Award of Excellence, Newspaper Spot News, Oakland Tribune, "Oakland Hills Fire"

David Lane, Award of Excellence, Newspaper Spot News, The Palm Beach Post, "Wave of Destruction"

Eric Mencher, Award of Excellence, Newspaper Spot News, The Philadelphia Inquirer, "Downdraft"

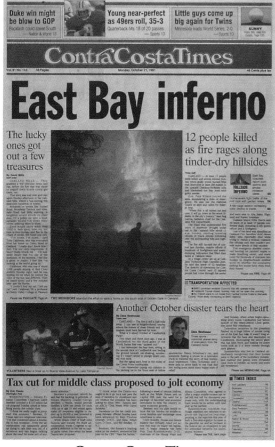

Contra Costa Times
2nd Place, Best use of photos in newspapers,
circulation 25,000 to 50,000.

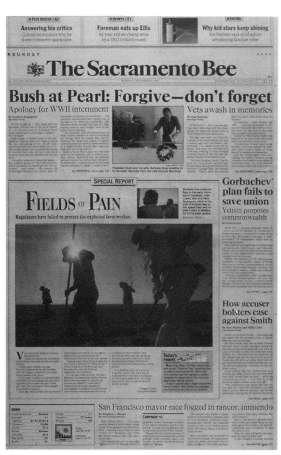

The Sacramento Bee
2nd Place, Best use of photos in newspapers,
circulation over 150,000.

Michael Norcia, Award of Excellence, Newspaper Spot News, New York Post, "Firefighter Rescues Trapped Man #1"

Hayne Palmour IV, Award of Excellence, Newspaper Spot News, Blade-Citizen (Oceanside, CA), "End of the Road"

Denis Paquin, Award of Excellence, Newspaper Spot News, The Associated Press, "Cukurca, Turkey / April 12, 1991"

NEWSPAPER GENERAL NEWS

Bill Snead, First Place, Newspaper General News, The Washington Post, "Tent of Despair"

Drew Perine, Second Place, Newspaper General News, The Herald (Everett, WA), "The Wild and the Innocent"

Steve Mellon, Third Place, Newspaper General News, The Pittsburgh Press, "Fear of the Streets"

Eric Albrecht, Award of Excellence, Newspaper General News, The Columbus Dispatch, "The Only Heat"

Candace Barbot, Award of Excellence, Newspaper General News, The Miami Herald, "Flea Woman"

Patrick Farrell, Award of Excellence, Newspaper General News, The Miami Herald, "Haitians"

Robin Graubard, Award of Excellence, Newspaper General News, New York Post, "Crown Heights 1991"

Bill Snead, Award of Excellence, Newspaper General News, The Washington Post, "Descending into Hell"

NEWSPAPER FEATURE PICTURE

Candace Barbot, First Place, Newspaper Feature Picture, The Miami Herald, "Schoolyard"

John Moore, Second Place, Newspaper Feature Picture, The Associated Press, "Sin Embargo"

Suzanne Kreiter, Third Place, Newspaper Feature Picture, The Boston Globe, "Group Spirit"

Jim Bates, Award of Excellence, Newspaper Feature Picture, The Seattle Times, "The Fountain of Youth "

Fred Conrad, Award of Excellence, Newspaper Feature Picture, The New York Times, "It's Mine"

Al Fuchs, Award of Excellence, Newspaper Feature Picture, The Pittsburgh Press, "South Side Beach"

R. Norman Matheny, Award of Excellence, Newspaper Feature Picture, The Christian Science Monitor, "Push Me"

Randy Olson, Award of Excellence, Newspaper Feature Picture, The Pittsburgh Press, "Any Port in a Storm Will Do"

Brian Plonka, Award of Excellence, Newspaper Feature Picture, Beaver County Times (PA), "Old Lust"

Massimo Sambucetti, Award of Excellence, Newspaper Feature Picture, The Associated Press, "Albanian Refugees"

Jose Luis Villegas, Award of Excellence, Newspaper Feature Picture, San Jose Mercury News, "Mr. Universe"

NEWSPAPER SPORTS ACTION

Eric Miller, First Place, Newspaper Sports Action, Reuter News Pictures / St. Paul Pioneer Press, "World Series Headstand"

Tom Copeland, Second Place, Newspaper Sports Action, Greensboro News & Record, "Fiery Crash"

Ronald Cortes, Third Place, Newspaper Sports Action, The Philadelphia Inquirer, "Bashing Bashiru"

John Freidah, Award of Excellence, Newspaper Sports Action, Peoria Journal Star, "Hitting the Mat"

Xavier Libbrecht Mazureau, Award of Excellence, Newspaper Sports Action, Presse-Sports, "Pegasus Failed"

Jonathan Newton, Award of Excellence, Newspaper Sports Action, Atlanta Journal-Constitution, "Heads up"

Erich Schlegel, Award of Excellence, Newspaper Sports Action, The Dallas Morning News, "Portugese Bullfighters"

Tim Sharp, Award of Excellence, Newspaper Sports Action, Lexington Herald-Leader (KY), "Clash at the Scorer's Table"

Mark Sluder, Award of Excellence, Newspaper Sports Action, The Charlotte Observer, "Dive to Safety"

Michael Sturk, Award of Excellence, Newspaper Sports Action, Calgary Herald, "Bulldogger"

Irwin Thompson, Award of Excellence, Newspaper Sports Action, The Dallas Morning News, "Is it the shoe"

Bill Wade, Award of Excellence, Newspaper Sports Action, The Pittsburgh Press, "Ooooh, that Smarts"

NEWSPAPER SPORTS FEATURE

Mark Garfinkel, First Place, Newspaper Sports Feature, freelance, "Gridiron Cryin'"

Michael Chow, Second Place, Newspaper Sports Feature, The Phoenix Gazette, "Last but not least..."

Jeffery Salter, Third Place, Newspaper Sports Feature, The Miami Herald, "Backstroke"

David McIntyre, Award of Excellence, Newspaper Sports Feature, The Phoenix Gazette, "Thrill of Victory"

Ruben Perez, Award of Excellence, Newspaper Sports Feature, Providence Journal-Bulletin, "Land Ho"

NEWSPAPER PORTRAIT/PERSONALITY

Michael Wirtz, First Place, Newspaper Portrait/Personality, The Philadelphia Inquirer, "War Grandmother"

Chien-Chi Chang, Second Place, Newspaper Portrait/Personality, The Seattle Times, "Three Friends"

Al Diaz, Third Place, Newspaper Portrait/Personality, Miami Herald, "Haydee and Sahara Scull"

Randy Olson, Award of Excellence, Newspaper Portrait/Personality, The Pittsburgh Press, "Man on the Mon"

Donna Terek, Award of Excellence, Newspaper Portrait/Personality, The Detroit News, "Child of God"

Cindy Yamanaka, Award of Excellence, Newspaper Portrait/Personality, The Dallas Morning News, "Capturing Spirits"

NEWSPAPER PICTORIAL

Craig Fritz, First Place, Newspaper Pictorial, Western Kentucky University, "Reflections"

Steve Apps, Second Place, Newspaper Pictorial, Sarasota Herald-Tribune, "Storm Clouds"

Todd Anderson, Third Place, Newspaper Pictorial, Jackson Hole Guide, "3 on 3"

John Moore, Award of Excellence, Newspaper Pictorial, The Associated Press, "An American Celebration"

Tom Reese, Award of Excellence, Newspaper Pictorial, The Seattle Times, "Fish Out of Water"

NEWSPAPER FOOD ILLUSTRATION

Peter Battistoni, First Place, Newspaper Food Illustration, Vancouver Sun, "Mango Magic"

John Luke, Second Place, Newspaper Food Illustration, Detroit Free Press, "Wine with Glasses"

Kevin Swank, Third Place, Newspaper Food Illustration, The Evansville Courier (IN), "Easter Eggs"

NEWSPAPER FASHION ILLUSTRATION

Not all places given

Red Huber, Award of Excellence, Newspaper Fashion Illustration, The Orlando Sentinel, "Underwater Blue"

NEWSPAPER NEWS PICTURE STORY

Bill Snead, First Place, Newspaper News Picture Story, The Washington Post, "Kurdish Refugees in Turkey"

Bradley Clift, Second Place, Newspaper News Picture Story, The Hartford Courant, "Triangle of Despair: Our House is a Gallery"

Steve Mellon, Third Place, Newspaper News Picture Story, The Pittsburgh Press, "The Violent City"

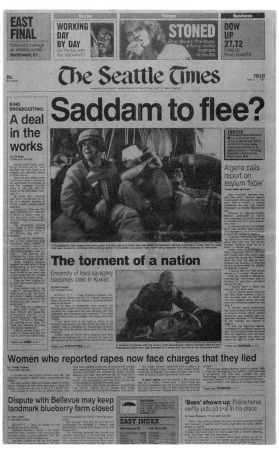

The Seattle Times
3rd Place, Best use of photos in newspapers, circulation over 150,000.

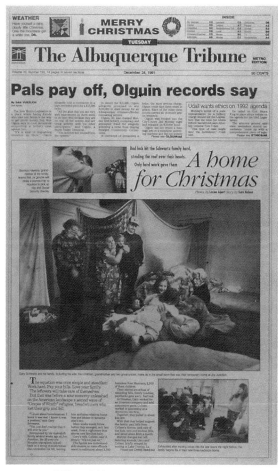

The Albuquerque Tribune
1st Place, Best use of photos in newspapers, circulation 25,000 to 150,000.

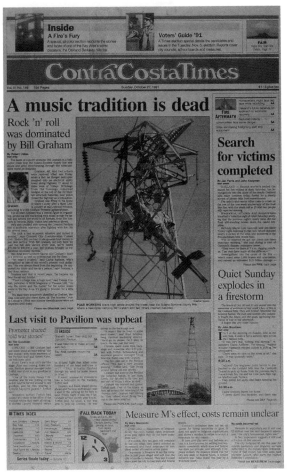

Contra Costa Times
2nd Place, Best use of photos in newspapers, circulation 25,000 to 150,000.

National Geographic
1st Place, Best use of photos in magazines.

Bradley Clift, Award of Excellence, Newspaper News Picture Story, The Hartford Courant, "Triangle of Despair: Heroin, Prostitution and HIV"

Bradley Clift, Award of Excellence, Newspaper News Picture Story, The Hartford Courant, "Triangle of Despair: Addiction is Stronger than Love"

Dimitar Dilcoff, Award of Excellence, Newspaper News Picture Story, Podkrepa (Sofia, Bulgaria), Untitled

Frederic Larson, Award of Excellence, Newspaper News Picture Story, San Francisco Chronicle, "Run For Your Life"

NEWSPAPER FEATURE PICTURE STORY

April Saul, First Place, Newspaper Feature Picture Story, The Philadelphia Inquirer, "...And Baby Makes Five"

Suzanne Kreiter, Second Place, Newspaper Feature Picture Story, The Boston Globe, "Special Care: Community vs. Institution"

Pauline Lubens, Third Place, Newspaper Feature Picture Story, Detroit Free Press, "Coming Home: Letting Go"

Beth Bergman, Award of Excellence, Newspaper Feature Picture Story, The Virginian-Pilot/ Ledger Star, "All in the Family"

John Kaplan, Award of Excellence, Newspaper Feature Picture Story, Block Newspapers, "Shooting Drugs and Selling Himself"

Charles Mason, Award of Excellence, Newspaper Feature Picture Story, freelance for Anchorage Daily News, "Reindeer Roundup"

Randy Olson, Award of Excellence, Newspaper Feature Picture Story, The Pittsburgh Press, "Corey's Guilt"

David Sanders, Award of Excellence, Newspaper Feature Picture Story, Arizona Daily Star, "Still Celebrating Life"

Callie Shell, Award of Excellence, Newspaper Feature Picture Story, The Pittsburgh Press, "Tracy: The Outsider"

Bill Tiernan, Award of Excellence, Newspaper Feature Picture Story, The Virginian-Pilot/ Ledger Star, "Batttle With Breast Cancer"

NEWSPAPER SPORTS PORTFOLIO

Ronald Cortes, First Place, Newspaper Sports Portfolio, The Philadelphia Inquirer

Gerard Michael Lodriguss, Second Place, Newspaper Sports Portfolio, The Philadelphia Inquirer

Not all places given

Pat Davison, Award of Excellence, Newspaper Sports Portfolio, The Pittsburgh Press

Vincent Musi, Award of Excellence, Newspaper Sports Portfolio, The Pittsburgh Press

NEWSPAPER–ONE WEEK'S WORK

Rod Mar, First Place, Newspaper–One Week's Work, The Seattle Times

Ruben Perez, Second Place, Newspaper–One Week's Work, Providence (R.I.) Journal-Bulletin

Not all places given

MAGAZINE NEWS OR DOCUMENTARY

Christopher Morris, First Place, Magazine News or Documentary, Black Star for TIME Magazine, "Father's Funeral"

Jean-Claude Coutausse, Second Place, Magazine News or Documentary, Contact Press Images, "Civil War in Yugoslavia"

Les Stone, Third Place, Magazine News or Documentary, Sygma News Photo, "Kurdish Crisis"

Terry Ashe, Award of Excellence, Magazine News or Documentary, LIFE, "I Could Not Keep Silent"

Karim Daher, Award of Excellence, Magazine News or Documentary, Gamma Liaison for TIME Magazine, "Flee"

Alexis Duclos, Award of Excellence, Magazine News or Documentary, Gamma Press Images, "Sudan"

Alberto Garcia, Award of Excellence, Magazine News or Documentary, SABA for TIME

Magazine, "Eruption"

Gustavo Gilabert, Award of Excellence, Magazine News or Documentary, JB Pictures for NEWSWEEK, "Cholera Epidemic / Peru"

Peter Menzel, Award of Excellence, Magazine News or Documentary, freelance, "Kuwait"

Christopher Morris, Award of Excellence, Magazine News or Documentary, Black Star for TIME Magazine, "Croatian Fighters"

James Nachtwey, Award of Excellence, Magazine News or Documentary, TIME Magazine, "Suicide"

Judah Passow, Award of Excellence, Magazine News or Documentary, Network/Matrix for LIFE, "Kurdish Child"

Richard Schultz, Award of Excellence, Magazine News or Documentary, Arbutus, "Electric Kids"

Les Stone, Award of Excellence, Magazine News or Documentary, Sygma News Photo, "Typhoon, Ormok Philippines"

Anthony Suau, Award of Excellence, Magazine News or Documentary, Black Star for TIME Magazine, "Final Moments of Sunlight"

GEO WISSEN
2nd Place, Best use of photos in magazines.

Magazine Feature Picture

Eugene Richards, First Place, Magazine Feature Picture, Magnum Photos, "Ugandan Family"

Eugene Richards, Second Place, Magazine Feature Picture, Magnum Photos, "Birth of First Child"

Sebastiao Salgado, Third Place, Magazine Feature Picture, Magnum for The New York Times Magazine, "Kuwaiti Inferno"

Ellen Binder, Award of Excellence, Magazine Feature Picture, freelance, "Saratov Region, Russian Republic"

William Campbell, Award of Excellence, Magazine Feature Picture, TIME Magazine, "Make Waves"

Steve Liss, Award of Excellence, Magazine Feature Picture, TIME Magazine, "Back on the Ranch"

Steve McCurry, Award of Excellence, Magazine Feature Picture, National Geographic Magazine, "Fiery Aliens"

James Stanfield, Award of Excellence, Magazine Feature Picture, National Geographic Magazine, "China Opera"

Magazine Sports Picture

Manny Millan, First Place, Magazine Sports Picture, Sports Illustrated, "Show of Hands"

Mike Powell, Second Place, Magazine Sports Picture, Allsport Photography for TIME Magazine, "Long Jump"

Stefan Warter, Third Place, Magazine Sports Picture, Sports Illustrated, "Decathlete Christian Schenk"

Lars Gelfan, Award of Excellence, Magazine Sports Picture, freelance, "Fierce Jackie"

Mike Powell, Award of Excellence, Magazine Sports Picture, Allsport Photography, "Sepak Takraw"

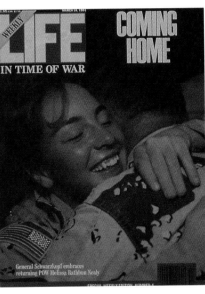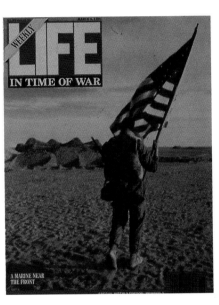

LIFE
3rd Place, Best use of photos in magazines.

Magazine Portrait/Personality

Linda Creighton, First Place, Magazine Portrait/Personality, US NEWS & WORLD REPORT, "War Bonds"

Linda Creighton, Second Place, Magazine Portrait/Personality, US NEWS & WORLD REPORT, "Safe With Nanny"

Charles Ledford, Third Place, Magazine Portrait/Personality, Commission Magazine, "Mother and Tuberculosis Patient"

Hoda Bakhshandagi, Award of Excellence, Magazine Portrait/Personality, Black Star, "Face of Hunger: Sudan"

Therese Frare, Award of Excellence, Magazine Portrait/Personality, freelance, "Two Spirits"

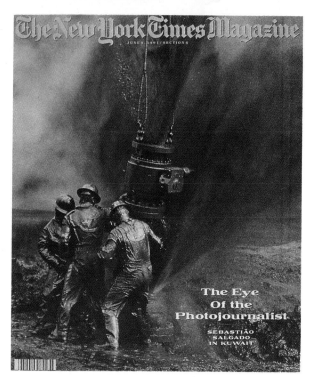

The New York Times Magazine
1st Place, Picture editing/Feature story/
Magazine

Charles Ledford, Award of Excellence, Magazine Portrait/Personality, Commission Magazine, "A Boy's Light to the World"

Steve Liss, Award of Excellence, Magazine Portrait/Personality, TIME Magazine, "The Blues"

Brad Markel, Award of Excellence, Magazine Portrait/Personality, freelance for Fortune Magazine, "The Shadow of War"

Michael O'Brien, Award of Excellence, Magazine Portrait/Personality, LIFE, "World War I Soldier"

Anna Susan Post, Award of Excellence, Magazine Portrait/Personality, freelance, "Jean Michelet - AIDS in Haiti"

MAGAZINE PICTORIAL

Greg Foster, First Place, Magazine Pictorial, freelance, "People Looking at Map"

Peter Korniss, Second Place, Magazine Pictorial, A Day in the Life of Ireland / Collins Publishing, "Vials' Home"

Charles Mason, Third Place, Magazine Pictorial, Black Star , "Reindeer Herding in Alaska"

Jim Brandenburg, Award of Excellence, Magazine Pictorial, National Geographic Magazine, "Lone Bison"

David Doubilet, Award of Excellence, Magazine Pictorial, National Geographic Magazine, "Sailboat and Sand Shoals"

Greg Foster, Award of Excellence, Magazine Pictorial, freelance, "Power Lines and Clearing Storm"

Alden Pellett, Award of Excellence, Magazine Pictorial, freelance, "Mount Mansfield, VT"

MAGAZINE EDITORIAL ILLUSTRATION

Melanie Rook D'Anna, First Place, Magazine Editorial Illustration, Mesa Tribune (AZ), "Dog Day at the Movies"

Pat McDonough, Second Place, Magazine Editorial Illustration, The Courier-Journal (KY), "Multiculturalism"

John Abbott, Third Place, Magazine Editorial Illustration, freelance for Fortune Magazine, "How the Average American Lives"

Peter Menzel, Award of Excellence, Magazine Editorial Illustration, freelance, "Insect Robots"

MAGAZINE SCIENCE/NATURAL HISTORY

National Geographic
2nd Place, Picture editing/Feature story/
Magazine

Steve McCurry, First Place, Magazine Science/Natural History, National Geographic Magazine, "Camels Under Blackened Sky"

David Doubilet, Second Place, Magazine Science/Natural History, National Geographic Magazine, "Black Cod"

Jim Brandenburg, Third Place, Magazine Science/Natural History, National Geographic Magazine, "Wolf: Spirit of the Forest"

David Doubilet, Award of Excellence, Magazine Science/Natural History, National Geographic Magazine, "Lagoon of Life"

David Doubilet, Award of Excellence, Magazine Science/Natural History, National Geographic Magazine, "Dolphin and Man"

Frank Fournier, Award of Excellence, Magazine Science/Natural History, Contact Press Images, "Wounded"

Wilbur Samuel Tripp, Award of Excellence, Magazine Science/Natural History, National Wildlife Magazine, "Brave Bird"

MAGAZINE PICTURE STORY

Anthony Suau, First Place, Magazine Picture Story, Black Star for TIME Magazine, "The Kurdish Persecution"

Christopher Morris, Second Place, Magazine Picture Story, Black Star for TIME Magazine, "Civil War in Croatia"

Eugene Richards, Third Place, Magazine Picture Story, Magnum Photos, "Uganda Hospital"

Stephane Compoint, Award of Excellence, Magazine Picture Story, Sygma for LIFE, "Hell on Earth"

David Lurie, Award of Excellence, Magazine Picture Story, Katz/SABA, "Life in the Liberated Zone"

Viviane Moos, Award of Excellence, Magazine Picture Story, Freelance, "Street Nomads of Rio"

Michael Nichols, Award of Excellence, Magazine Picture Story, Magnum Photos, "Brutal

Kinship"

Eugene Richards, Award of Excellence, Magazine Picture Story, Magnum for LIFE, "The Birth of a Family"

Sebastiao Salgado, Award of Excellence, Magazine Picture Story, Magnum for The New York Times Magazine, "The Kuwaiti Inferno"

Stephen Shames, Award of Excellence, Magazine Picture Story, Matrix, "Homicide in Houston"

MAGAZINE SPORTS PORTFOLIO

No awards given

GULF WAR NEWS/INDIVIDUAL

David Turnley, First Place, Gulf War News/Individual, Detroit Free Press, "Gulf War - Friendly Fire"

Wesley Bocxe, Second Place, Gulf War News/Individual, Sipa Press for TIME Magazine, "Liberation of Kuwait"

Kenneth Jarecke, Third Place, Gulf War News/Individual, Contact Press Images for TIME Magazine, "The Face of War"

Bruno Barbey, Award of Excellence, Gulf War News/Individual, Magnum for TIME Magazine, "Camels"

Lois Bernstein, Award of Excellence, Gulf War News/Individual, The Sacramento Bee, "Lost in the War"

Wesley Bocxe, Award of Excellence, Gulf War News/Individual, Sipa Press for TIME Magazine, "Liberation Day"

Jeff Horner, Award of Excellence, Gulf War News/Individual, Walla Walla Union-Bulletin, "True Blue"

Martin Simon, Award of Excellence, Gulf War News/Individual, SABA for LIFE, "Family Funeral"

David Turnley, Award of Excellence, Gulf War News/Individual, Detroit Free Press, "Waiting for Help"

Laurent Van Der Stockt, Award of Excellence, Gulf War News/Individual, Gamma Press Images, "Kuwait"

GULF WAR NEWS/STORY

Steve McCurry, First Place, Gulf War News/Story, National Geographic Magazine, "Kuwait: After the Storm"

Not all places given

Mark Peterson, Award of Excellence, Gulf War News/Story, JB Pictures, "Last Farewell"

PICTURE EDITING/NEWS STORY/NEWSPAPER

Bryan Moss, Geri Migielicz, Sue Morrow, Mary Jo Moss, Murray Koodish, First Place, Picture Editing/News Story/Newspaper, San Jose Mercury News, "Inferno"

Merrill Oliver, Second Place, Picture Editing/News Story/Newspaper, The Sacramento Bee, "Town mourns one of its own"

Mike Davis, Third Place, Picture Editing/News Story/Newspaper, The Albuquerque Tribune, "The War At Home"

PICTURE EDITING/NEWS STORY/MAGAZINE

Bert Fox, Tom Gralish, First Place, Picture Editing/News Story/Magazine, Philadelphia Inquirer Magazine, "Children of War: Photography by Eric Mencher"

Not all places given

PICTURE EDITING/FEATURE STORY/NEWSPAPER

Rick Shaw, First Place, Picture Editing/Feature Story/Newspaper, The Sacramento Bee, "Fields of Pain"

John Kaplan, Second Place, Picture Editing/Feature Story/Newspaper, Pittsburgh Post-Gazette, "Brian"

Timothy J. Cochran, Third Place, Picture Editing/Feature Story/Newspaper, The Virginian-Pilot/Ledger Star, "All in the Family"

Journal Tribune
1st Place, Best use of photos in newspapers, circulation under 25,000.

The Virginian-Pilot/Ledger Star
3rd Place, Picture editing/Feature story/
Newspaper

The Sacramento Bee
2nd Place, Picture editing/News story/
newspaper

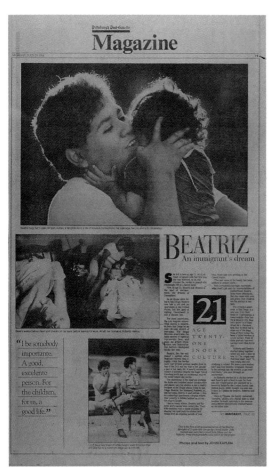

Pittsburgh Post-Gazette
1st Place, Picture editing/Series or special
section

Merrill Oliver, Award of Excellence, Picture Editing/Feature Story/Newspaper, The Sacramento Bee, "The Monkey Wars"

Mike Smith, Award of Excellence, Picture Editing/Feature Story/Newspaper, Detroit Free Press, "Soviet Defiance Gains Strength"

PICTURE EDITING/FEATURE STORY/MAGAZINE

Kathy Ryan, First Place, Picture Editing/Feature Story/Magazine, The New York Times Magazine, "The Eye of the Photojournalist"

Dennis Dimick, Second Place, Picture Editing/Feature Story/Magazine, National Geographic, "The Morning After"

J. Bruce Baumann, Third Place, Picture Editing/Feature Story/Magazine, The Pittsburgh Press, "No Vacation from Violence"

Thea Breite, Award of Excellence, Picture Editing/Feature Story/Magazine, The Providence Journal, "Pet Clinic"

Tom Gralish, Award of Excellence, Picture Editing/Feature Story/Magazine, Philadelphia Inquirer Magazine, "Outside the Dream"

Stephen Freligh, Award of Excellence, Picture Editing/Feature Story/Magazine, International Wildlife Magazine, "Watercolors"

PICTURE EDITING/SPORTS STORY/NEWSPAPER

Mike Davis, First Place, Picture Editing/Sports Story/Newspaper, The Albuquerque Tribune, "Swimming for Serenity"

Not all places given

John Scanlan, Award of Excellence, Picture Editing/Sports Story/Newspaper, The Hartford Courant, "Cricket, West Indies-style"

Peter Weinberger, Award of Excellence, Picture Editing/Sports Story/Newspaper, St. Paul Pioneer Press, "Minor leagues, major dreams"

PICTURE EDITING/SPORTS STORY/MAGAZINE

J. Bruce Baumann, First Place, Picture Editing/Sports Story/Magazine, The Pittsburgh Pres "Michael Moorer"

Not all places given

PICTURE EDITING/SERIES OR SPECIAL SECTION

John Kaplan, First Place, Picture Editing/Series or Special Section, Pittsburgh Post-Gazette, "21"

Susan Tripp Pollard, Second Place, Picture Editing/Series or Special Section, Contra Costa Times, "A Fire's Fury"

Scott Sines, Third Place, Picture Editing/Series or Special Section, Spokesman-Review, "A Last Look - The Photojournalism of Kit King"

John Kaplan, Award of Excellence, Picture Editing/Series or Special Section, Monterey Herald, "21"

Lisa Roberts, Award of Excellence, Picture Editing/Series or Special Section, The Sacramento Bee, "Book of Dreams"

NEWSPAPER-PRODUCED MAGAZINE PICTURE EDITING AWARD

J. Bruce Baumann, First Place, Newspaper-produced Magazine Picture Editing Award, The Pittsburgh Press

Mike Smith, **Steve Nickerson**, **A.J. Hartley**, **Deborah Withey**, Second Place, Newspaper-produced Magazine Picture Editing Award, Detroit Free Press

Not all places given

Not all places given

Best use of Photographs/ Newspapers: Circulation of under 25,000

First Place, Journal Tribune (Biddeford, ME)
Not all places given

Best use of Photographs/Newspapers: Circulation of 25,000 to 150,000

First Place, The Albuquerque Tribune

Second Place, Contra Costa Times (Walnut Creek, CA)
Not all places given

Best use of Photographs/Newspapers: Circulation of more than 150,000

First Place, San Jose Mercury News

Second Place, The Sacramento Bee

Third Place, The Seattle Times

Award of Excellence, The Orange County Register

Award of Excellence, St. Paul Pioneer Press

Award of Excellence, Detroit Free Press

Best use of Photographs/Magazines

First Place, National Geographic

Second Place, GEO WISSEN

Third Place, LIFE

Award of Excellence, GEO MAGAZIN - Das neue Bild der Erde

Newspaper Picture Editing Award/Individual Portfolio

Scott Sines, First Place, Spokesman-Review

Rick Shaw, Second Place, The Sacramento Bee

Mike Davis, Third Place, The Albuquerque Tribune

J. Bruce Baumann, Award of Excellence, The Pittsburgh Press

Newspaper Picture Editing Award/Team Portfolio

Mark Morris, Merrill Oliver, Rick Shaw, Lisa Roberts, Dave Mathias, Harlin Smith, First Place, Newspaper Picture Editing Award/Team Portfolio, The Sacramento Bee

Ron Londen, J. Bryant, Joe Gentry, Michele Cardon, Karen Kelso, Second Place, Newspaper Picture Editing Award/Team Portfolio, The Orange County Register

Bryan Moss, Sandra Eisert, Murray Koodish, Geri Migielicz, Sue Morrow, Mary Jo Moss, Third Place, Newspaper Picture Editing Award/Team Portfolio, San Jose Mercury News

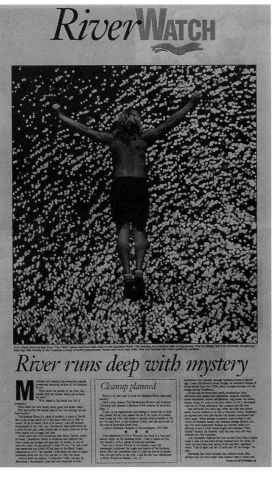

Spokesman-Review
1st Place, Newspaper picture editing/
Individual portfolio

The Albuquerque Tribune
1st Place, Picture editing/Sports story/
Newspaper

THE INDEX